THE WORK OF GRINLING GIBBONS

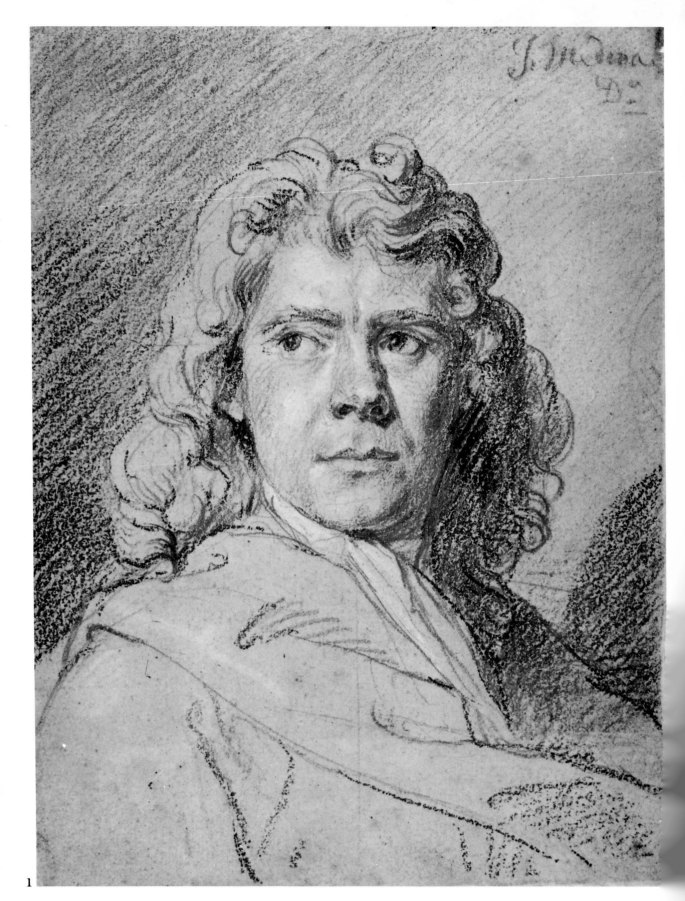

1. 'Grinling Gibbons' (1648–1721), drawing by Sir John Baptist Medina, *c.* 1686

THE WORK OF
Grinling Gibbons

GEOFFREY BEARD

THE UNIVERSITY OF CHICAGO PRESS

The University of Chicago Press, Chicago 60637
John Murray (Publishers) Ltd., London

Printed in Great Britain

99 98 97 96 95 94 93 92 91 90 54321

Library of Congress Cataloging-in-Publication Data

Beard, Geoffrey W.
 The work of Grinling Gibbons / Geoffrey Beard.
 p. cm.
 Includes bibliographical references.
 ISBN 0–226–03992–7
 1. Gibbons, Grinling, 1648–1721—Criticism and interpretation.
2. Wood-carving—England—History—17th century. 3. Wood-carving—
England—History—18th century. I. Gibbons, Grinling, 1648–1721.
II. Title.
 NK9798.G5B43 1989
 730′.092—dc20 89–20460
 CIP

Designed by Peter Campbell

Typeset, printed and bound in Great Britain by
Butler & Tanner Ltd, Frome and London

This book is printed on acid-free paper.

Contents

Preface

IN this preliminary note I want to explain the scheme of this short book, and also to say a little about the reasons for undertaking it. After a short Introduction which outlines the main events in Gibbons's life, the remaining text is divided into three chapters. The first of these deals with carved work for the Crown and the Church, the second with similar work for private patrons, and the third with the many monuments, mostly funerary monuments, and the interesting problems they raise. There are two Appendices, the first dealing with the many works which can only be attributed to Gibbons in the absence of documentation, and the second giving an outline pedigree of the Quellin (or Quellien) family who were important both in Gibbons's early life, and when Arnold Quellin became his partner in 1681. In this last particular I was fortunate to find an unpublished document recording a quarrel between them preserved in the Public Record Office. This is described in Chapter III, and, in part, illustrated (Pl. 66).

There have been two significant books on Gibbons this century: H. Avray Tipping's *Grinling Gibbons and the Woodwork of his Age* (hereafter Tipping, *Gibbons*, 1914) and David Green's *Grinling Gibbons, His Work as Carver and Statuary, 1648–1721* (hereafter Green, *Gibbons*, 1964). Over the years I was lucky enough to count David and Joyce Green as my firm friends. They were wonderful hosts and delightful letter-writers and on many occasions I was able to feed in small bits of information to help along David's own books. His death in April 1985 meant that his seminal work on Gibbons remained unrevised. It has also become, in the twenty-five years since its publication, an exceedingly difficult book to obtain. I therefore decided carefully to re-examine Gibbons's career; it was time his reputation was rid of many unworthy attributions.

I have erred on the side of caution by putting items without documentation or excellent circumstantial evidence about authorship into Appendix I. The economics of late-twentieth-century publishing have allowed me many fewer illustrations than either the Tipping or Green books. Choices had to be made and some items regrettably excluded, but I hope at least that all the information is recorded. On the subject of county names, I have employed those in use prior to government reorganisation, in view of the historical nature of the subject. Reference to a gazetteer provides post-1974 identification if needed.

I am indebted to many owners of houses, incumbents of churches, museum curators and friends who allowed me to see afresh the wood-carvings and the monuments, or freely provided information. In almost every case I was allowed to see the documentation without

relying on earlier notes. Everyone tried to be helpful, but in particular I would thank Bruce Bailey, Anthony Kersting and Wendy Woodhouse-Mowl for lending negatives, providing photographs or processing my film. Among librarians and archivists Victoria Colefox (Royal Collections), Peter Day (Chatsworth) and Philip Allen (Birmingham Reference Library) were also helpful beyond the call of duty. The text was typed efficiently by Maureen Barton, and my wife, Margaret, helped in too many practical ways to enumerate. All of them did so because they admire the work of Grinling Gibbons as an original and creative artist almost without peer. I join them in that view, without reservation.

GEOFFREY BEARD
Bath, January 1989

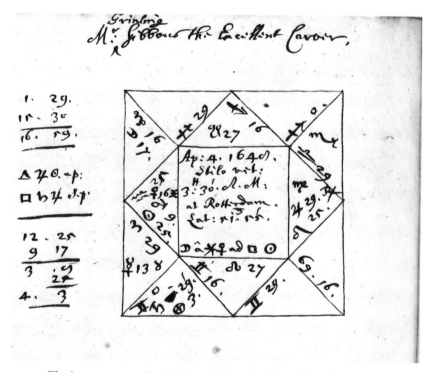

The horoscope cast for Grinling Gibbons by Elias Ashmole in 1682

INTRODUCTION

'An Original Genius'

*Grinling Gibbons [was] an original genius, a citizen of nature;
consequently, it is indifferent where she produced him . . .*
Horace Walpole, *Anecdotes of Painters*, 1798[1]

1. *The Works of Horatio Walpole, Earl of Orford*, 1798, III, p. 341.

GRINLING Gibbons was born to James 'Gibbens', citizen draper of London, and Elizabeth Gorlings, his wife, in Rotterdam at about 3.30 on the morning of 4 April 1648. The date, time and place is attested by the horoscope (facing) for Gibbons drawn up by Elias Ashmole in 1682, which is extant,[2] and is accompanied by a letter from Gibbons's older sister in which she attests: 'I have hard my mother say it was Ester Tuesday you were born,' and notes it was '4th Aprill 1648 about 3 or 4 Aclock in the morning being tuesday . . .'. It is signed 'Yor loving sister, M.B.'

2. Bodleian Library, Oxford, MS., Ashmole 243, f. 331, verso.

James Gibbens had married Elizabeth Gorlings in 1637 in Rotterdam and they lived on there for at least ten years after Grinling's birth. A first child, Elizabeth, had been born to them in 1644, and was baptised at the Dutch Reformed Church in Rotterdam on 13 March. Mrs Gibbens's father, Francis Gorlings, thought to have been an English merchant, had been dealing in tobacco in Rotterdam and had died there in 1640. So we envisage a small family group of English merchants and their families, with roots in England going back to drapers and tailors – Gibbons's grandfather, John, had been made free of the Merchant Tailors' Company in 1588, and his father of the Drapers' Company in 1638.[3] James and Elizabeth could contribute little to their boy's training except to seek out a good sculptor's studio for him to enter; there is no record of Gibbons's early formative years, or why such a profession was chosen by him, or for him.

3. *Genealogists' Magazine*, V, 1929–30, p. 322; 9 September 1943; *Notes and Queries* 161, p. 56.

It is assumed that for a short time Gibbons worked in the Quellin workshop. Artus Quellin I (1609–68) (or as he signed himself, 'Artus Quellien') had, like many Flemish sculptors, spent several years studying in Rome. He had left the Netherlands at the age of twenty or so, in about 1630, and spent about nine years in the busy studio of François Duquesnoy (1597–1643). This master of high Baroque decoration had earlier worked for Bernini at St Peter's in Rome, not only on the baldacchino, but in providing the great *St Andrew*, one of four figures beneath the dome. The young Quellin had thus had ample opportunities to improve his own skills before returning to Antwerp in 1639. Some of these, including the art of wood-carving, he passed on to his cousin, Artus Quellin II (1625–1700).

Grinling Gibbons had been born in the year 1648, in which the building of the Stadthuys

or Town Hall of Amsterdam was begun to the designs of the gentleman-architect Jacob van Campen (1595–1657). The Classical style was to be the chief characteristic of van Campen's town hall, and the Quellin workshop was involved by 1650 in its sculptural decoration.[4] Artus II spent two years with his cousin in Amsterdam, working in marble. He afterwards returned to Antwerp, but also went to Italy, for the influence of Bernini is strong in his other work. Artus II had two sons, the elder, Arnold (1653–86), and Thomas. Like his famous cousin, Artus II was also internationally known, carving the monument to Field Marshal Count Schack in Trinity Church, Copenhagen. The forms the Quellins used owed much to ancient Roman sculpture, to Cesare Ripa's *Iconologia* (available in a Dutch edition by 1644), to the work of Rubens in Antwerp, and obviously to that of Artus Quellin I's master in Rome, Duquesnoy. When one looks at a soft-wood swag or deep-carved violin by Gibbons (Petworth House, Sussex) the debt is obviously there. The Quellins' instruction and the Stadthuys carvings had made their impression on a young mind which had ample opportunity also to notice many rich canvases, often still lifes, by Jean Baptiste Monnoyer, Justus van Huysman the Elder, Jan Phillips van Thielen, Daniel Seghers and even Rubens himself.[5] Gibbons was also probably able to benefit from the two volumes on the Stadthuys carvings prepared by Artus I's brother Hubertus Quellin (1619–post 1665).

If some final 'evidence' is needed to strengthen Gibbons's association with the Quellin shop, albeit for a short time, it is surely given by the fact that when Arnold Quellin and his younger brother, Thomas, came to England they collaborated with Gibbons on various monuments.[6] It was a liaison fraught with problems, at least in the early 1680s. Just before this book was finished I was fortunate to find a document about the troubled nature of the partnership between Gibbons and Arnold Quellin. It is discussed in Chapter III, on the monuments. Thomas left England and worked mostly in Denmark, as his father had done earlier.

In 1667, 'at the age of nineteen', as Vertue noted,[7] Gibbons left Amsterdam and came to England. According to the Yorkshire historian Ralph Thoresby, writing in 1702,[8] he must have almost immediately moved to York: 'Evening, sat up too late with a parcel of artists I had got on my hands ... and Mr Etty, the painter, with whose father Mr Etty sen., the architect, the most celebrated Grinlin Gibbons wrought at York, but whether apprenticed with him or not I remember not well. Sate up full late with them.' 'Mr Etty sen.' was John Etty (*c*. 1634–1708), whose epitaph in All Saints, North Street, York reads: 'By the strength of his own genius and application had acquired great knowledge of Mathematicks, especially Geometry and Architecture in all its parts, far beyond any of his Contemporaries in this City.'

There would therefore have been experienced friends for young Gibbons, well versed in wood-carving, but on what basis he went to York, and indeed why, is not known. Of

4. Katherine Fremantle, *The Baroque Town Hall of Amsterdam*, Utrecht, 1959, p. 131.

5. David Green, *Grinling Gibbons, His Work as Carver and Statuary, 1648–1721*, 1964, p. 21; hereafter, Green, *Gibbons*.

6. Margaret Whinney, *Sculpture in Britain, 1530–1830*, 1964, pp. 54–5, 248.

7. *Walpole Society*, XVIII, 1929–30, pp. 125–6. The Vertue notebooks I–V were published in five volumes of the Walpole Society (XVIII, XX, XXII, XXIV, XXVI and indexed in volume XXIX); hereafter Vertue, *Notebooks*.

8. T. R. Whitaker, citing Thoresby in *Ducatus Leodiensis*, Leeds, 1816, p. 49.

course York was a busy city, with an active Company of Merchant Adventurers shipping cloth to Germany and across the North Sea.[9] John Gibbens, Grinling's grandfather, had been a merchant tailor and his father a draper and they may well have had connections in the Yorkshire woollen trade and with York merchants. In any case, anyone in York would have recommended John Etty, secure in his own reputation and descendant of a long line of mason-builder-carpenters in the city, as the best person to advise a young man about decorative work and trade in England. He would however have been able to show him little by way of good wood-carving – his own carving and that of his son William (d. 1734) on the reredos in St Michael-le-Belfry, York, is competent but lacks any verve or Baroque *bravura*. Nevertheless we know that Gibbons stayed in touch with John Etty, writing to him in July 1684 about a visit of his man to York to attend to the statue of Archbishop Sterne.[10]

George Vertue, who did much of his recording of artistic events within Gibbons's lifetime, follows Evelyn's account but says that after York 'where he was first imployed' Gibbons 'afterwards came to London and settled with his Family at Detford [*sic*] and follow'd ship carving'. At this stage I will quote a little of the entry John Evelyn made in his diary for 18 January 1671:

I this day first acquainted his Majestie with that incomparable young man Gibson [*sic*] whom I had lately found in an obscure place & that by meere accident, as I was walking neere a poore solitary thatched house in a field in our Parish neere Says-Court: I found him shut in, but looking into the window, I perceiv'd him carving that large *Cartoone* or *Crucifix* of *Tintorets* . . . I asked why he worked in such an obscure & lonesome place; he told me, it was that he might apply himselfe to his profession without interuption . . .

The diarist told Charles II of the great skill of the young carver, asked if he might bring him and his work to Whitehall – 'The *King* sayd, he would himselfe goe see him: This was the first notice his Majestie ever had of *Mr Gibbons*.'

Vertue's later account differs from Evelyn's, and notes that the actor-manager Thomas Betterton had asked Gibbons to 'carve for him the Ornements and decorations' of his new theatre in Dorset Gardens (off Fleet Street) which opened in November 1671. It was alleged that 'Sir Peter Lilly [*sic*] was well pleased and inquiring after the Artist that performed them, Mr Gibbons by *his* means was recommended to the King Charles 2d who then had ordered the beautyfying the Palace of Windsor in which work he was imployd.'

Evelyn continued his diary entries, noting on 13 February 1671 that he had that day dined with Christopher Wren, Surveyor-General of the King's Works, Samuel Pepys and other friends and that he had 'carried them to see the piece of Carving which I had recommended to the King'. It seems the busy King had not gone to see Gibbons and the

9. Bernard Johnson and Lionel Tripp, *The Last of the Old Hanse*, York, 1949.

10. J. Douglas Stewart, 'New Light on the Early Career of Grinling Gibbons', *Burlington Magazine*, CXVIII, July 1976, pp. 508–11.

diary records for 1 March 1671 that Evelyn had 'caused Mr *Gibbon* to bring to *Whitehall* his excellent piece of carving'. It was set down at the home of Evelyn's father-in-law Sir Richard Browne and the King walked there to see it: '... no sooner was he entred, & cast his eye on the Worke but he was astonish'd at the curiositie of it, & having considred it a long time, & discours'd with Mr *Gibbon*, whom I brought to kiss his hand, he commanded it should be immediately carried to the *Queenes* side to show her Majestie ...'

Despite this royal preferment Gibbons took care in 1672 to become free of the Drapers' Company by patrimony (that is, through his father having been a liveryman). He was admitted on 19 January 1672, and was living (according to the Company's quarterage books of 1673) at 'La Belle Sauvage' in Ludgate Hill. He took his first apprentice, Edward Sherwood, in 1672, and another, John Hunt, in 1675.

The early wood panels (discussed in Chapter I) are not typical of Gibbons's skill as it was to develop. By 1677 he was well into wood-carving at Windsor Castle and it was perhaps the comparative security of work for the Crown, although payment was always late, that encouraged him to move from Ludgate Hill to Bow Street, Covent Garden, near to where Sir Peter Lely lived. He gave his house a name – 'The King's Arms' – and a sign. When John Evelyn together with the Duchess of Grafton and the Lord and Lady Chamberlain visited him there in August 1679, they found the house 'furnish'd like a Cabinet, not only with his owne work, but divers excellent Paintings of the best hands'.

It has still not proved possible to establish the family name of Gibbons's wife, Elizabeth, whom he married in about 1670. She remains merely the 'Elizabeth Gibbons, d. 1719' in John Smith's mezzotint of John Closterman's lost double-portrait (*c.* 1691) of her husband and herself (Pl. 3). According to Vertue the painting was Closterman's 'first peice that gain'd much Credit'.[11] It has been suggested[12] that the painting was destroyed when the King's Arms collapsed in 1702; the house was rebuilt and Gibbons lived there until his death in 1721. A first son, James, was born to them in 1672 and a second, also called Grinling, in 1675. They were then still living on Ludgate Hill in the parish of St Bride's, Fleet Street (where the second Grinling was baptised on 28 May 1675) and they were probably married at St Bride's. However, the St Bride's marriage registers (Guildhall Library, London) are missing for the few critical years after the Great Fire; hence the difficulty in establishing Elizabeth's surname. The pair had, in all, ten children between 1672 and 1689 (whose baptismal dates are noted in my Chronology), several of whom may have died in childhood.

In 1682 Gibbons was appointed by Charles II as Surveyor and Repairer of Carved Work, Windsor, at a salary of £100 a year,[13] a post he held alongside others until his death. His proximity to the King, quite apart from his rare ability, meant that he was the obvious choice to carve the panel sent as a gift in 1682 to Cosimo III, Grand Duke of Tuscany,

11. Malcolm Rogers, 'John and John Baptist Closterman: A Catalogue of their Works', *Walpole Society*, XLIX, 1983, p. 247, No. 38.

12. J. Douglas Stewart, *Burlington Magazine*, CXXIII (1981), pp. 689–90.

13. H. M. Colvin, ed., *History of the King's Works 1660–1782*, 1976, V, p. 328.

and to carve the standing statues of the King at the Chelsea Hospital and the Royal Exchange. With the help of others Gibbons was now also much engaged upon funerary monuments, and from the late 1670s until 1710 more than thirty came from his workshops.

On 2 December 1693 Gibbons was appointed Master Sculptor and Carver in Wood to the Crown. He was already well known in this context for his extensive work in the royal palaces and had been known to the Surveyor-General, Sir Christopher Wren, ever since his 'discovery' by John Evelyn. Apart from the many tasks Wren supervised at the royal palaces of Whitehall, St James's and Kensington there were long years of activity at Hampton Court. Wren was also involved in the designing and building of St Paul's Cathedral, and of several university buildings in Oxford and Cambridge. In all of them were carvings in wood, stone and marble by Gibbons and his team.

At St Paul's, Gibbons was engaged upon wood- and stone-carving in the choir, and the carving in stone of three important monuments erected respectively to the memory of Robert Cotton (signed, 1697), the first Duke of Beaufort (1700) and the Earl of Fauconberg (1700), (Pls. 107, 111, 117).

An instance of the catholicity of Gibbons's tasks was the embellishment of the catafalque erected in 1694 in Westminster Abbey for the funeral of William III's popular Queen, Mary.[14] The daughter of the deposed Catholic King James II, she had died of smallpox at the early age of thirty-two. The grief felt by the King at the loss of his wife was so acute that for some weeks his own life was thought to be in danger. After the state funeral Wren and Gibbons were involved in the design of a fine marble monument to her memory, but only the drawing survives (Pl. 106). It was never built; furthermore, for a while the King could not bring himself to visit her favourite residence, Hampton Court. Work did not resume at Hampton Court until 1699. The King himself, however, did not have long to live. It was in the grounds of Hampton Court that he fell from his horse, and died within a fortnight, on 8 March 1702.

On this occasion the officers of the Works had little to do: the interment was carried out privately, at night, at an outlay of little over £100, a vastly smaller sum than the £3,000 or so expended on that of his Queen eight years before. Even a modified version of the drawing by Gibbons for the Queen Mary monument, intended for a tomb to both William and Mary in the Henry VII Chapel at Westminster Abbey, was cast aside with nothing built.

At Queen Anne's accession in 1702 Gibbons's two appointments, as Surveyor and Repairer of Carved Work and Master Sculptor and Carver in Wood remained unchanged. In 1706–7 the forty-five Scottish members of Parliament, soon to take seats following the Act of Union in 1707, were given a gallery designed by Wren, supported by thin cast-iron columns with Corinthian capitals believed to have been carved in wood by Gibbons, but based on a drawing by Jean Tijou. It was a very early use of cast-iron for a structural

14. *Wren Society*, V, p. 12; Green, *Gibbons*, p. 73 gives its cost (from PRO, Works 5/47) as £99 8s. 7d.

15. John Harris,
'Cast Iron Columns
at the House of
Commons, 1707',
*Architectural
Review*, July 1961.

purpose but by the time the Sergeant Painter Thomas Highmore had gilded the carved capitals and painted the pillars to imitate white marble, that fact was almost forgotten; it all perished in the fire of 1834.[15]

This was work to be fitted between the provision of more monuments, and the vast task of embellishing the newly rising Blenheim Palace, Oxfordshire. In September 1704 Queen Anne and Sarah, Duchess of Marlborough had ridden together to a thanksgiving service at St Paul's Cathedral following the defeat of French forces by the Duke of Marlborough at the battle of Blenheim. Crown and Parliament were soon to vie with each other in offering their victorious general a suitably generous reward. The appropriate gift seemed to the Queen to be that of the royal estate at Woodstock in Oxfordshire, as the site of a great house to be built for the Duke.[16] John Vanbrugh was appointed Surveyor of all the works, and an army of craftsmen pushed the edifice ever higher, occasionally taking down pieces and rebuilding to satisfy the irascible Duchess. Much of the carved stonework, from gate piers to the Duke's arms in the tympanum of the north portico, stone finials, and trophies (of three lions mauling the French cockerels) was made by Gibbons and his team. There were marble chimneypieces and door cases, niches in the saloon, columns and capitals; even the stone carving known as 'frostwork' on Vanbrugh's great bridge he provided at a shilling a foot. But in 1712 the Duchess stopped all the work. All the workmen, including Gibbons, left, and he at least never returned.

16. David Green,
Blenheim Palace,
1951; summarised in
Geoffrey Beard, *The
Work of John
Vanbrugh*, 1986,
pp. 37–50.

At the age of sixty-four, a tempestuous Duchess was not what Gibbons needed. He attempted only one further monument, in 1717 (Pl. 125), to the Duke of Chandos, who had already been married twice by then and before his death in 1744 would be married a third time.

In November 1719 Gibbons had to endure the death of his own wife Elizabeth; there is no memorial to her, or to Gibbons, who died two years later, on 3 August 1721. They were both buried at the church where they had worshipped, and where most of their children had been baptised, St Paul's, Covent Garden. It was not until March 1969, at the insistence of Gibbons's biographer, the late David Green, that a memorial was placed in the church: a limewood wreath of flowers carved by Gibbons for St Paul's Cathedral. This was presented to the lesser church by the Dean and Chapter, a poignant reminder of one whom years before John Evelyn had called 'our Lysippus'[17] and whose wood-carvings still delight and amaze us, as the products of unparalleled virtuosity.

17. John Evelyn,
Sylva, 1706, 'Of the
Lime-Tree . . .'.

CHAPTER I

'Our Lysippus'

*... The Trophies, Festoons, Frutages ... and other Ornaments and
Decoration, the Works and Invention of our Lysippus,
Mr Gibbons ... John Evelyn, Sylva, 1706.*

IN this chapter, describing Gibbons's work in wood in the royal palaces, churches
and university buildings, I have tried to exclude work merely attributed as in the
'Gibbons style', but there is a great deal, and conscious that some of it may eventually
emerge as authentic I have described it in Appendix I. The early wood panels, many
mentioned by John Evelyn in his *Diary*, but otherwise without documentation, deserve
more than mere relegation and are therefore mentioned below. There seems, however,
no way of establishing whether the works which survive are those Evelyn and others saw
in the late seventeenth century.

THE EARLY PANELS

When John Evelyn 'discovered' Gibbons in January 1671 he found him, as his diary entry
(18 January) makes clear, in 'a poore solitary thatched house in a field in our Parish neere
Says-Court'. Looking in at the window:

I perceiv'd him carving that *Cartoone* or *Crucifix* of *Tintorets*, a Copy of which I had also my selfe
brought from *Venice* where the original painting remaines: I asked if I might come in ... & I saw him
about such a work, as for the curiosity of handling, drawing and studious exactnesse, I never in my life
had seene before in all my travels ... the work was very strong; but in the Piece above 100 figures of
men etc ...

In 1564 Tintoretto had started on one of his major commissions, the decoration of the
Scuola di San Rocco in Venice. The first large scene he painted in 1565 was the *Crucifixion*,
spread over a canvas some 40 ft by 17. It is a great inventive work, technically of the
highest order, the busy scene divided by the dominant central cross, with Christ hanging
forward over a mourning group at its foot. Together with other paintings by Tintoretto
in various rooms of the Scuola di S. Rocco, it dominated a powerful group of visual
images. The Scuola was much visited from the time of the cycle's completion and many
engravings of the scenes were issued. Gibbons had perhaps acquired or borrowed one and
was endeavouring to turn its vibrant two dimensions into a relief carving. It is assumed
that the panel (Pl. 4) is the one which came into the possession of the Earls of Stamford and

Warrington and is now at Dunham Massey Hall, Cheshire. The carving is accomplished, but there is little hint in the figures or the carved 'frutage' of the surrounding frame to suggest virtuosity about to break forth. I find it unconvincing.

The panel is made up of two sheets of wood, perhaps pear, the upper one $2\frac{1}{2}$ ins thick, the lower one $1\frac{1}{2}$ ins. It seems from observation that the frame and the panel were made at the same time, but the fruit and flowers are kept behind a rigid line. Where are the elements of the quality which Evelyn commends: 'I asked him the price, he told me 100 pounds. In good earnest the very frame was worth the money, there being nothing even in nature so tender & delicate as the flowers & festoones about it ...'? Five years after this, in 1677, Gibbons was displaying consummate ability in his work at Windsor Castle (Pls. 13–20). I do not think he merely 'improved' from the date of the *Crucifixion* panel to the degree of skill shown at Windsor. It was inherent almost from the time he reached England. The panel was sold to the goldsmith Sir George Viner. It descended through his son Thomas's estate until 1683, and then may have been acquired by George Booth, second Earl of Warrington. It does not appear in a Dunham Massey inventory until 1758: '1 Fine carved piece of our Saviour's Crucifixion', in its present position, over the library chimneypiece.

A panel which has a better pedigree is the *St Stephen Stoned* (Pl. 5), now in the Victoria and Albert Museum, London. Horace Walpole suggested, apparently without any evidence and contrary to Evelyn's diary entry, that it was this panel that Gibbons was carving when discovered by Evelyn: 'The piece that had struck so good a judge was a large carving in wood of St. Stephen stoned, long preserved in the sculptor's own house, and afterwards purchased and placed by the duke of Chandos at Cannons.'[1] George Vertue wrote that the panel was kept in Gibbons's gallery of pictures in his Bow Street house, before its purchase by the Duke of Chandos. After passing through the hands of several owners it was finally acquired for £300 by the Victoria and Albert Museum.[2]

The scene is as crowded as any canvas by Veronese, or the arrangements of the *loggie* of the Vatican: indeed, the architectural scene owes much more to Renaissance architecture and painting than to the later accomplishments of Claude Lorrain and others. Figures peer from balconies set in receding façades lined with Corinthian columns, or stand silhouetted in shell-topped windows or vaulted arches. At least thirty figures crowd into the foreground with half a dozen engaged in the precise choreography of stoning the kneeling Stephen. At the bottom right more stones are being brought by a bent figure with a wicker basket atop his right shoulder. Above, the sun's rays shaft down from a heavily modelled cloudy sky. The panel, which is over 6 ft high and 4 ft wide, is carved from limewood and lancewood sections to form a depth of over 12 ins. It is an amazing essay in architectural perspective, and while deep cracks have run vertically through the piece, they do nothing to diminish this *tour de force* of the carver's art.

1. Horace Walpole, *Anecdotes of Painters*, 1763, III, p. 83, and 1798, III, p. 341.

2. Vertue, *Notebooks*, II, pp. 3, 8; V, p. 34; *Notes and Queries*, 4th series, III, p. 504. The interlaced Gs scratched near the ladder in the foreground are of little consequence.

A relief of *The Last Supper* at Burghley House, Northamptonshire, attributed to Gibbons is by contrast even less convincing than the *Crucifixion* panel. It would appear to be South German in origin and need not be considered further.[3] Nor is there any documentation of any kind or other reason to assume a Gibbons connection with the large wood reliefs *The Battle of the Amazons* at Warwick Castle, copied after Rubens's canvas (now Alte Pinakothek, Munich)[4], and the relief of *Tomyris and Cyrus* sold in 1979.[5] The same might be said of *The Valley of Dry Bones* elm panel at the church of St Nicholas, Deptford.[6] The gaunt, ill-proportioned prophet Ezekiel stalks about in a valley crowded with skeletons, enlivened only by God in a spiked halo shooting shafts of life down to the troubled scene. It is not a panel which I think owes anything to Gibbons's sharp chisels and gouges. The various portrait reliefs and boxwood medallions attributed to him are noted in Appendix I.

THE COSIMO PANEL, 1680–2

The salary which Gibbons drew for 'repairing cleansing and preserving the carved work at Windsor Castle' was first paid in 1682. As he was most active at Windsor in the early 1680s, it was perhaps to be expected that the Audit Office accounts should include among the many Windsor items:[7] 'Grinling Gibbons, Carver, for an Extraordinary fine peece of Carved worke made & Carved by him for his Matie & sent by his Matie as a present to the Duke of fflorence, £150.'

Cosimo III de' Medici (1642–1723), Grand Duke of Tuscany, visited England in 1669, was warmly received by Charles II, and became the King's guest at many entertainments, at Greenwich, Newmarket and elsewhere. An account of the Duke's travels was published in 1821,[8] and shows that when the time was due for his return to Florence the King gave a lavish banquet, 'protracted to a great length and finally concluded with a most kind wish tendered to His Highness by His Majesty and seconded by all present for the continuation of a sincere friendship and a confirmation of the alliance between the royal family and the Most Serene House of Tuscany.' It says a great deal for Gibbons's status with the King that he should be chosen as executant of the gift commissioned to seal this friendship. The panel survives in Florence, until recently at the Bargello, and now in the Pitti Palace: it has survived damage by fire there and whilst irretrievably darkened by smoke is still a remarkable example of the carver's art. Moreover it is signed by Gibbons (Pl. 7).

The limewood panel of 55 by 42 ins (Pl. 6) is a balanced composition, dividing into four areas of carving but with all contrived to appear as one satisfying whole. The first area is at the top (Pl. 8) and shows billing doves above at least five pierced cravats, flanked by scrolled acanthus. Gibbons was keen on carving such point-lace cravats – the King had ordered three for £194 – and there are other examples at Petworth and Chatsworth (Pls. 47, 51). Twisted underneath the acanthus are shell garlands on pearl ropes. The centre

3. Green, *Gibbons*, Pl. 19. I am indebted to Dr Eric Till, the historian of Burghley House and its collections, for his views on this panel.

4. Green, *Gibbons*, Pl. 15.

5. Christie's, 11 December 1979.

6. *Notes and Queries*, 8th series, VIII, p. 466. The panel measures $45\frac{1}{2}$ by 37 ins and was once 'over the porch of the charnel house in the churchyard'.

7. PRO, AO1/ 2479/272.

8. L. Magalotti, *The Travels of Cosimo III, Grand Duke of Tuscany, through England during the reign of Charles the second*, 1821.

panel has several areas of interest: England is represented by the crown, orb and sword of state and love by a quiver of arrows; there are chains and a key of office.

The arts of music, painting and architecture are exemplified in the trumpet of Fame, a notated score and a medallion portrait of the painter-architect, Pietro da Cortona (1596–1669) (Pl. 11). He had been in Florence for several years from 1640 completing various rooms named after the planets in the Grand Ducal apartments. Then at the right is Gibbons's signature before the feathered quill, and at the bottom (Pl. 10) the King's tumbled crown contrasted with the ducal coronet (now damaged) but a symbol of serenity. Scattered throughout are laurel, cyclamen, jonquils and bursting walnuts. The sword hilt with lions is identical to one in the panel formerly at Cullen House, Banffshire, and to one carved in the First George Room at Burghley House, Northamptonshire.

This supreme signed panel stands as the exemplar against which all carved woodwork attributed to Gibbons should be judged. It is a panel, I believe, wholly from his hand. Fear was expressed on its arrival at Leghorn that the panel might 'carry the plague'. It had been consigned in August 1682 in a deal case in the ship *Woolwich* to the British envoy Sir Thomas Dereham, who was to present the panel to the Grand Duke. It was therefore impounded for almost a month in the Lazaretto[9] before its presentation in December 1682 to the Duke in Florence.[10] The tradition is that the Duke sent a gift in return, a set of marble columns. They are allegedly the ones known as the Temple Ruins, now at Hackwood Park, Hampshire, having been given by George I to his Lord Chamberlain, the second Duke of Bolton.

9. E. Dummer, *A Voyage into the Mediterranean Seas,* 1685 (British Library, King's 40, f. 43).

10. Mary Webster and R. W. Lightbown, 'Princely Friendship and the Arts: a relief by Grinling Gibbons', *Apollo,* XCIV, September 1971, pp. 192–7. See my notes on Pls. 6–7.

THE MODENA PANEL, *c.*1685

There is no precise documentation about this limewood panel, which may have been carved when James II was still Duke of York, before the start of his troubled reign in 1686. The panel is signed by Gibbons on his self-portrait medallion (Pl. 12) 'GIBBONS INVENTOR ET SCULPSIT LONDINA'. The portrait bears a superficial likeness to Sir John Medina's portrait of Gibbons (Pl. 1). James II married the Catholic Mary Beatrice of Modena in 1673 and was censured for this act by the House of Commons. Mary was the only daughter of Alfonso IV, Duke of Modena, and the panel was presumably intended for him, or a close member of his household.

The notated score at the centre of the panel with a tumbled ducal (?) coronet to the right, carries words from James Shirley's poem 'Ajax and Ulysses' (1659):

> The Glories of our Blood and State
> are shadows, not substantial things;
> there is no armour against Fate;
> Death lays his icy hand on Kings.

Septers and Crowns must tumble downe
and in the dust be equal made
with the poor crooked Scythe and Spade.

This may well have been a poignant allusion to the mortality of kings, with the death of
Charles II in February 1685 suggesting to his brother Shirley's words: 'Death lays his icy
hand on Kings'. The panel is more open but less brilliant than the Cosimo panel.
Nevertheless it has attractive and telling detail, with carved barley, dead game birds,
swirling acanthus, five coins spilled above the skull (one of them seems to carry the legend
CAROL:II:DEI:GRATI . . .), an open pea-pod and snowdrops.

THE ROYAL PALACES

Much of Gibbons's best carved woodwork was done for his royal masters and is to be
found at Windsor Castle, Hampton Court and Kensington Palace.

John Evelyn recorded in his diary for 28 October 1664 a conversation with King Charles
II when he presented him with copies of his translation from the French of Freart's *A
parallel of the antient architecture with the modern* and his book on forest trees, *Sylva*: 'I
presented him with both, and then laying it on the Window stoole, he with his owne
hands, designed to me the plot for the future building of *Whitehall*, together with the
Roomes of State & other particulars . . .'. A mass of seventeenth-century drawings for
Whitehall Palace have survived, for the notion of its creation had been cherished not only
by Charles II but by his father. The drawings, distributed between Worcester College,
Oxford,[11] Chatsworth and the British Library, are first in the hand of John Webb and
divide into two groups. They show that the Palace was first planned in accordance with
Inigo Jones's ideas of the 1630s.[12] Charles I, however, did not live to build it, and when
his son Charles II took up the idea, John Webb recast the plans and moved away from
Jonesian ideas. At this time, only Jones's Banqueting House (1619–22), an early fragment
of the greater conception, was in existence.

In 1669, a year or so after Gibbons had reached England from Holland, Whitehall was
still the chief royal palace, a sprawling complex of buildings, partly Tudor and partly Stuart
in date. When the rebuilding was contemplated, Sir Christopher Wren made drawings but
none of the work they represent was carried out. It was to be 1685–6 before Wren built
a long new wing for James II, containing a suite of apartments for his Queen, a Roman
Catholic chapel and some offices. Work of this kind was entrusted to the Office of Works –
the King's Works – and it was through Wren that Gibbons became involved with its
activities.

When Charles II succeeded in 1660 his palaces were impoverished and he soon took
an interest in Windsor Castle. Its dramatic position on a hilltop afforded scenic and

11. John Harris and
A. A. Tait, *A
Catalogue of the
Drawings by Inigo
Jones, John Webb and
Isaac de Caus at
Worcester College,
Oxford* (Oxford),
1979; Margaret
Whinney, 'John
Webb's Drawings
for Whitehall
Palace', *Walpole
Society*, XXXI, 1946.

12. Sir John
Summerson, *Inigo
Jones*, 1966,
pp. 128–134.

picturesque possibilities beyond those of any royal palace in England, or in the France of his rival Louis XIV. The talented architect Hugh May (d.1684) rebuilt the block on the north side in brick with stone dressings to contain most of the new state rooms. He was careful not to disturb the general character of the medieval buildings but it was the interiors which were more important and innovative in their spacing. In the course of about nine years the King was to spend at least £190,000 on the new works, and under May's direction Antonio Verrio painted more than twenty ceilings, three staircases, the chapel and the hall, and Henry Phillips and Grinling Gibbons with their teams of carvers performed 'severall sorts of Carved Workes . . .', described later in this chapter.

In 1689, within a few months of William and Mary's accession to the English throne after the rout of James II, war was declared against France, but this did not stop the King ordering Wren to prepare schemes to adapt the old Tudor palace at Hampton Court to their use. A further programme of work to run concurrently with that at Hampton Court was begun at Kensington Palace. In June 1689 the King had bought the Earl of Nottingham's house in Kensington, and the work of adding to it began at once. The King did not like living at Whitehall, but work at Hampton Court had only just begun when building on the front facing the Privy Garden ran into trouble. As if this was not enough for the Office of Works (and anxious as its officers must have been without knowledge of the new King's moods), the new buildings at Kensington also fell down in November 1689. Fortunately the monarch had use of the old Tudor palace at Greenwich, which Wren was to convert for the use of disabled and superannuated seamen, and the palace at Winchester built for Charles II.

Royal Palaces: Windsor Castle

By 1677 the wood-carvers had moved into the many state rooms to work with the then Master Sculptor and Carver in Wood to the Crown, Henry Phillips, and with Grinling Gibbons. Almost as if the two were partners, parts of their first two bills read:[13]

13. PRO, AO1/2478/270 (E351/3450) cited by H. M. Colvin, ed. *History of the King's Works, 1660–1782*, V, 1976, p. 321. The second- and third-year bills are quoted by W. H. St John Hope, *Windsor Castle, An Architectural History*, 1913, I, p. 317.

(1676–7) Severall sorts of Carved workes by them performed upon the Chimney peeces Pedestalls and picture frames of the Kings Greate and Little Bedchambers, and Presence his Majesties Closett, Musicke roome, Eateing roome, Withdrawing roome, and Backstaires, the Queenes withdrawing roome, Bedchamber – and Gallery and in iiiie roomes at the Dutches of Portsmouths Lodgings. £625 14s.

(1677–8) for sundry Carved workes by them performed upon severall Wainscot Chimney-peeces, Doores, Doorecases Pedestalls and Pictures in his Majesty's Greate and Little Bedchambers, Eateing Roome, Musicke roomes and Privy backstaires, the Queenes Presence, Privy Chambers and Gard-Chamber, the Duke of Yorkes Bedchamber withdrawing roome and Closett and in the Dutchesse of Yorkes Presence Chamber Dressing Roome and Withdrawing roome and at the New Tower.

£614 17s. 8d.

Henry Phillips had been appointed to the post of Master Carver in September 1661;[14] the wording of his warrant of appointment is magisterial:

14. PRO, Works 6/2, 3 September 1661.

Whereas the Art of Sculpture or Carving in wood is an Art peculiar of it Selfe and not practised used or annexed with or in the Names Misteries Art or Occupations of Carpenters Joyners Masons or any other Art of manuall workemanship whereof Our Services are Already furnished, but an Art of more excellent Skill & Dexterity for the Adorning & Beautyfying of Our Pallaces Castles Manors houses & other Our buildings & workes whatsoever & whereas we have received good Testimony & proofe of the sufficient skill & rare knowledge of Henry Phillips in the aforesaid Art of Sculpture & Carving in wood . . . The Fee or wages to be Eighteenpence by the Day . . . and One Robe yearely of the Suit of other Esquires of our household.

Late in life Phillips retired from his office but continued to draw his fee as Master Carver until his death in 1693. Meanwhile, from 1688–92 his cousin William Emmett acted in this capacity and in 1693 a warrant was finally issued to Gibbons,[15] who had waited more than twenty years for a post so well suited to his abilities. It is tragic that so much of his carved work at Windsor was lost in the many remodellings and amendments made for George IV by Sir Jeffry Wyatville from 1823–40.[16] What survives, considerable as it may seem, has been moved several times since it was set up.

15. *Calendar of Treasury Books*, X, pp. 387, 716, 1138.

16. Derek Linstrum, *Sir Jeffry Wyatville: Architect to the King*, Oxford, 1972, p. 252.

Gibbons's bills (he submitted them alone from 1679) show that much of his carving was done to surround picture frames and decorate overdoors. Two of the decorative team, Nicholas Largillier and Philip Delesam, were paid for fitting pictures over doors and chimneys, and Gerrard Vyllenburgh was paid a gratuity of £50 for 'Enlargeing Painteing fitting and placeing of severall of his Majesty's Pictures sett over all the Chimneys and Doores in the Kings and Queenes Lodgings in Windsor Castle and for severall Journeys to some of the Kings Houses to make Choice of such Pictures as were most fitt to be sett in the severall places aforesaid according to his Majesty's Directions.'[17] This implies that Gibbons had set out his carving as drops and swags, leaving predetermined spaces for pictures, and had also embellished specific paintings with richly carved frames, many of which survive (Pls. 15, 16).

17. H. M. Colvin, ed., *History of the King's Works*, 1660–1782, V, 1976, p. 321.

Some of the interiors at Windsor were shown in fine aquatints in 1819, prior to Wyatville's work, by Robert Pyne in his *History of the Royal Residences*. They not only show the rich ceiling paintings by Antonio Verrio and his team but much carved woodwork that has not survived. Moreover, Pyne's view of the King's Eating Room, *c*.1800, shows none of the limewood carving in its present position. That now surrounding Jacob Huysman's splendid canvas of *Catherine of Braganza* is, however, of superb quality (Pl. 13) and matches in theme Verrio's *Feast of the Gods* above. The fruit and flowers are on a lavish scale: grapes, pomegranates, tumbling roses and daisies, swelled peaches, ripe ears of barley, plump bursting seed-pods, oak leaves and acorns are all disposed with considerable flair. The whole seems to be slung from the whorled ribbons at the top centre

and corners. Above, even the frieze is filled with richly carved upright leaves of acanthus, rigidly keeping at bay Verrio's strutting trumpeters, awkwardly perching herons, a scarlet lobster, dolphins, skate and dipping swans in the painted cove.

The two alcoves of the Eating Room, one at each end (Pl. 14), are filled, like a rich larder, with carved woodcock, teal and water birds, hung rabbits, fruit, flowers and scaly fish, all deeply undercut. A small carved bird in the west alcove sits on a startled rabbit, and the ducks peer out from ears of barley or rye while convolvulus and leaves of clover form festoons to link the delicate ribbons.

In the Queen's apartments, she is glorified as Britannia in Verrio's bright colours in the Guard Chamber, and two other ceilings survive, in the Presence Chamber and the Privy Chambers. Over two of the doors in the Presence Chamber Honthorst's paintings of William, Prince of Orange and William, Duke of Gloucester are surrounded by further displays of carved flowers and fruit. The *William, Prince of Orange* (Pl. 15) is crested by palm leaves, great roses and swelling hops, while the *William, Duke of Gloucester* has a marvellous display of swirling acanthus scrolls with pears, martagons and maize cobs tumbling down the sides. The scrolled carving above the door is an obvious afterthought in the nineteenth-century setting-out of the carvings. The overmantel carving is headed by a malevolent eagle presiding over tight massed drops. Again the carving behind the clock is in an unnatural pose.

In the Queen's Audience Chamber there is a large painting of Mary, Queen of Scots surrounded by another virtuoso display of carving (Pl. 16). The 'MR' letters below the crown do seem, however, a later addition, and the portrait was not in any case in the room when its contents were listed by Pyne in 1819.

Between the Throne Room and St George's Hall at Windsor is the top-lit Waterloo Chamber, built by Wyatville in 1830 in place of an open court. At the end the light from the lantern shines down over more redisposed Grinling Gibbons carvings – 'the wreckage of some of Gibbons' best work' as H. Avray Tipping put it in 1914.[18] Some of it is carved in oak but most is in limewood. The dead rabbit that hangs from the centre top and the game birds in the drops are ranged oddly round the palm and laurel oval, which itself is squeezed too tightly within the encircling nineteenth-century mouldings.

Some of the carvings in the Waterloo Chamber were moved from the King's chapel and there are more from there, and from the Queen's chapel and St George's Hall, in the Garter Throne Room. The Throne and the Ante-Throne Rooms were originally two rooms of equal area known as the King's Privy and Presence Chambers, an arrangement altered by Wyatville. The surviving carvings include the badge and insignia of the Order of the Garter, *putti* holding censers, and a small rectangular oak panel decorated with 'St George and the Dragon' (a motif appearing on the Gibbons tomb of the first Duke of Beaufort (Pl. 116), erected originally in St George's Chapel) surrounded by sprays of oak

18. H. Avray Tipping, *Grinling Gibbons and the Woodwork of his Age*, 1914, p. 65; hereafter Tipping, *Gibbons.*

and bay leaves. Gibbons had supplied two for St George's Hall, one of the richest gilded interiors of the several Baroque rooms.

Gibbons was active in the King's chapel at Windsor from 1680–2. It contained some of his best work and it is the more regrettable that the chapel was one of the rooms destroyed by Wyatville in 1827. The full exuberance of the Baroque had been unleashed there in Verrio's paintings, which not only covered the ceiling but spilled down the upper parts of the north and south walls and onto the altarpiece. The lower parts of the side walls were given niches. Between each, Gibbons carved sprays of palm and laurel and the pelican, a symbol of piety and sacrifice was, as the account records, 'laid upon XXVIIIt Seates and Stalls'. Each seat required 20 ft of enriched framing and 5 ft of cornice, with 'two members inrich'd with Leaves between each Seate'. For this Gibbons was paid £518 and a further £498 0s. 5½d. for: 'the Six Vasses with Thistles, Roses and two Boyes Laurels and Palmes and other Ornaments in the ffront and upon the Topp of the Kings Seate ... Drapery fruite, flowers, Crootesses, Starres, Roses and severall other Ornaments of Carveing about the Altar, Pews and other places in and about the King's Chapell.'[19]

When John Evelyn went on to a service in the chapel in June 1683, he wondered at music from the 'unseene Organs behind the Altar', and marvelled at Gibbons's carvings. He found them, as one would expect, 'stupendous and beyond all description ... the incomparable carving of our Gibbons, who is without controversie the greatest master both for invention and rareness of work that the world ever had in any age, – nor doubt I at all that he will prove as greate a master in the statuary art.' With the final comment it is possible to disagree: the 'statuary', described in Chapter III, formed an important source of income to Gibbons, but led to difficulties in his partnership with Arnold Quellin and was all too often mediocre.

The percipient observer Celia Fiennes, on her visit to the chapel in 1698, also wrote about Verrio's ceiling and wall paintings and, of course, the wood-carvings: '... there is alsoe the most exactest workmanship in the wood carving, which is (as the painting) the pattern and masterpiece of all such work both in figures, fruitages, beasts, birds, flowers all sorts, soe thinn the wood and all white natural wood without varnish; this adorns the pillars and void spaces between the paintings, here is a great qualiety so much for quantety.'[20] The total cost of decorating the chapel amounted to about £2,700, of which Gibbons received some £1,016 and Verrio £1,050. Gilding by René Cousin cost about £113, Bernard Smith's alterations to the organ £100, and money was paid to two joiners for wainscotting and furniture.[21] At the conclusion of the work in 1682, and perhaps as an indication of its quality, it was agreed that Gibbons should be paid £100 a year 'for repairing cleansing and preserving the carved work in Windsor Castle', and this sum continued to be paid to him throughout the reign of William III and of Queen Anne (until at least 1713).

19. W. H. St John Hope, op. cit. (Note 13 above), I, p. 321.

20. C. Morris, ed., The Illustrated Journeys of Celia Fiennes, c.1682–1712, 1984, p. 218.

21. Colvin, op. cit. (Note 17 above), p. 327.

Royal Palaces: Whitehall

When James II succeeded to the English throne in February 1685 he was eager to restore Catholicism in England. It had been in royal disfavour since the reign of Henry VIII. He therefore immediately commissioned a splendid Roman Catholic chapel. Begun in May 1685, so swift was its building and decoration that it was in use by November 1686, which throws light on Wren's efficiency in supervising the often tardy progress of the King's Works. Along with a Privy Gallery and other buildings, it was erected near to Jones's Banqueting House in Whitehall, but it all vanished in the great fires of 1691 and 1698[22] which reduced the Palace to ruins. The Banqueting House, owing to its massive construction and the special exertions at the time, was saved.

22. *Wren Society*, VII, pp. 80–1.

For the chapel, all the leading craftsmen of the Works were engaged. The mason's work was entrusted to Thomas Wise and the Master Carpenter Matthew Bankes chose oak and spruce deals. The Master Bricklayer Morris Emmett had so many labourers at work that his lists extend over one and a quarter pages in the accounts.[23] James Groves came in to assist Bankes with the carpentry and then the joiners took over. By July 1686 six firms of joiners[24] were at work. William Ireland expressed impatience at the delays to his glazing but in the measured order of things he had to wait for the correct point, alongside the Master Plumber, the Master Plasterer and the Sergeant Painter. All of them hastened about their teams of men and when all the plain work was done the decorative artists moved in. The ceilings and walls were to be painted by Verrio for £1,250 but by the time he had completed his *Assumption of the Blessed Virgin according to their tradition* (that is, the Catholic tradition), the *Salutation* over the altar and the many figures on the walls he was due £1,700. His gilder René Cousin charged a further £23 12s. 6d. for the 3,316 leaves of gold used on the ceilings of the Queen's bedchamber, closet and private chapel,[25] in the waterside Queen's building reserved for the use of Mary of Modena.

23. PRO, Works 5/33; *Wren Society*, VII, p. 96.

24. John Smallwell (Lesser Building); John Heysenbuttel and Edward Cannell (both Lesser Building); Charles Hopson (Queen's rooms); Roger Davis (Chapel); John Gibson (Treasury), and William Cleare (Council Chamber); Colvin, *op. cit.* (Note 17 above), p. 289.

25. Edward Croft-Murray, *Decorative Painting in England*, 1962, I, p. 239; *Wren Society*, VII, p. 114.

Most of the routine wood-carving in these rooms, such as mouldings to doors and cornices, was done by William Emmett, but the great bedchamber had a chimneypiece carved by Gibbons with a surmounting crown, coat of arms and soft-wood 'drapery'. This room was seen by John Evelyn in 1687 (*Diary,* 24 June); he admired the Queen's 'new bed, the embroidery which cost £3000. The carving above the chimney piece by Gibbons is incomparable.' The drawing room must also have been particularly rich, with an Egyptian marble chimneypiece (provided by the mason Edward Strong) topped by two marble figures by Gibbons (£180). While this seems to have been replaced quickly by a wooden chimneypiece, it must have looked somewhat like John Nost's marble chimneypiece, with attendant *putti,* made for the King's great bedchamber but now in the Queen's Gallery at Hampton Court. Gibbons also carved wooden chimneypieces in four other rooms (little bedchamber, dressing room, closet, lobby) for £100, as well as three doorcases in the

main bedchamber and several picture frames. Again he provided a bas-relief of Goliath with a marble base and cornice (for £110) and '2 marble Boyes and cornucopes ... over the chimney'. High in the room Gibbons carved a wooden 'ffreass', or frieze.

In July 1686 John Heysenbuttel was paid £4 for a model of the altarpiece designed by Wren which was to be erected in the chapel. The contract of 1 April 1686 to make the altarpiece itself was witnessed by Nicholas Hawksmoor and Thomas Hill. It was with Gibbons and Arnold Quellin jointly, so one must assume that the disagreement between them which had led to a Chancery suit (see Chapter III) had been resolved. The contract[26] named a penalty of £100 to be exacted if the work was not finished to Wren's satisfaction by 25 September 1686; Gibbons and Quellin therefore kept some fifty men hard at work on the white marble, veined pilasters and purple rance columns. It is all well described in *A New View of London* (1708):

The Altar-Piece is very curious and magnificent, of several kinds of fine polished Marble, as white, white vein'd with blue, and Porphiery. The lower Order consists of 10 Pilasters with their Entablature of the Doric Order; the Intercolumns here are a rich Hanging betn. 2 Niches with Enrichments of Cupids and those betn. 2 Apertures with Arches and the like Enrichments. The upper Orders consists of a large Quadrangular Space or Table adorned with 2 Demi-columns in a circular Range with an Entablature and pitched Pediment of the Composit Order; under this Pediment (which is between 2 Cartouches) is an Imperial Crown enriched with Palm-branches and above it is a Glory in the semblance of a Dove, within a circular Gruppa of Cherubims under a compas Pediment, whereon is placed the Figures of a Bible surported by 2 Cupids; all which parts above the Cornish of the upper Order are situate between 2 Angels, placed at a small distance in a descending Posture (respecting the Altar below) excellently represented in full Proportion.

Further descriptions were given in James Malcolm's *Londinium Redivivum* (1802) and Rudolf Ackermann's *Westminster Abbey* (1824), but whilst their accounts are more lucid they lack something of the interest of the 1708 account. The central portion of the altarpiece was about 18 ft wide and almost 39 ft high. It incorporated a great 8 by 7 ft picture frame which was to contain a painting on canvas by Benedetto Gennari. Evelyn worshipped in the chapel on Christmas Day 1686 (*Diary*, 29 December) and noted that nothing could be finer than 'the magnificent marble work'. While he was rapturous about 'the musiq of the Italians ... for the Popish service' and the quality of the statuary, he concluded with his disbelief that he should ever witness such things in a King of England's chapel.

When the altarpiece was dismantled after the fire, in 1695, the pieces were first taken to Hampton Court. Eleven years later, in 1706, Gibbons was asked to set up the altar again, as Queen Anne made a gift of it to Westminster Abbey. Four statues which had impressed John Evelyn stand, much weathered, in the college garden of Westminster School.[27] Soon after 1820 the altarpiece at Westminster was again dismantled and some small parts of it were installed by Walter King (sometime Bishop of Rochester, and a

26. PRO, Works, 5/145, ff. 184–5.

27. Whilst Evelyn identified them as 'SS. John, Peter, Paul and the Church', he was mistaken. Two figures were female (perhaps Faith and Hope) with SS Peter and Paul. See *Wren Society*, XI, p. 119; Green, *Gibbons*, pp. 59–62.

28. A. W. Vivian-
Neal, 'Sculptures by
Grinling Gibbons
and Quellin . . . now
in the Church of
Burnham-on-Sea',
*Somersetshire Arch.
& Nat. Hist. Soc.*,
LXXXI, 1935,
pp. 127–32; *Wren
Society*, VII,
pp. 236–9; Margaret
Whinney, *Sculpture
in Britain 1530–
1830*, revised edn
(by John Physick),
1988, p. 444, fn. 45.

29. *Survey of London*,
XIII, pp. 109–10.

former vicar of Burnham, in Somerset), in the little church there. In 1826 King published a pamphlet about them which shows how he disposed the statuary on pedestals and in narrow framing, completely blocking the east window. At least six figures of child-angels and the heads of ten cherubs survive at Burnham, with two panels used as a reredos. Other reliefs are in Dean's Yard at Westminster, and in 1973 the Victoria and Albert Museum acquired two panels, carved in bas-relief, of *putti* holding the arms of Ireland and Scotland, which are thought to have been part of the chapel carvings.[28] The great organ by Renatus Harris was given by Queen Mary in 1691 to the church of St James, Piccadilly. It survived damage in the Second World War and is at the west end of the church, facing the reredos by Gibbons at the east (Pl. 38).

The chapel had contained many other enrichments in wood and marble. Gibbons provided the pulpit (£90) with relief figures of the Evangelists set around with cherubs and 'frutage'. Worship ceased at the Whitehall chapel early in 1689: within a short time it was all dismantled, with almost indecent thoroughness. The pulpit was given in 1696 to the Danish Church, Wellclose Square. It is shown in Johannes Kip's engraved view (1697) of the interior, but has not been seen since the demolition of that church in 1869.[29]

Royal Palaces: Hampton Court

Sir Christopher Wren's position was made very difficult by the Whitehall chapel commission; the Queen's chapel at St James's Palace had been denuded to furnish the new Popish chapel, and anti-Catholic feeling was high. Constitutional matters came rapidly to a head, and seven leading peers decided to invite William, Prince of Orange to come from Holland and take the English throne. He landed at Torbay in November 1688, marched to London, and to Whitehall Palace. James II had left hurriedly for Rochester and thence for France, leaving his disorganised army behind, and nothing but bitter memories of his persecution of those involved in the Monmouth rebellion of 1685.

30. PRO, Works
5/5, printed *Wren
Society*, IV, pp. 39–
54.

Within a few months of the coronation in 1689 of William and his wife Mary (daughter of the deposed King) as joint monarchs, war was declared against France, but this did not stop William ordering Wren to prepare schemes to adapt the Tudor palace at Hampton Court for their royal use. The accounts begin in April 1689 and have been printed.[30] In December 1689 part of the great trusses of the roof on the Privy Garden front had fallen, carrying away the floor over certain rooms near the Cartoon Gallery. William Talman, Comptroller of the Works, tried to belittle Wren as Surveyor and criticised the quality of the work done. But the King, upon hearing Wren's evidence, ordered the work to proceed, unless his officers found material cause why this would be dangerous or ill-advised. No such cause was found, and work duly resumed, albeit slowly. The Queen wrote to the King about this in July 1690 – he was in Ireland intent on the final vanquishing of James

II at the Battle of the Boyne – telling him that the rebuilding was complicated by shortage of money and inadequate supplies of Portland stone; the work at Kensington Palace was also delayed, she wrote.

Around Christmas 1693 Wren had estimated that it would cost more than £35,000 to complete Charles II's Fountain Garden, a task urged on him by Queen Mary. But her keen involvement in these various projects was to be short-lived, alas; her deeply mourned death in December 1694 caused the King to lose all interest in Hampton Court, and it was not until 1697, when England found herself no longer at war with France, that William started again to make improvements to his house and gardens there. Wren submitted a revised estimate in April 1699, supposing that the King would finish the state rooms to the standard their size and position required. The aggressive Talman, anxious to take advantage of the situation, estimated completion at some £1,300 less than Wren. The King allowed the decorative work to press ahead, some of it under Talman's supervision.

The King's Staircase (1697–8), its walls painted by Verrio with a medley of gods, goddesses and heroes of ancient Rome 'associating the emperor Julian the Apostate with William III as the upholder of Protestantism and freedom', led up to five south-facing state rooms. The Master Joiner Alexander Fort covered their vast expanses of wall with wainscoting. It is one of the principal features of the state rooms and Fort was due more than £9,400 for his efforts. Over the sombre planes of wood were the soft wood-carvings. William Emmett supplied some at a charge of £918, and Gibbons carved several important features as well as the lesser mouldings around doors (Pl. 23) and windows for a little over £1,265.

In the Chapel Royal at Hampton Court Wren designed a reredos which is flanked by two Corinthian columns on plinths at each side, a large upright oval at the centre framed by soft-wood swags, and a carved 'Glory' of cherubs at the segmental head. Gibbons carved all this in 1699 in superb fashion, entering his work at £941 14s. 9d.

Gibbons's drawings for some of his work at Hampton Court, most of which have been reproduced by the Wren Society,[31] and which include three for chimneypieces and entablatures in the royal suites (Pls. 40–42), are very accomplished. It would of course be helpful to be able to move beyond speculation about Gibbons's early years in Holland and to know what opportunities he had to learn to draw with such facility and more about the tuition given him to enable him to express ideas so well on paper. Many of his spirited drawings are superior to those of his contemporary, the talented designer Daniel Marot, who worked for the King in Holland and in England. Certainly, an assumed association with Hubertus Quellin, whose two volumes of engravings of the sculptural decoration of the Amsterdam Town Hall were published in 1665–9, may have been very important to the impressionable young man.[32]

31. *Wren Society*, IV, Pls. 27–46.

32. Engravings of the Amsterdam Town Hall were published by E. Meyster in 1655, by Jacob Vennekool in 1661, and by Hubertus Quellin in 1665–9. See Katherine Fremantle, *The Baroque Town Hall of Amsterdam*, Utrecht, 1959, and the same author's catalogue of Quellin's work in the palace, *Focus on Sculpture*, Amsterdam, Royal Palace, 1979, p. 79. I am indebted to Mr John Harris for discussing Gibbons's drawings with me.

Royal Palaces: Kensington

A commission which proceeded concurrently with Hampton Court was Kensington Palace. In June 1689, it will be recalled, the King bought the Earl of Nottingham's house in Kensington and the work of adding to it began at once. The King had not liked living at Whitehall and the work at Hampton Court had only just been commenced when the first building failure had occurred. As if this was not enough, the new buildings at Kensington fell down in November 1689. Fortunately for Wren, the Queen intervened. She wrote to the King in December[33] that she had often gone over to Kensington to hasten on the workmen. She wanted to take up residence quickly, and it was all the pressure on them, she insisted, that had caused errors in their work, though the hand of God had also intervened. One can imagine how much this statement, with which few could argue satisfactorily, endeared the Queen to the hard-pressed officers of the Works. In February 1690 Evelyn records that he had visited Kensington and that despite the patching and alterations it made, with its garden, 'a very sweet villa'.

In the Kensington Palace contracts book[34] it was recorded that the stairs were to be of elm, and the joists and floors of oak and yellow fir. The oak doorcases were to be seven feet high and the floors in the Queen's Rooms were to be prepared with extra care. The joinery in preparing wainscoting for rooms was done by Henry Lobb and Alexander Fort, and after them all the important carvers came onto the site. Nicholas Alcock and William Emmett were old friends of the Works, and the latter still held his post of Master Sculptor and Carver in Wood to the Crown. Gibbons was the leading carver and Robert Osgood and Caius Gabriel Cibber were competent sculptors. The plasterer Henry Margetts was employed by sub-contract by the Master Plasterer John Grove, who was busy at Hampton Court.

With the exception of the King's and Queen's Galleries, the interiors at Kensington on which they all laboured have been altered completely. However, two inventories of 1697 and 1699 and several official warrants authorising the transfer of furniture survive and have been published.[35] Again, as at Hampton Court, the death of the Queen in December 1694 destroyed the King's interest in the work there, and various members of the household and court took advantage of the situation to appropriate much of the furniture.

After ascending the Queen's Staircase, with its plain newels and turned oak balusters set against Alexander Fort's oak panelling, the visitor now enters Queen Mary's Gallery, 84 ft long with a plain white coved ceiling. The oak panelling is similar to that on the staircase but the cornice and door heads are richly carved, the work of Alcock and Emmett. The room originally held 154 pieces of the Queen's vast collection of Chinese and Japanese porcelain (given in November 1699 to Lord Albemarle), as well as japanned tables, chests and chairs surrounded by crimson velvet hangings and white damask window curtains. The surviving features of the room are the two gilt mirrors (Pl. 21), called 'two glass

33. *Wren Society*, VII, p. 135.

34. PRO, Works 5/146.

35. Th. H. Lunsingh Scheurleer, 'Documents on the Furnishing of Kensington House', *Walpole Society*, XXXVIII, 1960–2, pp. 15–58.

panells over ye chimneys' in the 1699 inventory, and still serving as overmantels; the Vauxhall plate glass for them was supplied by Gerrit Jensen and their richly carved and gilt surrounds, composed of volutes, drapes and festoons of flowers, were carved by Gibbons in 1691.

In Queen Mary's bedchamber only the fine cornice carved by Gibbons remains – his splendid overmantel has gone, but the one in the Presence Chamber may be his work. It seems to have been designed in the first instance for the King's Gallery, and was transferred twice: in 1721 to the King's drawing room and in 1724 to the Presence Chamber. Gibbons received a total of £839 0s. 4½d. for all his work.

In the extensive grounds the Orangery, designed by Vanbrugh in 1704, has at either end examples of pine and pearwood carving by Gibbons. They are displayed over the arches which lead through to circular rooms in which is a pair of large vases sculpted by Cibber and Edward Pearce for the gardens at Hampton Court. It is regrettable that so much cannot be shown as the patron, architect and craftsmen intended: the wood-carvings in particular lose against the wood panelled walls, which are painted white. Gibbons had only charged a meagre £7 12s. 6d. for them, but in any case taste was changing in favour of the work of decorative painters such as Louis Laguerre and Sir James Thornhill.

ST PAUL'S CATHEDRAL, LONDON

A brief idea of Wren's building programme over the thirty-five years from 1675 to 1710 will help to fix the stages of structure and decoration of St Paul's. After the laying of foundations in 1675 the lower parts of the eastern elevation were commenced, and contracts entered into for the foundations of the dome and of the north side. By 1678 the walls of the choir were some 24 ft above the ground and late in that year preparations for supporting the dome (the final form of which was still undecided) were put in hand. By 1687 it was proclaimed optimistically in a newsletter 'that a few years now will perfect the Edifice'. It was, however, to be 1707 before the great west portico was complete.

By the early 1690s Grinling Gibbons and Jean Tijou were providing wood-carvings and metal screens for the interior, and in 1694 Bernard Smith contracted to supply the organ, with its splendid (but now amended) case by Gibbons. The final solution for the dome came about in 1704, and the competition for its decorative painting was announced in 1709. It was not until June 1715 that Sir James Thornhill, as the chosen painter, was instructed to go ahead. The upper storeys of the cathedral were completed by the addition of a balustrade in 1718, a feature which Wren had not intended. By this time he was ready to resign, wearily, from the Surveyorship of the Cathedral and silently to accept his shabby dismissal from the post of Surveyor of the King's Works through the trumped-up political appointment of the inefficient William Benson.[36]

36. PRO, Works 6/11, pp. 103–5; *Calendar of Treasury Books*, 1718, XXXII, Pt. II, p. 9.

The richest work in the interior of St Paul's falls into three categories: wood- and stone-carving (including the organ cases); the metal grilles and gates; and the paintings on the inside of the dome. Only the first concerns us here. Gibbons and his team were at work by 1696 or 1697, carving in stone and in oak and limewood in the completed choir, and working on the case and screen of the great west organ. The joiner Charles Hopson had prepared certain models for important features of the interior wood structures, such as the seats in the choir, the altar, Dean's seat, choir stalls and organ-cases.[37] Gibbons's carving, skilful as it was, was giving concern due to its cost. In July 1696 John Oliver, Assistant Surveyor at St Paul's, was instructed to compare the measurement Gibbons had set down in his bill with his own specially taken measurement. Gibbons had to put such prices to this measurement as he intended to stand by and no money was to be paid to him until this was agreed. In September Wren was instructed to adjust certain prices with Gibbons, particularly in respect of work on the organ-cases.

37. *Wren Society*, XV, pp. 11–12.

A wood-carver of similar stature to Gibbons working at St Paul's was Jonathan Maine of Oxford, who had an extensive private practice and who was on friendly terms with the Assistant Surveyor. There is often little to choose between his work and that of Gibbons. There is, however, no evidence that he undertook stone-carving, as Gibbons did.

The wood-carving in the vestries and side chapels was all by Maine, who showed his abilities in the rich carving in oak of the Morning Prayer Chapel screen. The accounts from the two artists for wood-carving indicate the amount of work each did: Gibbons was paid £2,992 11s. 4½d. and Maine £1,252 6s. 11d. For stone-carving Gibbons was paid a further £586.[38]

38. *Ibid.*, XV, Introduction, pp. xxii–xxiii.

39. *Ibid.*, XVI, pp. 7–10.

Gibbons started at St Paul's on various external stone-carvings. No contract has been traced for this among at least forty[39] for tasks done by other master craftsmen. By July 1694 he was being paid for interior carving in the legs of the dome, and in 1694/5 for twenty-six stone 'Festoones' at £13 each on the outside under the windows in the length of the nave. Gibbons was one of several master craftsmen who loaned money to St Paul's at 6 per cent interest. They trusted Wren, and by receiving some interest on their investment they were kept satisfied. There was certainly work enough for all.

The greatest surviving range of wood-carving by Gibbons and his team is in the choir, which was originally divided from the body of the church by a great screen supporting the organ-case (Pl. 31). Except for the carved angels on the organ-case there was, in deference to Protestant feelings, no interior figure-sculpture, only Gibbons's swirling foliage, doves, pelicans and emblems, none of which was allowed to project more than two inches. The interior thereby lacked the full sensual appeal typical of its Baroque counterparts on the Continent.

The work consisted in providing two banks of choir stalls to the north and south of the choir, a bishop's throne and stall, a Lord Mayor's stall, the organ-cases and a stall for

the Dean. The Bishop's throne on the south side (Pl. 33) has a canopy supported by oak pilasters and two oak columns which were carved so richly as to appear to be 'swathed in brocade'.[40] The canopy soars up to an open 'lantern' surmounted by four *putti*, which bear aloft the Bishop's mitre. This was made for Henry Compton (1632–1713), Bishop of London, who saw both the foundations laid and the cathedral completed thirty-five years later. Some sketches survive for the throne.[41] The cornice is continued westward over six stalls, with eleven large scrolled festoons (at 22s. 6d. each) headed by a winged cherub with the Lord Mayor's stall at the centre of the range. In the whole length of stalls there were originally sixty-six of the limewood cherubim, charged by Gibbons at £1 each;[42] there are now fifty-five. Almost from the moment of its completion the woodwork at St Paul's has been vulnerable to amendment. This was particularly so in the nineteenth century; the woodwork was also removed from the cathedral during the Second World War and then replaced in post-war conditions which, for supply of materials and quality of workmanship, were not ideal.[43]

Beneath the cornices the galleries are supported by cherub caryatids swathed in acanthus leaves, which run westward above six panels of carved fruit and flowers, four of which have the crossed trumpet motif as a dominant feature (Pl. 36). Gibbons charged in his July–September 1697 bill for '62 ffestoones under ye projection of ye Gallery at 30s, & finding wood, £93'.[44] On the south side of the choir, facing the Bishop's and Lord Mayor's stalls, are the Bishop's domestic stall and the Dean's stall. The latter was originally part of the organ screen facing east. It features an acanthus canopy with two singing *putti*, and three more are carved in the back of the stall with one, the dove of peace aloft on its head, above an open bible and crossed swords. Palms, wheat, forget-me-nots, tulips, peonies, swags, flowers and ribbons are all carved with considerable verve. For carving the 'Book & Cherubins Heads' Gibbons charged £6, with £20 for 'ffinishing part over ye Dean's stall with boys etc'. The Bishop's and Lord Mayor's seats were charged at £36 each.[45] Gibbons also carved the (surviving) communion table and two panels in the rail in front of the communion table, but no altar rail by Gibbons survives.

Wren at first intended that there should be two organs at St Paul's: the great organ mounted on a screen across the entrance to the choir, and a choir organ between the piers of one of the choir arches. There are two excellent sketches by Gibbons for the proposed choir organ.[46] However, as both carried a likeness of Queen Mary in an oval cartouche (and one of them a likeness of the King too), nothing further seems to have been done after the Queen's death in 1694. There are also drawings for the great organ[47] which was to be set up at the east entrance to the choir, high on its screen; it is illustrated thus in all early eighteenth-century engravings (Pls. 29–30). Looking down the long processional route from the great west doors its silhouette must have been most impressive, with the two 5 ft terms (at £15 each) and 'the Drapery & whole Boys & 2 half Boys'

40. Jane Lang, *The Rebuilding of St. Paul's after the Great Fire of London*, 1956, p. 168.

41. *Wren Society*, II, Pls. 27, 29; III, Pls. 34–5, together with two drawings, formerly St Paul's Library, now Guildhall Library, London.

42. *Ibid.*, XV, p. 32.

43. I am indebted to the Clerk of Works (Michael Peyton) and the chief Carver (Tony Webb) for discussing these matters with me.

44. *Wren Society*, XV, p. 32.

45. *Ibid.*, XV, p. 32.

46. *Ibid.*, III, Pls. 36–37; Green, *Gibbons*, Pl. 134.

47. *Ibid.*, XIV, and various drawings for interior woodwork in vols. II and III.

(£25) a dominant feature. Unfortunately by 1860 the cathedral authorities had started the long process of moving the organ to one side as they opened up the vista from the nave to the high altar. They seized on the fact that Wren had intended a choir organ to fill the second arch on the north side of the choir, and in 1872 the organ-case was split in two, and the two cases placed facing each other across the western end of the choir. Acoustics were ignored and as the east and west faces of Gibbons's case were different, the duplicate was faked to jut out above the southern stalls, dominating the Dean's stall, which was moved to face north instead of east. Wren's magnificent plan for the choir as an architectural whole to be enclosed in a fine range of carved stalls was wrecked for all time, and the west-east vista was replaced by an over-long tunnel, confusing to the eye.

We do not know how many carvers Gibbons employed on all this work, and no drawings survive. Different hands can be observed when pieces are on the bench and under repair. Parts were held superimposed on one another by sharp hand-made nails which have rusted over the years; carving is often in lengths of a few inches in height, implying many hands producing running pieces which were then put together *in situ*. The profile is normally kept to below two inches, apart from dominant features such as swinging *putti* and scrolled consoles; some carving is in oak, some in limewood. Nor do we know the ratio of work done in the workshop and *in situ*, but one assumes that most of the carving was executed within the comparative shelter of a larger workshop maintained by Gibbons, and then prepared for installation at a site workshop.

Fragments of the dismembered organ-case are scattered in many parts of the cathedral, to be built into porches in the north and south doors of the transept, as backing to the choir stalls on the north-west, and over a side altar at the eastern end of the south aisle, and much other carving from other positions in the Cathedral is now in boxes in the carver's store. A steady programme has been in hand since 1986 to restore these fragments as much as possible to their original positions, a process helped by the illustrations in the books on Gibbons by Albert E. Bullock (1914) and H. Avray Tipping (1914), noted in my Bibliography.

By the end of the seventeenth century the choir and dome were almost finished but the final decoration and enrichments took several more years to complete. Gibbons may have been disappointed that in 1706 Wren entrusted the carving of the stone-relief *The Conversion of St Paul,* intended for the great tympanum of the pediment on the west front, to Francis Bird. He had, according to Vertue, worked both for Gibbons and for Cibber. The carving measures 64 by 17 ft and Bird charged £620 for it.[48] In view of the great height of its position and its weathered condition it has been less appreciated than it deserves as an excellent portrayal in the Roman Baroque style.

48. Whinney, revised edn, *op. cit.* (Note 28 above), p. 151, Pl. 98.

LONDON CHURCHES

In the busy years after the Great Fire Wren concerned himself particularly with the design of the new City churches. The complex administration needed to supervise so many individual rebuildings – eighty-seven had been destroyed and fifty-two were rebuilt – may be gauged from the fact that seventeen were started in 1670, and by 1676, when Wren was also much involved with St Paul's, twenty-eight were in hand. With Robert Hooke and Edward Woodroffe to help him as surveyors, each vestry had to be listened to and their various comments and demands noted. The greatest interest (much nineteenth-century and post-Second World War rebuilding apart) lies in the variety of interior plans and the towers and steeples soaring over crowded streets.

Too many of the interior carved fittings of the City churches have been credited to Gibbons. The only ones that are documented and can be attributed to him with certainty are the altarpieces of St Mary Abchurch and St James's, Piccadilly, and the organ-case and font at the latter church.

St James's, Piccadilly, c.1684

This church, consecrated in 1684, was visited by John Evelyn on 7 December in that year: 'I went to see the new church at St. James's, elegantly built; the altar was especialy adorn'd, the white marble inclosure curiously & richly carved, the flowers & garland about the walls by Mr Gibbons in wood; a pelican with her young at her breast, just over the altar in the carv'd compartments & border . . . There was no altar any where in England, nor has there been any abroad, more handsomely adorn'd.'

In Stephen Wren's gatherings about his illustrious architect father, called *Parentalia,* he also describes the altarpiece at St James's: 'very curious and spacious, consisting of fine Bolection Pannels, with Entablature of Cedar with a large Compass Pediment under which is very admirable carved work . . . all very neatly done in Limewood.' He also describes the 'noble Feston with exceeding large Fruit of several kinds' (Pl. 38), which consisted of carved grapes and a large gourd (a special attribute of St James). The collection of carved shells alludes to St James's pilgrimage, whilst the pelican and pomegranates symbolise sacrifice.

At the west end of the church is the fine organ-case carved by Gibbons, with trumpeting *putti,* formerly in King James's Catholic chapel at Whitehall and given to the church by Queen Mary in 1691. To the north-west is the Adam and Eve font (Pl. 39) which is credited to Gibbons on the strength of an engraving[49] of it in 1718 bearing the italic inscription: '*Opus Grinlini Gibbons Ære jam perenniori sculpsit Georgius Vertue* 1718'. As this was issued three years before Gibbons died there seems little reason to doubt his authorship.

49. Green, *Gibbons,* Pl. 72.

The font has a pedestal shaped as the trunk of an apple tree. The bowl is enriched with cameo-reliefs of Noah's Ark, the baptism of Christ, and the baptism of the eunuch of Candace by St Philip. The serpent is coiled languorously around the tree trunk and offers an apple to Eve who offers another to Adam. It is not a wholly satisfying work, and but for Vertue's engraving it would not be attributed to Gibbons. We must be more cautious still when looking at the font at St Margaret's, Lothbury, where the same relief appears in facsimile on the bowl. The lid of the font at St Margaret's is also an accomplished piece of Gibbonesque carving but there is no documentation.

St Mary Abchurch, Abchurch Lane, 1681–6

When Gibbons came to work here he was following craftsmen whose abilities he knew from their employment in the King's Works or at St Paul's. John Grove, Master Plasterer and his partner Henry Doogood worked in many of the Wren City churches, and Christopher Kempster was a competent stonemason whose family had long been associated with Wren's projects. Gibbons's receipt[50] for part of the payment for the altarpiece survives, signed on his behalf on 31 August 1686 by his apprentice, Henry Summer. It is only for £10, but further documentation[51] shows that he received in all over £100. This documentation includes a letter from Gibbons to Mr Chamberlain, the churchwarden at St Mary Abchurch, dated 12 May 1686.

50. Guildhall Library, London, MS. 3295.

51. *Ibid.*, other documents as MS. 3295.

Mr Chamberling
Sr I wold beg the faver from You to send me the £30 due of the Alter pecs but if the Gentellman Consarnd does not beleave it be not folle Anof then obleage me to send me £20 by this baerer and as soen as I kane kome in toune Agane I will waet one You and sattisfy You Youer desire.
Sor I am Youer sarvt Grinling Gibbons

A bill of March 1686 indicates that the font cover and two coats of arms and '8 Cherubins heads' were carved by William Emmett, the pews by William Newman, the pulpit by William Grey and the rails of the communion table and other work by 'Mr. Almandry Howart'. There is considerable risk in assuming therefore that any competent piece of carved work must be by Gibbons.

As at St James's, Piccadilly, the St Mary Abchurch reredos (Pl. 37) has the pelican as its central gilded motif and the whole is topped by four flaming urns, with the arms of James II between winged cherubs at the apex. The reredos is framed by two pairs of fluted Corinthian columns. The church was bombed in 1940 but the debris of the reredos was gathered painstakingly by the vergeress and restoration started in 1948.

CAMBRIDGE AND OXFORD

In the last decade of the seventeenth century Gibbons was at work on a number of private commissions and monuments, as well as on Hampton Court, Kensington Palace and St Paul's Cathedral. It is a measure not only of his standing but of the capabilities of his large workshop that he could consider work in the university towns of Cambridge and Oxford. Sir Christopher Wren had long been involved with both. On 29 April 1663 he had shown his model of the Sheldonian Theatre in Oxford to the members of the Royal Society, and a fortnight later the Master of Pembroke College, Cambridge, laid the foundation stone of the new chapel, also designed by Wren. After telling the Royal Society in 1664 that being a benefactor to mankind was best effected by advancing knowledge, profit, health and the conveniences of life, Wren turned to his work for various university friends, fitting it as best he could amid pressing alternatives.

Wren's friend Dr Isaac Barrow, the Master of Trinity College, Cambridge, wanted a new library and this was begun in 1675. As is often the case with projects where the finances may be diverted to other more urgent causes, the building progressed slowly, and the fabric was not finished until about 1690. The previous year a Trinity man, Charles Seymour, sixth Duke of Somerset (for whom Gibbons was shortly to work at his Sussex house of Petworth), had been appointed Chancellor of the University. At his imperious instigation progress was speeded up, and the first payment to Gibbons for interior carving at Trinity College was made in 1691.[52]

Gibbons's carving was of course laid over wainscoting done by a host of competent joiners. At Cambridge much of this work was in the hands of Cornelius Austen, and at Oxford it was undertaken by Arthur Frogley and the Minn family. In the Trinity College Library at Cambridge Austen was responsible for the cedar bookcases which stand out from the walls to form small study cells (Pl. 26); for each one Gibbons carved a limewood coat of arms on the bookcase ends (Pl. 28). Wren's design was altered to include a niche in the upper part of the south end to take a marble monument of the sixth Duke by Gibbons. The Duke's three crests and cyphers were repeated four times each in limewood; Gibbons was paid £245 for the statue of the Duke, an unspecified number of 'bustos' and all but one of the coats of arms, nine of which were named. A further bill for £160 was submitted but it is not known what this was for.[53]

Down the eastern side of the Library the lesser benefactors were commemorated. They had given £28 each towards the cost of bookcases, and the Bishop of Coventry had left £50 a year to purchase books. The coats of arms are carved from laminated sheets of limewood, each about $2\frac{1}{2}$ ins thick. Within the small area of 15 by 21 ins they are spirited affairs (Pl. 28), charged at £5 each. They give life to a rather dull room which has great doorcases with Corinthian columns at each end. The royal arms of William III are set aloft

52. Margaret Whinney, *Grinling Gibbons in Cambridge,* Cambridge, 1948, p. 7.

53. *Ibid.,* p. 8.

in the broken pediment. Some of the busts on the bookcases are later, of eighteenth-century date, and by Roubiliac, but among the plaster ones of the upper layer two, of Anacreon and Ben Jonson, are of painted wood and may be by Gibbons. Whilst there is no precise evidence for their authorship, the sculptor had charged for 'bustos' but did not name the subjects or material.[54]

When Celia Fiennes visited the library she noted that 'the Library farre exceeds that of Oxford . . . the finest Carving in wood in flowers, birds, leaves figures of all sorts as I ever saw'. She does state, though, that the fine reredos in the chapel at Trinity College, Oxford,[55] which she visited in 1694, was 'very fine carving of thin white wood just like that at Windsor, it being the same hand'. The reredos frame, with an acanthus frieze, whilst typical of Gibbons, is complicated by the evidence of two letters (at Corpus Christi and the Bodleian Library) which indicates it is by Jonathan Maine.[56] Unfortunately the accounts for 1692–3, when it was being erected, do not survive: the chapel had been designed in 1691 (in consultation with Wren and the Dean, Henry Aldrich) and was consecrated in April 1694, with the carving probably done in 1693. The Trinity College, Oxford, work is fully worthy of Gibbons but his authorship still rests on the slender evidence of Celia Fiennes alone as being by the same hand as the carvings she had seen at Windsor. But in 1694 the carver had other things on his mind in the work Wren needed him to do in London at St Paul's Cathedral, and moreover, some of it in stone.

54. *Ibid.*, p. 10.

55. Illustrated in Geoffrey Beard, *Craftsmen and Interior Decoration in England, 1660–1820*, Edinburgh, 1981. Col. Pl. 3 and Pls. 112–3.

56. *Country Life*, 31 December 1948.

'Incomparable Carved Works'

...with silent wonder oft have I beheld
Thy Artful works by Nature scarce excell'd,
Inhabitants of Air, of Sea and Land,
And all the fair Creation of thy Hand ...
'To Mr Gibbons on His Incomparable Carved Works' in Nahum Tate,
Poems Written on Several Occasions, 1684.

WHEN Allan Cunningham wrote his *Lives of Eminent British Painters, Sculptors and Architects* in six volumes (1829–33), he recorded of Gibbons, sombrely: 'Those who labour in wood commit their hopes of fame to a most deceitful foundation and need not hope to survive in their works.' It is easily possible to become too lyrical about Gibbons as an arbiter of taste in woodworking. At his best he was untouched, and whilst helped by a group of assistants (such as John Selden at Petworth), he undoubtedly set his own lively and imaginative standards of unusual daring. His work should be judged by the few documented commissions and never on the basis of his use of the pea-pod as a motif. Both of Gibbons's biographers, H. Avray Tipping and David Green, cast on it the discredit it merits: that if Gibbons had meant the pea-pod as a signature it was 'equally in vogue with his contemporaries'.[1] Far better to observe carefully the way a festoon might swing, or how a truss was hung, and to notice the details of the carved vine tendrils, a butterfly, a ripe peach or two, and a sprig of jasmine. It is all in soft wood, carved with rare dexterity, and noteworthy for the extreme naturalism present in the recurrent elements of the floral motifs: the tulips in flamboyant stance, open-throated against the double poppy, the split pomegranate – a symbol of sacrifice or of royal favour – and the tall sunflowers. Poised perilously above, the cooing doves and soaring eagles, eager to escape the folds of curled acanthus and twisted vine, also represent favourite themes. In one form or another they are present from the very first commissions.

1. David Green, 'A Pea-pod Myth Exploded', *Country Life*, 8 August 1963.

SUDBURY HALL, *Derbyshire*

In 1677 George Vernon, a Derbyshire squire, paid Grinling Gibbons £40, presumably for the overmantel carving (Pls. 43–44) in the drawing room of his newly erected house, Sudbury Hall. George Vernon inherited his estate in 1658 and soon after the Restoration he started his house in diapered brick in a late Jacobean style. In 1675 the decoration

moved away from local hands when George Vernon agreed with the London plasterers Robert Bradbury and James Pettifer and the London carver Edward Pearce to embellish his house with fine fretwork ceilings, an elaborate staircase with acanthus foliated balusters and splendid doorcases on each landing. It is surprising that Gibbons was not given more wood-carving to do, but at this time he was not well known: his work for the King at Windsor was about to commence and in any case Edward Pearce, who was some fifteen years older, was very competent. One wonders if Pearce could have played any part in the younger man's development? They were to work often on the same commissions and for a similar circle of patrons. It is a theory that should be borne in mind but not taken further without documentation.

PETWORTH HOUSE, *West Sussex*

When Gibbons had finished his work at Windsor in the early 1680s he could turn to his first major commission outside the King's Works, that for the sixth Duke of Somerset at Petworth.

I described in Chapter I Gibbons's finest panel of carved wood, that presented in 1682 by Charles II to Cosimo III, Grand Duke of Tuscany (Pls. 6–11). Certain panels by Gibbons in England are similarly impressive, such as those in the Carved Room at Petworth House.

The 'Proud Duke', Charles Seymour, sixth Duke of Somerset, had married the young heiress Elizabeth Percy in May 1682; she came into her inheritance at the age of eighteen three years later, in 1685. It provided the means for the Duke to start altering the Elizabethan house at Petworth, which itself had been formed from a medieval one, of which the fourteenth-century chapel still survives. The main west front was given a significant vertical emphasis by the provision of a squared dome with an iron balcony at the centre, statues and urns on the parapet, mansard roofs and projecting three-bay wings at the north and south ends. The dome and mansard roofs were probably destroyed in the fire of 1714 and the central vertical emphasis was therefore lost against the over-long stretches of the façade.

Most of the workmen employed by the sixth Duke at Petworth from 1686–92 were active in the service of the King's works. Indeed, the agreement of December 1686 with the London joiner Thomas Larkin to provide wainscoting specified that it should be 'according to the worke in his Maties Great & new Gallerye at Whitehall, and window shutters and Compass pedimt over the doores as those in the newest lodgings in Whitehall.' Among the many surviving documents (now at the West Sussex County Record Office)[2] there are only scraps of evidence to record the presence at the house of William III's Huguenot architect, Daniel Marot, and nothing but a few signed drawings by the shadowy

2. Noted in Gervase Jackson-Stops, 'The Building of Petworth', *Apollo*, 105, May 1977, pp. 324–33.

'Pouget, a Frenchman' who seems to have been involved at Petworth as well as designing Montagu House, London, and Boughton House, Northamptonshire, in the late 1680s for Ralph, first Duke of Montagu. He had been several times ambassador to the court of Louis XIV, and had married the 'Proud Duke's' mother-in-law, the widowed Countess of Northumberland.

Within the series of state rooms at Petworth the least altered is the Marble Hall, decorated in 1692, perhaps to designs by Daniel Marot. The robust wood-carving is by John Selden, the plasterwork (of which nothing survives) was by Edward Goudge and David Lance, the 'dove-coloured' bolection chimneypieces were by Nicholas Mitchell, the black and white marble paving by a Mr Stroud and the wainscoting, with niches, by Thomas Larkin. It is, however, the mention of John Selden which is most important when considering the wood-carving. The Selden family first appear in the Petworth parish registers in the early seventeenth century. John Selden lived in Petworth: he was working in the house in 1687 and he appears in the accounts until they cease in 1697. He was paid at times a lump sum of £40, which may well have been his year's wages.

As with many carvers, Selden seems to have been skilful at working in both stone and wood. In John Bowen's account roll for 1696 there are payments for sending letters for John Selden about Portland stone as well as a long, detailed entry about various wood- and stone-carving including mouldings, festoons and even a periwig stand.

The two account book entries for 1692 relating to Gibbons's work at Petworth show payments of £173 on 26 March and £150 on 10 December.[3] Gibbons probably supplied the twelve figures shown along the parapet in an anonymous oil painting of the west front of Petworth, c.1700,[4] and the £173 represents reasonable payment for that. The second payment of £150 in December 1692 must relate to the pair of picture frames and the attendant pendants at either end of the wall in the Carved Room (Pls. 51–56). The carving around the overmantel portrait of Henry VIII used also to be regarded as Gibbons's work but is presumably that referred to in John Selden's bill of 1689–90[5] as for the dining room: 'large chimney peece ... made with ffowles, ffishes and flowers, £30' and 'a picture frame for the chimney in the said roome carved with fouldinge & Flowers conteyning 22 feet at 5s. the foot, £5.10s.'

Several account rolls are missing for important years of the sixth Duke's building. I have therefore also examined the Duke's account at Hoare's Bank which contains one payment additional to the two noted above. This is dated 8 January 1687/8, and is to 'Mr Gibbons', for £70. Four months previously the duke's account (which peters out after a year or two of activity) included a payment of £20 on 3 September 1687 to John Selden.

The work in the Carved Room at Petworth is now seen, as at Windsor, out of its original setting. The plan of Petworth held by a boy in Laguerre's great painted scheme,

3. West Sussex CRO, Petworth MS., 245.

4. Jackson-Stops, *op. cit.* (Note 2 above), Pl. 4. In the collection of the Duke of Rutland at Belvoir Castle.

5. Petworth MS. (Note 3 above), 172.

*c.*1719, on the new staircase (the previous one had been destroyed in the fire of 1714), shows that the present Carved Room had originally been two rooms of almost equal size. Inventories of 1749–50 and 1763 show that the one next to the little dining room contained Gibbons's carving. The northern half was used as a 'tapestry room'. The two rooms were made into one in 1794–5, and various carvings by Selden from other parts of the house were then assembled there. The onlooker is confused further by work by the talented carvers from northern Cumbria, Jonathan Ritson (*c.*1780–1846) and his son, which is in a seventeenth-century style. Their work in the cove of the Carved Room (*c.*1815) however did not approach that of Gibbons and Selden. Jonathan Ritson senior and his son (also Jonathan) are better known for the work they did for the eleventh Duke of Norfolk at Arundel Castle. Their carving in the library there in Honduras mahogany is a better indication of what they could do when there was no need to copy an earlier style. Finally, some of the flowers in the carved baskets (Pl. 54) in the Carved Room at Petworth were renewed early this century by the estate carpenter, Henry Hoad.[6]

6. Christopher Hussey, *Country Life,* 5 December 1925.

The present Carved Room (60 ft long, 24 ft wide and 20 ft high) is a fitting setting for the sumptuous array of carved limewood. It covers the whole of the long east wall, opposite the windows looking out to the deer park and is also arrayed on the shorter north and south walls. At the centre of the east wall, over the chimneypiece, is a copy of Holbein's cartoon of Henry VIII flanked by two pairs of full-length portraits; to the left (or north) is J. B. Closterman's likeness of the sixth Duke with a negro page and John Riley and Closterman's portrait of the sixth Duchess with her son, Algernon Seymour (later seventh Duke). To the right (or south) of the chimneypiece are two portraits of the Duke's grandparents, Francis, first Baron Seymour of Trowbridge, and his wife Frances Prinne. Tribute is paid to two of the carvers with late portraits by George Clint (1770–1854) of Gibbons and Jonathan Ritson senior. They were commissioned from Clint by the third Lord Egremont.

Around the portraits of the sixth Duke and Duchess are frames of raised pierced acanthus. Between them Gibbons has depicted the George of the Order of the Garter (also shown in Closterman's portrait) hanging from the wings of Fame (Pl. 55). The ducal coronets are mounted high on palm plumes set over each portrait and are further supported by crossed cornucopiae from which tumble the rich plenty of fruit, flowers and ears of wheat. As drops to the portraits *amorini* support baskets on their heads (Pl. 54); the Garter star is prominent and below is an allusion to the Duke's artistic patronage in the form of a pair of classical vases. Horace Walpole referred to 'an antique vase with a bas-relief, of the purest taste, and worthy the Grecian age of cameos'. *Putti* display their noiseless trumpets around the two portraits of the Duke's grandparents and there is a yet more wondrous sheaf of silent musical instruments (Pl. 51). It is all, in Walpole's words about Gibbons again, 'the most superb monument of his skill'.

Whist the sixth Duke was overbearingly imperious, Gibbons had already worked for him in 1690 when the Duke, as Chancellor of Cambridge University, was a considerable benefactor to Trinity College there. Whether we owe the survival of the Petworth carvings to John Selden is not clear. George Vertue noted[7] that Selden had lost his life in the 1714 fire whilst trying to save the carvings but the Petworth parish register shows that he was not buried until 12 January 1715. Could the fire have been on New Year's Day, 1714–15 (or as we should now call it, 1715) and Vertue be correct in recording Selden's death from the burns suffered when trying to save the carvings? It is an interesting speculation, but as with so much in the Gibbons story, stubbornly remains unresolved.[8]

The Petworth trophy which contains musical instruments, a notated score and a quiver of arrows (Pl. 51) is close to two panels (Pls. 49–50) in the north and south galleries of the Amsterdam Town Hall; the quiver of arrows appears as part of Diana's hunting equipment, and the gathered instruments are on a panel in the north gallery, near to statues of Mars and Venus. Venus's belt of coral beads, shells and roses is twined into festoons which with a stretch of imagination might appear, similarly, in any assemblage of Gibbons's carved wood; naturalistic, straining into fantasy but still imbued with overtones of the impressive Quellin prototypes.

BADMINTON HOUSE, *Gloucestershire*

Within a few miles of Bath and Bristol is the great estate of the Dukes of Beaufort, with the important house of Badminton at the centre of an array of seventeenth-century 'rides', within a rolling deer park, all engraved by Leonard Knyff in the late seventeenth century and painted by Canaletto in the 1740s. In the great parlour (now dining room) at Badminton there is one carved frame by Gibbons set over the chimney, and some drops and overdoors; the fine Gibbons monument to the first Duke's memory, set up originally in St George's Chapel at Windsor (and, since 1874, in the adjoining church to the house at Badminton), for which there are bank payments totalling £1,000, is noted in Chapter III (No. 36). The relevant entries for that are in the Child's bank account[9] for the first Duke, which starts in 1663 when he was still Marquess of Worcester, and continues to his death in 1700. On 6 July 1683 'Mr Gibbons, Carver' was paid £50. Then there is a curious entry for 4 June 1684: 'Paid Mr Grymlin Gibbons for Pictures £98'. The last entry seems to relate to an aspect of Gibbons's career we know little about, picture dealing. In 1686 Gibbons and Parry Walton (d. *c*.1700), the 'Supervisor and Repairer of the King's Pictures', were allowed by James II to sell 'a Collection of the best Italian masters, both Ancient and Modern' in the Banqueting Hall at Whitehall. The sale was advertised in the *London Gazette* and sale catalogues were prepared but for some reason it did not take

7. Vertue, *Notebooks*, II, p. 81.

8. Hussey, *op. cit.* (Note 6 above); Green, *Gibbons*, p. 107, fn. 4.

9. I am indebted to Sir Michael Young-Herries and Sir Nicholas Goodison for their help in arranging for me to examine all the Child's Bank ledgers at 1 Fleet Street, London, for payments to Gibbons.

10. John Woodward,
Apollo, March 1963;
Vertue, *Notebooks*,
III, p. 123; Green,
Gibbons, p. 111,
fn. 2.

place.[10] It is, however, one recorded indication that Gibbons found picture dealing a useful sideline to be involved in.

The first Duke of Beaufort was very active in re-modelling his house throughout the 1680s, and there are many payments in his bank account (for example, 1684) to various master craftsmen associated with the King's Works such as the bricklayer Maurice Emmett, the smith William Bache, the plasterer John Groves the elder, and the carpenter Matthew Banks the younger.

In respect of decoration in the house there are the payments to Gibbons, one of £15 (9 July 1683) to the London carver Charles Okey (to whom the 'house carver' at Chatsworth, the talented Samuel Watson, had been apprenticed), and within the first Duchess's account (as Dowager Duchess), interesting payments in 1703 to the Dutch cabinet-maker Gerrit Jensen and in 1706 to the celebrated clock-maker Thomas Tompion. Much of what they all provided is still at Badminton.

The Badminton overmantel carving (Pls. 45–6) in the dining room was photographed in 1914 for H. Avray Tipping's book on Gibbons. Its side-drops then incorporated fishes, and the two festoons between the facing windows contained the game-birds. The late Duchess of Beaufort interchanged these, to the probable original arrangement, on the advice of the late Queen Mary (who spent some of her wartime years at Badminton). The pearwood drops now over the chimneypiece are therefore heavy with dead game (Pl. 46): woodcock, plover and partridge. Those on the opposite wall, decorating the window piers, are redolent with tied bundles of fish, dark and glistening, amid the lobsters, waterlily leaves, peaches, grapes, roses and the inevitable pea-pods. The chimneypiece and its overmantel is set between Corinthian pilasters, and at the corners of the room there are garlanded doorcases. All of this later woodwork is by Edward Poynton, a Nottingham carver who worked for the Warwick architect, Francis Smith, who remodelled the house for the third Duke of Beaufort in the early 1730s.

BURGHLEY HOUSE, *Northamptonshire*

11. Vertue,
Notebooks, IV, p. 34.

George Vertue recorded that at Burghley House there were 'picture Frames, Chimneypeices & door Cases, carvd with Birds, Fruits & Flowers, in a most Beautifull manner, done by Grimlin Gibbons'.[11] This, however, is too simplistic, for there is much good wood-carving at Burghley House which is not by Gibbons. My own researches into this again centred around the late-seventeenth-century bank account of the fifth Earl of Exeter, also, like the Beaufort ones, at Child's Bank, London. This summary of payments was necessary in that there are voluminous archives at the house: these have been examined in detail over several years by Dr Eric Till, who has kindly shared his findings with me.

Firstly, on 6 July 1683 Gibbons was paid £50 from Lord Exeter's account, and two years later (21 December 1685) another £50 'in full'. The £100 is more or less a seventh of the £730 paid to the Oxford carver Jonathan Maine and the London carver Thomas Young, working in partnership. It would seem much of the carved work at Burghley, particularly door surrounds and cornices, is from their hands. As late as 1691 they worked together at Burghley for a full year, earning £143. The superb oak wainscoting was the work of the versatile London joiner Roger Davis, who also made picture-frames and furniture.

Possibly the clue to Gibbons's work at Burghley is to be found in the design quality of the 'drops' which hang together as a continuous cascade, whereas the other carvers' work does not have such fluency. There is really no difference in the undercutting, and isolation by motif is never simple. For example, the west overdoor in the first George Room shows an open watch on a chain and a portrait medallion of Charles II inscribed 'Carlo Secundo. D.R.' But in the first state room at Chatsworth, Young (or the 'house-carver' who worked with him, Samuel Watson) has carved a similar watch and medallion.

The carving around the chimneypiece in the Marble Hall is carried out in oak and done to a high standard of design and technique. It is probably not by Gibbons, but the north-west and south-west overdoors in the first George Room probably are the master carver's work. There is, alas, despite the payment to Gibbons, no certain method of establishing what he did when it is surrounded by work of such high standard by the team of carvers led by Maine and Young.

In view of the mentions of Chatsworth and the fact that the fifth Earl of Exeter sent his carvers on there to work for his brother-in-law, the first Duke of Devonshire, it is sensible to consider the carvings. In May 1744 the first Earl of Egmont visited Chatsworth and stated: 'There is a handsome chapel in it painted by Vario and Laguar and there is a good deal of fine carving in wood by the late Grinlin Gibbons, a famous master that way.'[12] This does not seem to be accurate, and I can do no better than quote Chatsworth's historian Francis Thompson, writing about the woodwork in 1949:[13]

> ... one thing is certain: there is not the minutest shred of evidence in support of the popular belief that Grinling Gibbons was its author. Gibbons is not mentioned in the Accounts, or by Celia Fiennes (1696, only five years after the carving was finished), or by Leigh (1700) or by Kennet (1708) or, an even more significant omission, by Vertue (1725). The earliest allusion to the legend I have been so far able to trace is in Walpole's *Journal* (1760); he accepted it without question ...

Samuel Watson's book of *Designs, Bills and Agreements* at Chatsworth supplies strong evidence that the wood-carving was his work, alongside payments to him and those made by the accountant 'in part of their bargaines of carved worke' to Thomas Young, Joel Lobb and Roger Davis. Jonathan Maine did not join the team at Chatsworth as he soon had enough work alongside Gibbons at St Paul's Cathedral.

12. Historic Manuscripts Commission. Egmont MS!

13. Francis Thompson, . History of Chatsworth, p. 136.

14. Vertue,
Notebooks, I, p. 160.

Horace Walpole usually enriched the earlier statements by George Vertue and others. Vertue noted a small frame of fragments and mentioned carvings of musical instruments (now missing);[14] Walpole, after attributing the carvings in the chapel to Gibbons, wrote that '. . . over a closet door, a pen not distinguishable from real feather. When Gibbons had finished his works in that palace, he presented the duke with a point cravat, a woodcock, and a medal with his own head, all preserved in a glass case in the gallery.' This is still at the house (Pl. 47) and of a quality one associates with Gibbons, although the portrait medallion shows a younger man than the one in the medallion on the Modena Panel (Pl. 12). Walpole continued, 'I have another point cravat by him, the art of which arrives even to deception, and Herodias with St John's head, alto relievo in ivory.' The limewood 'Walpole cravat' is now in the Victoria and Albert Museum.[15]

15. Green, *Gibbons*,
Pl. 50.

BELTON HOUSE, *Lincolnshire*

16. Geoffrey Beard,
*Decorative
Plasterwork in Great
Britain*, 1975; —,
'The Beste Master in
England?', *National
Trust Studies*, 1979,
pp. 20–7.

Over many years the architecture at Belton House has attracted attention, because of its quality and the robust nature of the plaster decoration therein. Built from *c*.1686–88 for the third baronet, Sir John Brownlow (1659–97), it is assumed that plans may have been given for it by Captain William Winde, although only the name of the supervising mason, William Stanton, appears in the accounts. Many years ago I attributed the fine plasterwork at Belton to Edward Goudge, on the basis of a mention of his work for Sir John Brownlow in a letter of 8 February 1690 from Winde to his cousin, Lady Mary Bridgeman.[16] I was therefore pleased to see more facts emerge from a detailed examination of the house archives undertaken by Mrs Rosalind Westwood for the National Trust (which now administers the house) in 1985–6. Mixed in with good woodwork of the late 1680s by Edmund Carpenter is carving given since the early eighteenth century to Gibbons. There is however no bill or letter to connect him more firmly. The left-hand overmantel in the Marble Hall (a room much amended in the eighteenth and nineteenth centuries, being furnished as a dining room in 1830) is, nevertheless, of finer quality than Carpenter's work and may be worthy of the family's traditional attribution of it to Gibbons (Pl. 48). The fifth Baronet, Sir John Brownlow (1690–1754), had been created Viscount Tyrconnel in 1718. He had a London house in Arlington Street where, according to the 1738 inventory, there hung in a passage 'a fine piece of carving in a panel by Gibbons'.

17. Belton Archives,
Brownlow family,
f. 101.

In the saloon at Belton (which has a convincing late-nineteenth-century ceiling in the style of the mid-1680s) there are two pieces of carving. The one at the east end would seem to correspond to Carpenter's bill of March 1688: 'ffor a Chimny peece in the greate Parlor wth fruit and flowers . . . 18.00.00',[17] At the west end the overmantel carving is bolder and richer and may be by Gibbons. The realisation of dead game in the two drops surmounted by a cresting with grapes and ears of wheat is worthy, in parts, of him. The

evidence is too flimsy to say more, and in any case a considerable amount of work was done to all the carvings in the nineteenth century by W. G. Rogers (1792–after 1867)[18] who is said to have been associated with an old craftsman named Birkbeck who was in direct touch with the Gibbons tradition, having restored carvings at Burghley House in 1754. It is possible that Rogers, who was regarded as the expert on Gibbons in the mid-nineteenth century, added a group of four fishes to the centre of each of the Marble Hall drops; in the saloon the *appliqué* drops of *putti* on the south wall may also be his work.

18. Tipping, *Gibbons*, pp. 197–8; *Proceedings*, Royal Inst. of British Architects, 1867, p. 180.

WORK IN SCOTLAND

The great Scottish houses belonging to the Dukes of Buccleuch and Queensberry, Drumlanrig, Dalkeith and Bowhill, contain much that was perhaps intended originally for the English houses of Moor Park, Boughton and Montagu House, London. These descended from Ralph, first Duke of Montagu (1638–1709) and became merged into the possessions of the Dukes of Buccleuch by the marriage in 1767 of Henry, the third duke, with Elizabeth, daughter and eventual heiress of George, Duke of Montagu. He, as Earl of Cardigan, had taken his father-in-law's name when created a duke in 1786.

Between 1700 and 1705 the architect James Smith, who had succeeded Sir William Bruce in 1683 as Overseer of the Royal Works, remodelled the medieval courtyard Dalkeith House, which had been bought by the second Earl of Buccleuch for his daughter, Anne, who had become Countess of Buccleuch in her own right. At the age of twelve, in 1663, she was married to James, Duke of Monmouth, the illegitimate son of Charles II, and the couple were created Duke and Duchess of Buccleuch on their wedding day. Many years later, in October 1701, the Duchess took up residence at Dalkeith House.[19]

The relevant documents show the various structural items provided by a wide range of craftsmen, including Gibbons. The materials for upholstery came from London or Amsterdam and in 1706 came marble, deal and chairs from Rotterdam. The payments to Gibbons are as follows:[20]

19. John G. Dunbar and John Cornforth, 'Dalkeith House', *Country Life*, 19 and 26 April, 3 May 1984.

20. Scottish Record Office, GD 224/924/45, pp. 12, 18, April–June 1701; and 224/924/46, July–August 1706.

		£
1701	Mr Grin Gibbons for Carving a Marble Baster-leafe	80
	Grinling Gibbons for Marble Chimnys	74.6s.
1706	Mr Gibbons, Carver, for Marble Chimney to Dalk . . .	123.7s.

The 'Baster-leafe in Marble being the story of Neptune and Gallatea' (Pl. 58), costing £80, was first installed at Moor Park, Hertfordshire, in 1701 and sent north two years later. In red and white marble it was an accomplished work and was set into the great closet at Dalkeith. The great closet with the adjoining picture closet linked the great

apartment to the Duchess's apartment in the east range. The great closet acted as her dressing room and the woodwork was elaborate, with the doors laid in contrasting grains, and well carved architraves, cornices and mouldings at every suitable point. The colour of the marble was picked up in what the 1756 inventory describes as 'one piece red velvet hanging flower'd with gold'. Daniel Defoe regarded the house as the 'finest and largest new built House in Scotland'.

Gibbons had agreed to charge £6 to £12 each for eight marble chimneypieces, apart from the Neptune and Galatea panel. These were always intended 'for Scotland' and have 'moved' variously between the family houses as required.

The Neptune and Galatea panel, representing a favourite theme since Roman days, is some 60 by 30 ins (Pls. 57–59) and shows the relaxed upright figure of Neptune, trident aloft, riding across the waves in a perilously tipped cockle-shell coach drawn by four prancing seahorses. Around are mermen blowing conch shells or accompanying the coach. Galatea lies recumbent, surrounded by mermaids, in a great shell drawn by two dolphins and steered by two winged cherubs. It is all carved with great skill and as, perhaps, Gibbons's best work in marble, must have given Duchess Anne great pleasure. Above the red-white marble frames is a blue glass panel with a design of palm leaves framing the Duchess's coronet and cypher, overlaid in white glass. It was sent north from London to Leith in 1704 and special permission was obtained for the customs examination to be held at Dalkeith so that damage would not be caused by careless opening of the crates.[21]

21. Dunbar and Cornforth (Note 20 above), 26 April 1984, p. 1161.

At Drumlanrig Castle there are panels and overdoors which may be by Gibbons, but there is no means of determining this. The 1756 Dalkeith inventory notes a chimneypiece and overmantel in the Green Velvet Room which is now at Drumlanrig. Whilst the frame may be by Gibbons the chimneypiece may be the work of John Nost, who made the fine Baroque monument to James, second Duke of Queensberry (d.1709) at Durisdeer, nearby; the model for it is at Drumlanrig.

Elsewhere in Scotland there are fragments which purport to be by Gibbons. One was at Cullen House, Banffshire, from 1874 to 1976, when it was sold; I have not traced its present location. The panel was probably acquired at a sale in Hereford and may have come from Holme Lacy. It is headed by acanthus scrolls and with the usual array of fish, game, shell garlands, wheat, ribbons, flowers and pea-pods may be just one more competent piece were it not for the point-lace cravat, the music score, quill and the twin-lion hilt sword which is identical to that in the Cosimo panel in Florence and to work at Burghley House. It is one of the hazards of research into carved work by Gibbons that exact documentation always seems to be lacking to help in advancing our knowledge.

BLENHEIM PALACE, *Oxfordshire*

By the end of the seventeenth century fashions in interior decoration were changing. The great painted rooms with feigned colonnades (such as Antonio Verrio's 'Heaven Room' at Burghley House) were no longer in favour, and with Petworth and Chatsworth it was one of the last houses with a fine series of Baroque state rooms, richly decorated with carved wood. The turn of the eighteenth century and the reign of Queen Anne, when Gibbons was in his early fifties, has therefore produced little of his work to record. Amid the small commissions like 'a Cocks Head for ye Dutchesse of Marlborough's side Board' or 'a Snakes head for ye Basin at ye Queens Back Stairs', Gibbons must have been delighted when a major opportunity occurred: work for the Duke of Marlborough at Blenheim Palace, Oxfordshire.

Queen Anne, it will be recalled, had decided to reward the victorious Duke of Marlborough with the royal estate at Woodstock, as the site of a great mansion she would have built for him. It was perhaps to ensure that this promise was fulfilled that Sarah, Duchess of Marlborough managed, after a stormy personal campaign, to obtain the post of Treasurer to the Household for Francis, second Earl of Godolphin, who had married her daughter, Henrietta. In 1705 Lord Treasurer Godolphin 'at the request and desire of the said Duke of Marlborough' signed a warrant on 9 June appointing John Vanbrugh Surveyor of all the works and buildings which the duke had 'resolv'd to erect' at Woodstock, and authorising him to make and sign contracts 'for and on behalf of the said Duke'.

The long and complicated story of Blenheim's evolution has been told elsewhere.[22] In view of the Duke's absence on military campaigns, his subsequent illnesses and death twenty years before her own, much was left to Sarah, his Duchess. She was determined, as she wrote later of her house at Wimbledon,[23] 'to have no one thing carved . . . my taste having always been to have things plain and clean, from a piece of wainscot to a lady's face.' And yet Gibbons was to complete work at Blenheim in wood, stone and marble to the tune of £4,135 8s 7d, rendered in six bills between September 1708 and November 1712. Surprisingly, all but £298 10s 2d. (marble work £262, woodcarving £36 10s 2d) of this large amount, which exceeded his bills for St Paul's Cathedral by £557, was for working in stone.

The Duchess expressed almost daily disagreement over several years with everything about the great house. She disliked the schemes for the decoration of the entrance hall and saloon. Away in the distance of the park on the north side there was also the partly finished Grand Bridge which she had never accepted as necessary. During the great frost of January–April 1709, the Duke came away from his campaigns for a brief time to see the hard, white rearing expanses of his royal 'present' to which a trickle of Treasury money, always slow, had now almost ceased. Whilst work on the main house had proceeded

22. H. Avray Tipping and Christopher Hussey, *English Homes,* IV, pt. 2, *The work of Sir John Vanbrugh and his School 1699–1736,* 1928; David Green, *Blenheim Palace,* 1951; Kerry Downes, *Vanbrugh,* 1977; Geoffrey Beard, *The Work of John Vanbrugh,* 1986.

23. Gladys Scott Thomson, *The Letters of a Grandmother,* 1946, p. 23.

throughout 1709 and the first half of 1710, the craftsmen were becoming uneasy over extending credit after the Queen's dismissal of Lord Godolphin as Treasurer in August 1710. In October the Duchess Sarah had, perhaps wisely, stopped all work at Blenheim, with but £7,000 allowed for the work to be covered for the winter.

As the snow settled on the great pile in December the Duchess's final break with the Queen was now a painful fact for all to witness. Their friendship had lasted thirty years but in the final sad *débâcle*[24] the Duchess had angrily removed all the portable fittings from her apartments at St James's Palace, and the Queen had ordered the building to halt, saying 'that she would not build the duke a house when the Duchess was pulling her's to pieces'.[25] But even she found it difficult to halt the ponderous machine of the Treasury and payments for Blenheim trickled on for another few months until June 1712. Gibbons and his assistants were among the last to lay down their tools, and all of them might be able to take some payment from what came, but, as with the work, the arrears were left unheeded. The site was soon the quiet haven of the gardeners and the night-watchmen; the Duke, dismissed ignominiously by the Queen, was abroad in self-imposed exile and was soon joined there by his wife. Little was to happen again to Blenheim until the Queen was dead and the outstanding problems could be taken up again by the ever-complaining Duchess. This later history of the house however, fascinating as it is, is of no consequence to us in considering Gibbons's work. In more detail, what did he and his team do in exterior and interior enrichment between 1708 and 1712?

The erection of the main pile of Blenheim, owing something in conception to prototypes such as the château of Vaux-le-Vicomte, had been entrusted to the masons Edward Strong and his son. They always worked hard and efficiently, and the central block was up to the principal floor by May 1706. Gibbons and his assistants then dealt with the enrichment of thousands of yards of masonry. The coronetted finials on the four great towers (1709) are the most impressive (Pls. 60–61). They were charged as 'carv'd Pinacles, the Scrolls a flower De Luce revers'd and Corronett upon the Same, in all 30 ft. high, at £20 each'. It is a measure of the care taken with their silhouette that a series of model trophies, spheres, fleur-de-lys, 'globuler vauses' and other objects were hauled up into position 'for my lady Dutchesses approbation'. Not infrequently they were not accorded this. The Strongs had to pull down two 60 ft stretches on the south front in 1707 and change the architectural order from Doric to Corinthian. The whole silhouette was altered, incorporating eventually the corner lanterns but with an overall increase in height of nearly one third. Vanbrugh, tossing the idea about with Nicholas Hawksmoor and the craftsmen, rarely made a bolder move in amending an already impressive façade.

By November 1708 the imposing portico on the north front was also some 28 ft high and in its tympanum Gibbons carved the Duke's arms at a charge of £75. He, or someone in his team, had also carved, at £25 each, thirteen of an intended eighteen statues, 6 ft

24. David Green, *Sarah, Duchess of Marlborough*, 1967.

25. Edward Gregg, *Queen Anne*, 1980, p. 329.

6 ins high, nine for each of the two north front quadrants. Of this statuary (shown in Colen Campbell's engraving of the north front in his *Vitruvius Britannicus*[26]) only two examples now survive. In 1770 the fourth Duke, wanting to soften the 'rude' aspect of Vanbrugh's design of the East Gate, asked Sir William Chambers to have the statues moved from the top of the north court to two niches either side of the east entrance arch. The statuary which is now on the balustrade, level with the north pediment, was replaced by the ninth Duke of Marlborough in 1804, with terracotta statues obtained from France.

In 1709 the Duchess complained that Vanbrugh's rising building was blocking all her views. She wanted it stopped: 'till you give me an account how far it is designed to be carried up, for I apprehend it may help spoyle the View into the Parke as the Orange house has done already and I think nothing in a garden or Building can make amends for that.' Two piers opposite to her favourite west front bow window were, however, especially fine. At least 30 ft high, they were enriched with vermiculated carving in the form of 'frost-work' and topped with baskets of stone flowers, for which Gibbons had charged £8 each. They now form part of the Hensington Gate (Pl. 63) on the Woodstock to Oxford road. Such frost-work panels had also been designed by Gibbons for the western side of the Great Bridge.

Despite the Duchess's pleas, work continued. The Strongs hoisted Gibbons's lions and trophies into their high position in October and Gibbons's team saw the capitals on the south portico columns which they had carved also reared in that month. At each side of the north front steps Gibbons also provided, about 1710, two stone trophies. On one of them (Pl. 62) the helm has slumped from a higher position (it was shown in a better condition in Tipping and Hussey's 1928 book on Vanbrugh[27]). The emphasis is, however, still evident: the accoutrements of military activity are interpreted in a Roman manner.

Inside the house the Gibbons team was also active, but in a more limited way due to the gradual slowing down of work and its cessation altogether in the early autumn of 1712. In 1710 the team had enriched the capitals of the Corinthian capitals of Edward Strong's fluted columns in the Great Hall. With their furling acanthus they stretch towards the carved cornice, also by Gibbons's men. On 22 June 1712 Henry Joynes, the Duke and Duchess's Comptroller, told Samuel Travers, the surveyor-general for Blenheim, 'Mr Gibbons has eight men working Marble for ye Neeches in ye Salon etc'.[28] These had been carved (Pl. 64) to receive statues 10 ft high, cast in Florence at a cost of over £1,000 and delayed until the Duke sent part-payment for them. In the end they were not sent at all because of work at Blenheim coming to a halt, and the niches were to disappear beneath Louis Laguerre's paintings on the walls of the saloon, done in 1719–20.

The small amount of work Gibbons did in marble at Blenheim included the marble doorways in the saloon (Pl. 65), a chimneypiece in the Bow Window Room and one in the Duchess's bedchamber, and there is, in the same style, a 2 ft coronet and cartouche

26. Vol. I, 1715, Pls. 57–8.

27. Tipping and Hussey (Note 23 above), Pl. 114.

28. British Library, Add. MS., 19, 609.

over the undercroft chimneypiece, carved in freestone.[29] In wood there is even less; the frieze and Corinthian capitals in the Bow Window Room are all that survive, but as only £36-odd was charged for woodwork there was never, perhaps, much more than this. Carved woodwork may not have been planned as a decorative feature and the disruption of work from 1712–16 would not have helped if it was. When work did recommence Gibbons was almost seventy years old. He did nothing more to grace the great apartments to which the Duchess and her ailing husband moved in 1719, fourteen years after the laying of the first stone of the 'Nation's gift' to the Duke. Moreover he had been lucky to receive his money whilst it was in supply: the long-suffering Strongs in particular had to proceed at law in 1720 and the £12,229 they claimed was reduced after appeal in May 1721 to £9,044. They may have mentioned it all to Gibbons, but three months later he was dead. The long and troubled history of Blenheim's building had not occurred when Nahum Tate wrote in 1684 his 'To Mr Gibbons On His Incomparable Carved Works'. His last four lines do, however, summarise the artist's considerable achievements for all his patrons:

> What Muse, great Artist, can perform for thee
> That Right, which thou hast done to Majesty?
> From Europe thou long since the Palm hast won,
> But in this Piece thou hast thy self out-done.

CHAPTER III

'The Tombs of the Great'

*When I look upon the tombs of the great, every emotion
of envy dies in me ...* Joseph Addison,
Spectator, No. 66, 1712.

ALTHOUGH Gibbons was represented in his portrait by Sir Godfrey Kneller
(Pl. 2) as a sculptor, measuring a head based on Bernini's *Daphne* (from the
Apollo and Daphne, 1622–4, in the Galleria Borghese, Rome but reversed in
position), George Vertue thought him variously 'neither well skill'd or practis'd in Marble
or in Brass' and 'one of the best statuaryes' of the age. This apparent contradiction arises
not only from the many commissions which Gibbons was given but from the presence of
talented hands in his shop. We know that Gibbons spent some time in the late 1650s and
early 1660s in the Quellin workshops in Antwerp and Amsterdam. Artus Quellin I had
set up in Amsterdam in 1650 in anticipation of work on the Town Hall. He was to be
active there for fourteen years before returning to Antwerp.

Most of the carved work at the Town Hall is in marble (Pls. 49–50), although a good
studio was able to work stone, brass and bronze. It is assumed that Gibbons overlapped
for a year or two with young Arnold Quellin, who, born in 1653, was probably around
the studio from his early teens. There were excellent opportunities for the young Quellin
to profit from the elder Quellin's Baroque training. Nevertheless, when Arnold Quellin
came to England in 1678 at the age of twenty-five he may have been a little less skilled
than his contemporaries. His work provoked the comment:[1] 'although Arnold Quellin
appears a relatively good sculptor by English standards, his work is below the average then
being produced in Flanders, and he may have felt that competition would be less damaging
in England ...'. Quellin had married Frances Siberechts, the daughter of the Antwerp
painter, Jan Siberechts. Siberechts was in England some time after 1672 and might have
encouraged his son-in-law to join him.[2] However, the first mention of Quellin's presence
is in 1678.

A licence was granted in London in November 1678[3] for the stone-cutter John
Vanderstaine (or Van der Stein) to be employed under the architect Hugh May in the
King's service at Windsor Castle. He was to 'remaine here wth out molestation together
with John Oastes [John Nost] and Arnold Luellan [Quellin] his servants ...'. A few
months later the Privy Council allowed another permit, of 21 May 1679,[4] which gave
various painters and other artists employed 'in painting and adorning his Maties castle at

1. Margaret
Whinney, *Sculpture
in Britain, 1530–
1830*, revised edn,
1988, p. 119.

2. Rolf Loeber,
'Arnold Quellin's
and Grinling
Gibbons's
Monuments for
Anglo-Irish
Patrons', *Studies*,
Dublin, Vol. 72,
Spring 1983,
pp. 84–101.

3. Gunnis,
Dictionary, p. 407.

4. Noel Blakiston,
'Notes on British
Art, from Archives',
*Burlington
Magazine*, XCIX,
February 1957,
p. 57.

Windsor' the right 'to move freely in London and Westminster'. They included several in the service of Antonio Verrio, the accomplished decorative painter, as well as noting the presence of the aforesaid John Vanderstaine, Laurens Vandermuelen, Anthony Verhuke and Arnold Quellan (or Quellin). These last three were described as 'servants to Grinling Gibbons, the Carver'. To this list George Vertue added 'Dievot of Malines'.[5] There was the nucleus here of a talented workshop.

Secondly, the newly discovered Chancery document,[6] dated 25 October 1683, provides firm evidence of a 'coepartnership' between Gibbons and Arnold Quellin from some point in 1681 to May 1683. It might also be assumed, in view of Quellin's permit of May 1679, where he was in Gibbons's service, that he was active in matters to their joint interest for some time before the formal articles of partnership. It is therefore difficult to determine how independent Quellin was and whether work credited to him alone – for example the Thomas Thynne monument in Westminster Abbey – was really on behalf of Gibbons and himself.

The partnership document (Pl. 66) records that Gibbons, called the 'Orator', had, in the '. . . two and Thirtieth yeare of his now Maties Raigne [1681] entered into Certaine Articles of Coepartnership with Arnold Quellyn of the parish of St. Martin in the fields in the County of Middlesex . . . for the undertaking & p'forming of all sort of Carvers worke in Stone, joyntly to be undertaken between them . . .'. The cost of acquiring marble, Portland stone and other materials was to be shared equally and money or loss, received or borne, likewise divided. Each partner would be allowed seven shillings a day 'for every day they or either of them should work in the said undertakeing'. The partnership continued to 'in or about the moneth of May last' (May 1683), and at the previous settlement of their accounts, on 22 December 1682, the partnership was due about £250. After this date Gibbons laid out £220 for marble, stone and other necessary items. Quellin had advanced 'very little' and, 'severall controversies & differences' occurring between the partners, Gibbons 'was enforced to beare allmost the whole charge thereof'.

It seemed, to Gibbons at least, time for a 'determination'. The articles of partnership were cancelled in May 1683 and materials and stock divided into two lots. The one amounted to £10 3s. 6d. more than the other, and it was agreed that 'he to whose share the said loss should fall should pay the other' that amount. It was further agreed that Gibbons should be paid and reimbursed the money advanced by him 'for worke then done and undertaken & in hand', and that Quellin 'should finesh the worke then undertaken & in hand upon accot of the said coepartnership'. The text continues its indictment of the devious Quellin, who, having got the

said loss or share in his possession and being well acquainted with the persons who were indebted of the said coepartnership, and neglecting the fineshing the said worke which he hath taken upon him, he

doth not onely refuse to pay your Orat[r] the said Ten pounds three shillings & sixpence, but hath allso received several great sumes of the said debts & doth detaine the same & convert the same to his owne use, p'tending that he hath allso disbursed & advanced money in the said coepartnership, & by neglecting the p'formance & fineshing the said worke so as aforesaid undertaken hath caused the same to be refused & turned back upon your Orat[r]'s hands to his very great loss, & doth conceale from your Orat[r] at what rates & prices he undertooke severall p'cells of worke since the last adjusting the said accots, & sending to yor Orat[r] much lesse & lower rates then in trueth he hath or is to receive . . . contrary to Equity and good Conscience . . .

Unfortunately, the suit does not seem to have run its normal course of a 'pleading' – the document quoted – the 'deposition' or evidence taken from witnesses, and a final 'decree and order'. Despite a careful search there seems no record of the case proceeding. The argument between the partners would seem a sufficient cause to terminate any later association, but both Gibbons and Quellin did work in the mid-1680s on the Catholic chapel in Whitehall for King James II. However, Quellin's death in September 1686[7] brought an end to whatever disagreement had remained.

7. PRO, Prob.11/384, 3 September 1686.

The year in which a monument was erected is often difficult to determine, as a long period could elapse after the date of death, due to the tardy actions of executors and the amount of work in hand by busy sculptors. It seems sensible first to describe those monuments and statues on which it is assumed Quellin was the partnership's executant. In the case of an Anglo-Irish series there is fortunately some documentation[8] and it is also known that Quellin provided four statues of the Stuart kings (James I, Charles I, Charles II, James II) and a bust of the Earl of Strathmore and Kinghorne to be set up in 1686 at Glamis Castle.[9] Two of the statues (*James I* and *Charles I*) and the bust are still there: the agreement was witnessed by Quellin's father-in-law, Jan (or 'John' as he signs himself) Siberechts.

8. Loeber, *op. cit.* (Note 2 above).

9. M. R. Apted, 'Arnold Quellin's Statues at Glamis Castle', *Antiquaries Journal*, LXIV, Pt. 1, 1984, pp. 53–61.

I have given each monument a consecutive number to aid cross-references.

1. The Burgoyne Monument, All Saints, Sutton, Bedfordshire, c.1679

On 16 September 1677 Sir Roger Burgoyne died at Sutton in Bedfordshire at the age of fifty-nine. He was the second baronet of his line, the son of John Burgoyne; one of their family homes was the late Elizabethan house of Spains Hall, near Finchingfield, Essex. He married twice and it was his second wife, Ann Robinson of Deighton, a few miles south-east of York, who entered into negotiations to raise the monument. She and Roger must have been friends of the Verney family, for in Frances Parthenope Verney's *Memoirs of the Verney Family*[10] it is recorded:

10. Second edn, 1904, p. 324.

The last office of friendship which Sir Ralph [Verney] can perform for Sir Roger [Burgoyne] is to design the monument which the widow wishes to put over the family pew in Sutton Church. He gives the maker his most careful attention, and entrusts the work to Grinling Gibbons, whose signature and seal are appended to the specification. Sir Peter Lely, Kt., and Hugh May, Esquire, are to decide, when the monument is complete, whether 100 L. or 120 L. should be paid for it, but the payment is not in any case to exceed the latter sum, 'the overvalue being for the credit of the said Greenlin Gibbons at his own offer' – which sounds more like the deed of a generous artist than of a man of business.

When David Green wrote his *Grinling Gibbons* in 1964 it had not proved possible for Sir Harry Verney and himself to trace the specification referred to in 1904. Documents had been extracted for the book and not refiled. Careful cataloguing of the Verney papers is now underway. There is hope that the contract will reappear, but it had not done so by the time this book was committed to press.

The monument is on the east wall of the north aisle of All Saints, Sutton, with a window at the left, which it partly overlaps. A heavily gadrooned marble sarcophagus, surmounted by a gadrooned urn in a niche and two awkwardly placed winged *putti*, it set a style which, with variations, was followed in many successive monuments. Admittedly the urn was often improved with wreathing flames and there was a growing concern for the overall style. The Burgoyne monument, however (Pl. 67), still has a somewhat clumsy appearance. The long Latin inscription is not centred on the rectangular tablet and is therefore squeezed at the right margin. Furthermore, the coat of arms, now much faded in its fruit- and palm-circled cartouche at the base, seems an afterthought. The dominant features are in the upper part, forming an inverted pyramid of no great grace. Could it be that this first job of about 1679 (at the moment we know of no earlier monument by Gibbons) indicates by its shortcomings how much Gibbons needed the skills of Arnold Quellin, who entered his service in that year? It is also, I think, significant in view of such an increase in work that Gibbons took on his fourth apprentice, Henry Summers, in 1679. Summers is recorded receiving money on behalf of his master in August 1686 for the carving of the altarpiece at the London City church of St Mary Abchurch.[11]

11. Guildhall Library, London, MS. 3295.

2–4. *The Perceval and Southwell Monuments*

In the past thirty years there have only been two advances in ascribing monuments to Gibbons by the discovery of documentation. Dr J. Douglas Stewart wrote up three monuments in 1963, referred to below (Nos. 5, 27, 35), and in 1983 Dr Rolf Loeber described a series of monuments for Anglo-Irish patrons in an excellent article.[12] From about 1680, Sir John Perceval, third baronet, entered into negotiations with Gibbons and Quellin for several monuments to his family. His father, Sir John Perceval, the first baronet, had died fifteen years previously in 1665 and was to be commemorated by a monument

12. Loeber, *op. cit.* (Note 2 above).

in St Audoen's Church, Dublin. This does not seem to have been erected. John's elder brother Philip, the second baronet, had died in suspicious circumstances in September 1680. John therefore corresponded with his uncle, Sir Robert Southwell, about a monument for Philip, which was erected in 1683, at Burton, Co. Cork, in southern Ireland. It was apparently destroyed in the 'troubles of the Williamite War', but is known from a drawing of 1742. Sir Philip and Sir John's other brother, Robert Perceval, had been murdered in the Strand in 1677 and was buried in the chapel of Lincoln's Inn. Sir John corresponded with Arnold Quellin in February 1682, but presumably because of the disagreement with Gibbons (revealed by the Chancery suit), Sir John changed his mind on a monument. Instead he erected a plain piece of marble over the grave: this is unfortunately no longer extant. Another monument (No. 2) was planned to John's maternal grandfather, Robert Southwell (d.1677), and his wife Helena Gore, who with their son Robert (later Sir Robert), survived him. This was erected at St Multose Church, Kinsale, Co. Cork. Finally, his mother Catherine, who had died in 1679, was also commemorated in a monument (No. 3). This was likewise erected in St Multose Church in 1680, but negotiations about the inscription were still going on well into 1682.

The upper stage of the monument to Robert and Helena Southwell at Kinsale (Pl. 75) bears a superficial resemblance to the Burgoyne monument (No. 1): that is, both a gadrooned sarcophagus and a gadrooned urn, but with a more sensitively placed coat of arms above the horizontal tablet. The monument to Dame Catherine Southwell also has a coat of arms in a cartouche in the upper stage, surrounded by carved fruit, foliage and a *putto* head. The two skulls belong, however, to the 'curved indentures of the lower corners'.

Sir John's uncle, Sir Robert Southwell, was born near Kinsale in 1635 and after being educated at Queen's College, Oxford, and at Lincoln's Inn, travelled abroad. In 1664 he married Elizabeth Dering of Surrenden in Kent and by her had six children. In political terms he had a distinguished career as a clerk of the Privy Council, envoy to Portugal, in Flanders and in Berlin, and finally as Secretary of State for Ireland, appointed by William III. He died at King's Weston near Bristol in September 1702 in his sixty-sixth year. This led David Green to assume that his monument (No. 4) at Henbury Church, Bristol, dates from about that year. The story is a little more involved.

Lady Elizabeth Southwell, Robert's wife, had died in 1684 and her husband considered setting up a monument to her at Henbury Church near their King's Weston estate. It is known that this monument was designed by the engineer Sir Henry Sheers (d.1710) and that its execution was to be by Grinling Gibbons. A volume entitled *Sir John Vanbrugh's designs for King's Weston,*[13] which is in the care of the Trustees of the Bristol Municipal Charities, includes a drawing (No. 72) of the Henbury monument which bears the inscription: 'The Monument was designed by Sir Henry Sheers, and wrought by Mr.

13. See Kerry Downes, ed., 'The King's Weston book of drawings', *Architectural History*, 10, 1967, p. 25, fig. 49.

Gibbons'. The cost of the monument, its marble workmanship, carriage and erection, was £62. 18s. according to a further inscription on the drawing, with 'a Guinea to the Workman that went downe with it to Henbury'. If the monument was really to Elizabeth's memory the inscription hardly mentions her and could not have been cut until after Sir Robert's own death. Its plain form implies it is by Gibbons, after Quellin had left him, or had died (1686), and that for some reason it was used years later as Robert's memorial. Whilst the gadrooning and *putti* heads are there, they are part of an awkward, somewhat gauche, monument, which belies Sir Robert's important position in life. It is a good case of the levelling of reputations; by death in the one case, and by Gibbons coming to terms with a less skilled workshop in the other.

5. *The Ferrers Monument, St Editha, Tamworth, Staffordshire, c.1681*

This is one of the most important monuments to be fashioned in the Gibbons–Quellin partnership and shows the younger Flemish sculptor at his best. The basic shape of tablet, high gadrooned sarcophagus, coat of arms and flaming urn are certainly there (Pl. 68), but the whole is given a strong rectangular base (with a carved panel), and above it are two dramatic kneeling figures (Pls. 69–70). David Green dated this monument to 'about 1690', but it must be some years earlier than that, *c.*1681. It commemorates John Ferrers (d.1680) and his son Sir Humphrey, who was drowned crossing the River Trent in 1678. Quellin shows them in Roman dress and wigs, stanced dramatically with pointing gestures. Forty years ago the monument was thought to be from the hand of Samuel Watson, the Chatsworth house carver, on the basis of a drawing by him.[14] Watson, however, drew anything which interested him, and the involvement of the Gibbons–Quellin partnership was established in 1963 when Dr J. Douglas Stewart recorded the text of a letter to Gibbons, dated 5 October 1698, from Theophilus, seventh Earl of Huntingdon,[15] relating to his own monument in St Helen's Church, Ashby-de-la-Zouch (No. 35). In the letter Huntingdon mentions three more works: 'I like not your painting of the arms on Sir Humphrey Ferrers at Tamworth, Mr Poole at Radborn nor the Duchess of Somerset at Westminster, which were all your work.' I note the latter two monuments below (Nos. 7, 27) but the Ferrers monument is our present concern. Green suggested[16] that Gibbons did the design and worked on the upper stages with ever-active *putti* disporting amid the stone fruit swags – the supporters to the coat of arms are also very spirited – and that Watson executed the trophy relief on the plinth in view of its similarity to his trophies in the inner court at Chatsworth,[17] and Arnold Quellin carved the crouching figures of father and son. My own view is that Quellin took over the conduct of the monument, giving it the *bravura* it possesses, and that Watson's involvement is unlikely. It is tempting to speculate that the monument, which in its upper stages and tablet is of unexceptional

14. Rupert Gunnis, 'A Derbyshire Sculptor', *Country Life*, 9 February 1951.

15. J. Douglas Stewart, 'Some Unrecorded Gibbons Monuments', *Burlington Magazine*, CV, March 1963, pp. 125–6.

16. Green, *Gibbons*, p. 157.

17. Francis Thompson, *A History of Chatsworth*, 1949, Pl. 94.

design, had a plinth, figures and livelier coat of arms added when construction was under way. But this short account needs to eschew speculation and unfortunately the various groups of Ferrers family papers[18] do not throw any light on the subject. Comparison should however be made here with the Rustat monument (No. 21), especially the identical poses of the two *putti*, based on two in Rome on a tomb by François Duquesnoy, under whom Quellin's father had studied. There are also similar *putti* on the monument to the Oxinden family at Wingham, Kent, of 1682 which has been attributed to Quellin, who was, as we now know, firmly in partnership with Gibbons that year.

6. *Sir Richard Browne, St Nicholas, Deptford Green, 1683*

The year 1683 was a busy one for the Gibbons–Quellin partnership, with several monuments in hand. One was to John Evelyn's father-in-law, Sir Richard Browne, in the church of St Nicholas, Deptford Green. John Evelyn wrote to Gibbons on 23 March 1683,[19] suggesting that they should talk about the memorial. The resulting drawing survives,[20] showing that a small tablet with a painted coat of arms, surmounted by an urn and festoons of flowers, was proposed. Unfortunately enemy action in the Second World War almost completely destroyed the church: in its 1958 rebuilding, fragments of the monument were re-erected.

7. *German and Anne Pole, Radbourne, Derbyshire, 1683/4*

Much more involved was the large monument at Radbourne, Derbyshire, to German and Anne Pole. The measured language of the surviving agreement, made in 1683,[21] records that there was to be no effigy but:

a Tombe and an urne on the Tombe and two Cherabims heads graspinge a scutcheon, two Cherabims bearinge a Coate of Armes, with a Mantel and Crest, on each Pedestall two urnes with Cherabims heads and drapery with the inscriptions. On the cornishes two shields adorned with flowers, with severall mouldings and enrichments as appears by a Moddell made and approved by the abovesaid Madam Anne Pole and the said John Musters Esq ...

On the plinth there were to be carvings of 'a 'Snake and Palms' and 'betwixt the two Pedestalls an houre glasse with other Ornements about it'. Gibbons signed a receipt for £300 on 22 September 1684.

As one steps into the little church in the park at Radbourne it is this Pole monument which dominates the north-east aisle. Above the plinth is the double pile of gadrooned sarcophagi, a great rearing urn with writhing flame and the two fat *putti* holding the coat of arms and helm aloft (Pl. 77). As the flanking inscriptions show, German Pole died on

18. The various Ferrers papers at the Warwickshire and Leicestershire Record Offices, the Shakespeare's Birthplace Trust, Stratford-on-Avon, and the William Salt Library, Stafford, have yielded no details of the monument.

19. Letter, Christ Church, Oxford.

20. Drawing, Deptford Central Library.

21. Archives, Major J. W. Chandos-Pole, Radbourne Hall, Derbyshire, but not accessible to me in 1988. The text of a letter from Samuel Pole referred to is cited in *Derbyshire Archaeological and Natural History Society*, NS XXIV, p. 81.

2 March 1683, and his wife Anne on 14 November 1700. There is visual evidence that the date of her death was inserted at a later date, for the surviving correspondence shows that Charles Coke wrote to his uncle, Samuel Pole, on 21 February 1684: 'This afternoone I was with Mr. Gibbons, who desires that asoone as the roads are passable for waggons, some may be appointed for the bringing of the monument down.'

There is reason to assume that Quellin (and perhaps the foreman John Nost) was involved to a degree with the Pole monument. The *putti* are in Quellin's lively style, but the date of erection is certainly after his break-up with Gibbons. One wonders how much of a separate practice he had? Should it be assumed that the one monument credited to him, that of Thomas Thynne in Westminster Abbey (Pl. 72), was done really for the partnership? 'Tom o' Ten Thousand' as he was called, on account of his reputed annual income, was murdered in his coach in February 1682 on the orders of the jealous Count Charles John Königsmark, who desired Thynne's wife, Lady Elizabeth Percy. This event took place in Pall Mall and is illustrated, graphically, on the carved plinth of the monument. The text of the intended inscription recording the facts was objected to by Thomas Sprat, then Dean of Westminster, but some of the original wording is in the Thynne papers.[22]

Some confusion in a previous account of Quellin's career[23] has led to the assumption that he was author of the monument raised by the Thynne family at Great Bedwyn, Wiltshire, to Frances, Duchess of Somerset, widow of the first Duke, who had died in April 1674. This would seem to be unlikely as the main Thynne–Somerset connection did not occur until May 1682 when the sixth 'Proud' Duke of Somerset took Tom o' Ten Thousand's widow, the sixteen-year-old Elizabeth Percy, as his wife. What is certain is that the Thynne archives contain a letter from Quellin of 8 October 1685 to the builder of Longleat, Sir John Thynne (d.1580), and an account book entry of 28 October 1685,[24] both referring to a monument at Longbridge Deverill, Wiltshire. The white marble tablet in the Bath chapel is embellished with drapery and two cherubs' heads. The suggestion (by Christopher Hussey in 1949), that Quellin provided the four roof-top statues on the south front at Longleat seems likely. They commemorate an unlikely quartet – Boadicea, Alexander, Zenobia and Henry V. Quellin's authorship is supported by mention of the statues (but without ascription) by his patron, the first Viscount Weymouth, and by the fact that he provided similar statues in 1686 to decorate the exterior of Glamis Castle.[25] He also wrote to the first Viscount in October 1685 about the Longbridge Deverill tablet indicating that the man who 'Doth all my Business in ye Cuntry' was being sent to set it up. This was presumably either Arnold Quellin or John Nost, the man who had worked with Quellin at Windsor and was there described as 'John Oastes', servant to John Vanderstaine.[26] Nothing is known of John Nost's training or even the date of his birth at Malines. It would, however, be reasonable to assume he was in the Gibbons–Quellin shop for five or six years. He was not slow in 1686, at Quellin's death, to marry the widow,

22. Longleat House, Wiltshire, Thynne Papers, Book 179B, f. 20 recto, and Book 185, p. 31. Two printed copies of the trial survive (Longleat Library). Thynne was reported to have been dallying with the sister of Lord Trevor but instead secretly married the young Duchess of Somerset (Thynne Papers, XXVII, f. 172). The Dean objected to the inscription text, variously described as by Dryden or Mark Arundel, because of some words in it which he thought reflected on King Charles II. The executor, Mr Hall of Bradford, therefore chose to have 'no Inscription at all'.

23. Gunnis, *Dictionary*, p. 313.

24. Thynne Papers, *op. cit.*, XXII, f. 247, letter from Quellin to the first Viscount Weymouth; account book, *ibid.*, Book 176, p. 78, entry of payment made, 28 October 1685.

25. *Ibid.*, Book 179B, f. 20 verso; see also Christopher Hussey, *Country Life*, 15 April 1949, p. 866 and Apted, *op. cit.* (Note 9 above), p. 60, fn. 3.

26. Blakiston, *op. cit.* (Note 4 above), p. 57.

the daughter of John Siberechts, the topographical painter. He had then to clear up the outstanding work left by his erratic but talented master and build up his own business. The first dated monument known in his own name is that of 1692 to Sir Hugh Windham, at Silton, Dorset.[27]

27. Geoffrey Beard, *Country Life*, 9 May 1952, p. 1408.

8. *Archbishop Richard Sterne, York Minster, 1683/4*

In the north choir aisle of York Minster is the imposing monument to Archbishop Sterne, who died in 1683, and was grandfather of the writer Lawrence Sterne. The monument was only moved to its present position some forty years ago, being then reassembled, re-erected and restored as it had been originally designed. In 1976 Dr J. Douglas Stewart published the text of a letter[28] from Gibbons, dated 10 July 1684, to John Etty in York. He wrote: 'I received You'ers and Mr Stavnes today and I toeld him that was to pay the Carvigs and thar fore I wold not medell with the bargine. I hartely beg You'er pardon for not writing to You in dead my busnes is so great … my man will be in Yorck I hoep in 5 or 6 daes for I hoep he has don in darby.' The letter shows that Gibbons kept in touch with John Etty senior and gives support to his having known him when he first arrived in York from Holland. Secondly 'Mr Stavnes' (or 'Starnes') is likely to be a reference to Richard Sterne, Archbishop of York from 1663 until his death. The monument (Pl. 79) is assured, and is surely from Quellin's hand? The reclining figure in robes and mitre rests on the left arm, is flanked by two delightfully stanced *putti*, and is beneath a draped canopy with semi-circular head with another imposed mitre above a spritely cartouche. Admittedly we know nothing of the 'man' at Derby, working on the Pole monument (No. 6) and going on to York. Again, it is assumed that Gibbons meant John Nost.

28. J. Douglas Stewart, 'New Light on the Early Career of Grinling Gibbons', *Burlington Magazine*, CLXVIII, July 1976, pp. 508–9.

9–17. *Statues of Charles II and James II by Gibbons and Quellin*

The most important statue from the beginning of Gibbons's association with Quellin in 1679 is the equestrian *Charles II* in the Brick Court at Windsor Castle (No. 9), but their exact involvement is unclear. It was stated by Sir Christopher Wren in a letter of 3 December 1681[29] that the horse was first cut in wood 'by a German', presumably Gibbons, 'and cast by one Ibeck, a founder in London …' Gibbons's bill of 1678–80 charges for: 'Carving & Cutting ye white IIIIr Marble pannells of ye Pedistall of his Ma Statue on horse backe 400l … and for cutting & carving ye Mouldinges & ornaments for ye pedistall of ye large Diall in ye North Terrace' (Pls. 17–19).

29. *Wren Society*, V, p. 52, Pls. 42–3.

The horse itself is signed on the hoof 'Josias Ibach Stadti Blarensis 1679 fudit' and there seems no reason to assume Gibbons had much to do with the figures of the King or the horse. Evelyn does not mention his involvement. It has been suggested that 'Ibach'

30. W. H. St John Hope, *Windsor Castle*, 1913, I, pp. 318–20; II, p. 555; Thompson, *op. cit.* (Note 17 above), pp. 36, 124, 204.

31. K. A. Esdaile, 'Arnold Quellin's Charles II', *Architectural Review*, CII, 1947, p. 174.

32. Nahum Tate, *Poems written on Several Occasions*, 2nd edn, 1684.

33. British Library, MS., 11641, h. 10(3).

34. Noted there as surviving 'battered and mutilated, inside the Royal Exchange' by K. A. Esdaile in *The Architect*, 30 September 1921; regarded as 'destroyed' by Whinney, *op. cit.* (Note 1 above), p. 119.

35. Vertue, *Notebooks*, IV, p. 35.

36. Christopher Morris, ed., *The Illustrated Journeys of Celia Fiennes, c.1682–1712*, 1984, p. 223.

37. British Library, Crace Collection, Portfolio 22, Sheet 9B.

38. Guildhall Library, London.

39. Everyman edn, eds. G. D. H. Cole and D. C. Browning, 1962, I, p. 351.

or 'Jback' may be identical with the coppersmith who worked with Jean Tijou at Chatsworth.[30] He was obviously a proficient craftsman.

We do not know the terms of the partnership which Gibbons had with Quellin, and how much freedom the latter had to do his own commissions. The standing figure of Sir John Cutler (Pl. 71) at Grocers' Hall in any case could have been fashioned before the formal agreement, for Quellin was paid £83 for it in 1681/2. However, the badly weathered statues of Charles II, and again Sir John Cutler, from the College of Physicians (now Guildhall Museum, London) were made in 1683 at a cost of £80. There is perhaps more interest in considering other royal statues. There is an excellent terracotta model (Pl. 82) by Quellin of *Charles II* (No. 10), now in Sir John Soane's Museum, London.[31] There is little doubt that the King's popularity brought much work for likenesses of this kind to Gibbons and his partner. The model, dressed in Garter robes, was the first stage of a statue intended to be set up in the Royal Exchange in 1684 at the expense of the Worshipful Company of Grocers. The statue was described twice in poems of 1684: first in Nahum Tate's 'To Mr Gibbons On His Incomparable Carved Works',[32] and within an anonymously written 'A Poem Upon the New Marble Statue of His Present Majesty, Erected in the Royal Exchange by the Society of Merchant Adventurers of England'.[33] The statue (No. 11) survived the fire of 1838 which destroyed the Exchange, but is in a sad and mutilated condition.[34] However, it is 'in the habit of a Roman Emperor with a Laurel about his Head' which supports the fact that Quellin made two statues, one for the Grocers' Company and one for the Merchant Adventurers.

The story is further complicated by the fact that Vertue records[35] that the King granted Gibbons 'a patent or prohibition ... that no one shoud presume to coppy the statue of King Charles in the middle of the Royal Exchange, not in print without especial leave from Mr Gibbons' and Vertue continues: 'This statue of the King tho' under took by Mr Gibbons was actually the work of Quellin.' It was executed in marble. The indefatigable traveller Celia Fiennes noted[36] that 'on the top of the piaza's' of the Royal Exchange 'are the effigies in stone of most of our Kings and Queens since the Conquest ... In the midst of it stands in stone work on a pedestal the effigies [*sic*] of King Charles the Second railed in with iron spikes.'

The pedestal for the *Charles II* statue is shown in its original central position within the Royal Exchange in a number of drawings, for example in a watercolour,[37] and in an engraving[38] by Vanderbank which shows two of the reliefs. Daniel Defoe, in his *A Tour through the Whole Island of Great Britain*, 1724–6, wrote:[39] 'The statue of King Charles II, in marble, standing in the middle of the Royal Exchange, is the best beyond comparison ...'. For his part Quellin, apart from the *Charles II*, had provided statues of four of the earlier Kings, to which Celia Fiennes referred (Nos. 12–15; now Guildhall Museum, London). These were of Henry VI, Edward IV, Edward V and Henry VII, made to the

orders of four of the City's livery companies, respectively the Armourers, Ironmongers, Leathersellers and Tallow Chandlers.[40] They were placed in niches around the piazza.

Much more accessible are two bronze statues from the Gibbons studio, the *James II* (No. 16), now (on a modern base) on the north side of Trafalgar Square, in front of the National Gallery (Pls. 83–4), and the *Charles II* (No. 17) at Chelsea Hospital (Pl. 81). I have made previous reference to Vertue's[41] comment that Gibbons 'was neither well skill'd or practis'd in Marble or in Brass, for which works he imployd the best Artists he could procure'. Vertue noted two of them as Laurens Vandermuelen of Brussels and Dievot of Malines.[42] It is also not uninteresting that John Nost came from Malines and they all had perhaps intended to work together after their start for the King at Windsor. One of Vertue's many informants, Mr Snooke, told him[43] that 'the Statue of Brass, standing in Privy Garden against the banqueting house Whitehall, of King James 2d, was modelled and made by Laurens (of Brussels) and Devoot (of Mechlin), who was imployed by Gibbons, carver to the King. These men are still living at Antwerp.'

Sir John Bramston (1611–1700), an active lawyer, recorded that the *James II* was set up in the Pebble Court of Whitehall Palace on 1 January 1687.[44] Tobias Rustat, Yeoman of the Robes, had signed the agreement 'for a Statue of King James the Second to be made by Mr Grinling Gibbons for the sum of three hundred pounds'. One half of the money was to be paid over on the date of agreement and £50 more at the end of three months. The final £100 was to be paid when the statue was finished and erected. Gibbons's receipt for the first payment of £150 is appended, and he took another £50 on 11 August 1687.

It is, however, necessary to bear in mind Vertue's statement that the *James II* was cast by Thomas Bennier (or Besnier). This is supported by the inscription 'Thomas Beneir made this statue' on a drawing by William Stukeley dated 1722, which was sold in 1963. Finally, the story is complicated by five drawings in the British Museum which seem to be studies for the Chelsea *Charles II* and the *James II* and perhaps the Royal Exchange figure.[45] They may be drawings by Gibbons but this is not certain. The connection with Rustat is interesting because he had also commissioned the equestrian *Charles II* at Windsor (dated 1679), and may have paid for the standing figure of the King at Chelsea Hospital. I make reference below to the authorship of Rustat's own monument in the chapel of Jesus College, Cambridge (No. 21).

At Chelsea Hospital is the standing *Charles II* (Pl. 81) which Vertue noted as 'a Brass Statue of King Charles 2d in the antique Roman dress, bigger than the life standing upon a marble Pedestal, raild round with Iron given by Mr Tobias Rustat and cost 500 ll'. The *Wren Society* editors[46] dated the statue, which was originally gilded, to 1676, but this is too early: it is probably nearer to the date of the founding of the hospital by the King in 1682. As well as the statue, Rustat gave £1,000 to the foundation fund.

40. K. A. Esdaile and M. Toynbee, 'More Light on English Quellin', *Trans., London and Middlesex Arch., Soc.,* XIX, pt. 1, 1956, p. 34.

41. Vertue, *Notebooks,* V, p. 59.

42. *Ibid.,* I, pp. 61, 106; IV, p. 50.

43. *Ibid.,* I, p. 61; see also Tipping, *Gibbons,* pp. 95–6.

44. Bramston, *Autobiography,* Camden Society, 1845, p. 253.

45. The contract is PRO, AO1/2478, f. 271. Vertue's statement about Bennier is in *Notebooks* I, p. 89. The Stukeley drawing was sold Sotheby's, 19 February 1963, lot 412. For the British Museum drawings, see E. Croft-Murray and P. Hulton, *British Museum, Catalogue of British Drawings,* I (1960), pp. 333–6, II, pp. 135–6.

46. *Wren Society,* XIX, p. 80.

It is interesting to compare the two standing figures, both crowned with laurels and in Roman armour, with a cloak thrown over the left shoulder and a baton in the right hand. The baton of the *James II* was replaced in the eighteenth century. It is undoubtedly still the best classical statue in London, poised so that the figure looks down at the baton to give a good line. The *Charles II* moves forward with the head turned to the left. Both probably owe something in style to the large statue of Louis XIV, now in the Orangerie at Versailles, and made between 1679 and 1683 by Martin van den Bogaert, known as Desjardins, a Dutchman trained in Antwerp. 'It is so close in type to the Stuart figures that the resemblance can hardly be accidental, though whether the knowledge of the French statue came through Charles II or through the sculptors themselves cannot be decided.'[47] The statue of Charles II is still decked with oak leaves by the Chelsea pensioners once a year.

47. Whinney, *op. cit.* (Note 1 above), p. 119.

18–19. *The Seventh and Eighth Earls of Rutland, Bottesford, Leicestershire, 1684–6*

The church of St Mary the Virgin at Bottesford is rich in monuments, particularly those which commemorate the burial of eight Earls and four Dukes of Rutland over a period of some 250 years.

Situated between the tomb of the sixth Earl of Rutland and his two Countesses, Frances and Cecilia (known as the 'Witchcraft Tomb' because of the inscription on it recording that the two sons born to Cecilia had died in their infancy by 'wicked practice and sorcerye') and the priest's door on the south side of the chancel, is the white marble figure of George, seventh Earl of Rutland who had died in 1641. But there is a difference between this and the three effigies on the Witchcraft Tomb for it was done by Grinling Gibbons, and perhaps with Arnold Quellin, in 1684.

On the north side of the chancel is the monument to John, eighth Earl of Rutland and his Countess, Frances, daughter of Edward, first Baron Montagu of Boughton. The eighth Earl died on 29 September 1679 and was buried at Bottesford almost a month later, on 24 October. These two monuments span the year when the Gibbons–Quellin partnership was breaking up. Both could have been sculpted by Quellin, but that of the eighth Earl and his Countess is less accomplished and may be from the Gibbons shop, thrown into some confusion by Quellin's sudden departure. Before discussing the monuments, two interesting family connections with further monuments by Gibbons should be noted.

The eighth Earl of Rutland's wife, Frances (d.1671) was the daughter of Sir Thomas Cotton (d.1662) of Conington in Huntingdon. Gibbons's signed monument (No. 32) to Robert Cotton (d.1697) at St Mary's Church, Conington, Cambridgeshire, is noted below. There are also two monuments at All Saints' Church, Conington, Huntingdon,

to Sir John Cotton and his wife, both of whom died in 1702, which are very similar to the Robert Cotton monument.

Secondly, John Manners, who succeeded as ninth Earl of Rutland at his father's death in 1679 (he did not become first Duke until 1703), had married in January 1674 for the third time. His wife, Katherine, was a daughter of Baptist Noel, third Viscount Campden by his fourth wife, Elizabeth.[48] The marriage ceremony of John and Katherine was celebrated in Exton Church, Rutland. Twelve years later, in 1686, Katherine's father (who had died on 29 October 1682)[49] was commemorated by the erection in the same church of a fine monument (No. 20) by Gibbons. It would therefore be natural enough for Katherine to suggest to her husband that instead of using Caius Gabriel Cibber to fashion his father's tomb, as he had decided,[50] they should use Gibbons, whom her brother had decided on for the tomb to their much-married father. Elizabeth, the Viscount's fourth wife, a daughter of the second Earl of Lindsey, 'in her lifetime gave monyes and left orders for ye erecting this Monument', as the inscription on the monument at Exton states. She only outlived her husband by eight months, dying on about 20 July 1683, and her son acted as executor to her will which gave the means to give action to her words.

One question which must be posed, even if there is no satisfactory answer, is whether Quellin played any part in the creation of the three monuments, the two at Bottesford and the one in Exton. His partnership with Gibbons had ended in the Chancery Court in October 1683, but there is a strong possibility of reconciliation with Gibbons; the suit, after all, does not seem to have proceeded. The monuments of the 1684 to 1686 period are very uneven in quality, however, and there must have been disruption, as the surviving team sought to limit the damage. Work lay incomplete, paid for and not even done, and with little hope of recompense for Gibbons for the cost of materials or the return of misplaced fees. Disarray in his workshop is borne out by the fact that in 1684 he took (through the Clothworkers' Company) two new apprentices, John Byng from Wiltshire on 25 February, and Valentine Tomon from Switzerland on 28 May. Perhaps the young Continental lad led them, bravely, to the stance of the figure on the seventh Earl of Rutland's monument?

The monument to George, seventh Earl of Rutland at Bottesford (No. 18), shows him as a moustached and bearded figure in Roman dress. The right hand is expressively raised (Pls. 85–6); the whole stance is Baroque and almost Italian but, as Pevsner puts it, the gesture is 'operatic' and the figure 'lacks ease'.[51]

The second Gibbons monument (No. 19), to the eighth Earl and his wife Frances Cotton (Pls. 87–8), is on the north side of the chancel, next to the vestry door, and facing on to the central alabaster tomb to the first Earl (d. 1543) and his Countess, Eleanor Paston. It is not a very satisfying work: the figure of the moustached eighth Earl stands to the left of the great urn of Death, which is gadrooned and almost reaches to the

48. The ninth Earl of Rutland was son-in-law of the third Viscount Campden, not 'brother-in-law' as stated by M. Whinney and O. Millar, *English Art 1625–1714*, 1957, p. 248, fn. 1, repeated by Green, *Gibbons*, p. 157.

49. Not 1671 as in Whinney, *op. cit.* (Note 1 above), p. 120.

50. As noted in Historical Manuscripts Commision, Rutland MSS. II, p. 67; IV, p. 228.

51. N. Pevsner, *The Buildings of England: Leicestershire and Rutland*, 1960, p. 70.

shoulders of his wife. She stands clutching a swirling gown about her with pearls in her hair and yet with her left breast exposed. Two *putti* with swinging legs sit astride the broken pediment, with a cartouche bearing a coat of arms between them. The sinister hollow skull (Pl. 88) betokens frail mortality. But overall there is a lack of assured placing of the figures, and too much unrelated black touch background. Yet there is some similarity, albeit less competent, to the two figures on the towering Campden monument (No. 20).

20. *The Campden Monument, Exton, Rutland, 1684–5*

There is a new style and a better hand at work than at Bottesford in this imposing monument at Exton (Pls. 89–93). I would like to think this betokens some time given to the Gibbons studio by Quellin's erstwhile foreman John Nost. There is no formal architectural frame but the two standing figures, of Lord Campden and his fourth wife, are well stanced against a shaped niche; that of the Viscount recalls the bronze *Charles II* at Chelsea, with the head also turned to the left. The urn between the figures is of a different, non-gadrooned form, but the draped curtains and coat of arms above their heads are linked to two further dark and gadrooned marble urns. A 'frame' is suggested by the two obelisks,[52] each bearing an oval relief, framed with oak leaves and depicting the first and second wives with their children: the first wife (Anne Fielding), whose three children died in infancy (Pl. 90) and, on the right, the second wife, also Anne, with her one, still-born, child (Pl. 91).

Two further reliefs, one (framed) below the two central figures (Pl. 93) show the nine children of the fourth wife (Elizabeth Bertie) and, in a frameless panel at the foot (Pl. 92) the third wife (Hester Wotton) and her six children. The babies apart, the children are in Roman dress, tunics and togas for the boys, loose robes for the girls. The carving is fluent and assured, and there is even the occasional poignant touch, as, on the upper long relief (Pl. 93) a boy points to the cradle of his still-born half-brother. The other children link their arms, carry flowers, or turn one to the other, seemingly in animated conversation.

As the third Viscount had died in 1682, and his wife in 1683, the monument was probably done in 1684–5: indeed, James Wright's *History and Antiquities ... of Rutland* (1684) mentions that the monument had been 'lately erected'. We owe it again to George Vertue[53] for useful information in recording that the monument cost £1,000, a sum befitting its crowded 20 ft height and careful use of black, white and veined marbles. It was an amount which Gibbons was probably not to charge again until 1699–1700, for the imposing monument to the first Duke of Beaufort (No. 35).

52. I was able to photograph inside these by directing a remote control camera with flash. There were no cramps or signs of internal fixings of any kind.

53. Vertue, *Notebooks*, IV, p. 25.

21. *Tobias Rustat, Jesus College Chapel, Cambridge, c.1685*

I am introducing this monument without documentation but on the basis of strong circumstantial evidence. Tobias Rustat had been Gibbons's patron for the equestrian *Charles II*, and the bronzes of Charles II and James II. He was Yeoman of the Robes to Charles II, and died at the age of eighty-seven on 15 March 1694 (the 1693 on his monument should read 1693/4). It is said that he had his monument prepared and set in his house eight years before his death: indeed, his will of 20 October 1693 decrees that he shall be 'reverently buryed in the Church or Chappell of Jesus Colledge in Cambridge, where my Tomb is in readinesse to bee set up'. It is of consummate quality (Pl. 94) and because the poses of the two *putti* resemble those on the Van den Eynde monument by François Duquesnoy in S. Maria dell'Anima in Rome (under whom Artus Quellin senior studied) and are nearly identical to those of the Ferrers monument (No. 5) attributed to the Gibbons and Quellin partnership (Pls. 68–70), this Rustat likeness was presumably also cut by Quellin.

The portrait medallion (Pl. 99) on the tomb of Sir Richard Head (No. 23) bears some resemblance in pose and drapery to the finer Rustat portrait.

22. *John, Fourth Baron Coventry, Croome D'Abitot, Worcestershire, d.1687*

On 25 July 1687 there died, in his thirty-third year, John, fourth Baron Coventry Aylesborough (not as Green states in his 1964 study of Gibbons, the fourth Earl of Coventry) who was buried in a little Worcestershire church, much altered in the 1760s by the architect Robert Adam and now categorised as 'Redundant'. The confused Coventry earldom, held at one point as a subsidiary title by the Villiers family, Dukes of Buckingham, was revived in 1697. It was then confirmed on Thomas Coventry, who had succeeded his nephew, John, in 1687 as fifth Baron Coventry of Aylesborough, a title held by the family since 1628. The long contract[54] concerning the monument, dated 30 April 1690, is between Gibbons and the Baron's mother, Margaret, Lady Coventry, a daughter of John, second Earl of Thanet, through his marriage with a daughter of Richard Sackville, Earl of Dorset. John had been born to her and her husband, George Coventry, third Baron, in 1654, a little over a year after their marriage.

For the quality of the monument Gibbons was only to receive a final sum of £322 10s.,[55] and for that he was required to:

Work, Carve and compleatly make and Finish a Sepulchrall Monument, All of the best and purest white Italian Marble . . . [to include]: Three Statues as big as the Life, One, the Principall whereof to be the Semblable and perfect Figure of the said John, late Lord Coventry, in all his Barons Robes, lying upon

54. Croome Court Estate Office, Severn Stoke; photocopy at Worcs. County Record Office, Worcester.

55. Gibbons entered into a bond of £500 though the monument was to cost £215. On signing the contract he was paid £107 10s. and in the end the total sum of £322 10s.

a Tomb properly Adorned, with his Coronet tumbled at his feet, and his Right hand stretcht out to Catch at a Starry Crown, presented towards him by the Serene Statue, representing Faith and standing at the head of the first Statue. And the Third Statue representing Hope, and standing at the Feet of the said First Figure. Under the Tomb and the said Figures Two pedestalls. And between the said Pedestalls a fair smooth Tablet, whereon to write an inscription. On each side of the Tomb a Death's head with Bones, adorn'd with Ears of Corn Leaves Flowers or Branches. Upon the Pedestalls behind the Statues of Faith and Hope Two Pilasters fluted of the Corinthian Order, with its Entablature and proper Adornment. Over that, the Coat of Arms . . . And above that, an Urn finely adorn'd and Carved with Festons. And the Intercolumniation to contain a large Fair and Smooth Table for the Epitaph, with a handsome Moulding above it . . . And the Name of the said Grinlin Gibbons to be Engraved in some convenient place, as the Artificer of the said Monument . . .

At some point the 'Starry Crown' presented by the statue representing Faith was lost and Lord Coventry's coronet had been placed, incongruously, on his head for which it was too small. Mercifully, in recent years it has been returned to a position suggesting 'tumbled at his feet', and is so illustrated here (Pl. 97). Lord Coventry lies a little awkwardly on the gadrooned sarcophagus with his left hand on a tasselled marble cushion which is decorated with cut acanthus leaves. The skulls, noticed by Green in 1964, are now missing from beneath the sarcophagus. The three figures are all well modelled, if a little large in the case of Faith and Hope; the italic lettering is cut with great fluency.

The Coventry monument, which despite the agreement is unsigned, is one of the more important of those done by the Gibbons shop after Quellin's death in 1686. There is a strong architectural feel to it with two Corinthian headed pilasters flanking the tablet, a neat grouping of shallow recessed planes on the plinth, and a discreet surge of foliage around the fluted urn, with its gadrooned cover and twisting flame of immortality. The contract specified that mention should be made of John's father, George, third Baron Coventry, who had died in London in December 1680. This is done, neatly, on the plinth, with mention of the role played in the monument's commissioning by his wife and the fourth Baron's mother, Margaret Tufton. The Gibbons shop had here moved forward decisively from the awkward monument to the eighth Earl and Countess of Rutland (Pls. 87–8). One wonders whether some of this new impetus was given by the young Francis Bird (1667–1731)? Little is known of his origins, except that he had studied in Flanders and Rome and was in England, hardly able to speak an intelligible word, by 1698. On Vertue's authority[56] he worked for both Gibbons and Cibber, but returned to Rome for a few more months' study. He was back in England again by 1700, and then did a great deal of work at St Paul's Cathedral. Whilst in Italy Bird had, according to Vertue, sensibly bought Italian marble. While the Gibbons shop had to have a ready supply, it is possible they allowed Bird to sharpen the source. This is only speculation, however, and marble was readily obtainable from stocks in Amsterdam to most sculptors who sought it.

56. Vertue, *Notebooks*, III, pp. 1–5, 18, 34.

23. *Sir Richard Head, Rochester Cathedral, Kent, 1689*

The monument to Sir Richard Head (Pl. 99) is a modest affair and we owe it to an eighteenth-century writer to tell us it is by Gibbons. In his *English Baronetage* of 1741[57] Arthur Collins notes 'a fair monument with an elegant bust carv'd by Gibbons, erected ... in the fourth aisle of Rochester Cathedral, where he lies interr'd'. The monument, with a small tablet below the usual swelling gadrooned sarcophagus, is obviously lacking the urn finial. The bas-relief portrait is competently done, and would look as well in carved soft wood.

57. III (1741), p. 599. See also Rupert Gunnis, *Friends of Rochester Cathedral*, 6th *Annual Report*, May 1948.

24. *Elizabeth Jeffreyes, St Kenelm, Clifton-on-Teme, Worcestershire, 1689*

This modest tablet, 10 ft high and 5 ft broad, is well documented. Gibbons's drawing (Pl. 101) for it, with an alternative suggestion for the finial, survives in the Prattinton Collection at the Society of Antiquaries Library, London, together with the contract.

May 10 1689
Mr Gibbon doth undertake to make a monument of the best Italian marble after this draught, & to set it up at his own Charge in the parish church of Clifton upon Teme in ye County of Worcester ...

Henry Jeffreyes' wife, Elizabeth, had died in 1688. It was for her tablet that Henry was presumably Gibbons's patron. He died in 1709. Elsewhere in the church is a monument (Pl. 102) with a shallow gadrooned base, and two winged cherubs at the top to Henry Jeffreyes' cousin and 'heir adopted', Jane Winnington (d.1718). It may be by Gibbons but there is no precise evidence, only the use of the same drawing.

25. *William Windham, Felbrigg, Norfolk, 1691*

Another small wall-tablet in the remote church in the fields of St Margaret, Felbrigg, in north Norfolk, is known to be by Gibbons by a payment of £50 being recorded to him. It bears some similarity to the Jeffreyes tablet at Clifton-on-Teme, Worcestershire (No. 24). The Felbrigg monument is to the memory of William Windham (1647–89); his wife Katherine (1651–1729) and daughter Mary (1676–1747; buried at Bury St Edmunds) are also commemorated thereon. Two small *putti* stand tearful by the gadrooned urn – the shape of the flame, now missing, can still be seen on the wall beneath the framing arch mould. Two small winged cherubs are set at the gadrooned base.

The researches of the late R. W. Ketton-Cremer, the owner of Felbrigg Hall and its historian,[58] have shown that William Windham I (the first of five owners of the house to bear this Christian name) had enlarged the Jacobean house after his marriage in 1669 to Katherine Ashe, the daughter of a wealthy Twickenham merchant, Sir Joseph Ashe

58. R. W. Ketton-Cremer, *Felbrigg: The Story of a House*, 1962.

(d.1686) who traded with Antwerp. Mr Ketton-Cremer noted, incidentally, that Sir Joseph's own memorial in the tower of Twickenham Church bears a similarity to the documented Windham one at Felbrigg. Whatever the involvement of Gibbons may have been, it is not uninteresting to note Sir Joseph's connections with Antwerp, in a country which had seen the training of Gibbons, Quellin and Bird.

26. *Archbishop Thomas Lamplugh, York Minster, 1691*

We may assume that the Lamplugh monument was dealt with rather speedily, in 1691. The Archbishop, who had been elevated to that position in November 1688, had died on 2 May 1691. Some six months later, a receipt[59] was issued by Gibbons, dated 9 October 1691, which reads:

59. Bodleian Library, Oxford, MS. Autog. LII, f. 335.

Re'd then of ye Reverd Mr Thomas Lamplugh the summa of one hundred pounds, on account of a monument I am oblig'd to make for his Father the late Arch Bp of York, wch sd. summe of one hundred pounds I oblige my self heires & Executors to repay to ye aforsed Mr Lamplugh in case the sd monument be not finish'd & set up, witnes my hand Grinling Gibbons.

The Archbishop is carved as a standing figure, with mitre, and holding the pastoral staff he had secured when his outspoken views happened to agree with those of people in power. The York historian Francis Drake in his *Eboracum* (1736) quoted the French proverb 'to lie like an epitaph', and that might well be applied to the Lamplugh one, which reads:

At length though he had solicitously declined that dignity, he was promoted to this metropolitical see in the month of November, 1688.

The monument was erected at the instructions of the Archbishop's son, Thomas Lamplugh, who became Rector of Bolton Percy and a Canon Residentiary of York Minster. He was buried in 1747 beneath a simpler monument in the Lady Chapel. The Archbishop's monument in the south choir aisle (Pl. 103) lacks the brilliance of that to Archbishop Sterne (No. 8) in the north choir aisle, which perhaps owed something to Arnold Quellin's interventions. The marble curtains of the Lamplugh monument are drawn back awkwardly behind the thin linearity of the rising pilasters, and the *putti* in front of the semicircular head seem too remote from the figure below, for whom one is weeping but disinterested in further action, or from the staid arms surmounted by the mitre between them. An urn is perched unsatisfactorily at the apex, and the simple inscription is in a tight oval form in the centre of the plinth.

27. *Sarah, eighth Duchess of Somerset, Westminster Abbey, 1692*

Gibbons's authorship of the eighth Duchess of Somerset's monument was established in 1963 by Dr J. Douglas Stewart.[60] He had noted the reference in the seventh Earl of Huntingdon's letter to Gibbons of 10 September 1698: 'I like not your painting of the arms on Sir Humphrey Ferrers at Tamworth, Mr Poole at Radborn nor the Duchess of Somerset at Westminster, which were all your work.' The Somerset tomb is in St Michael's Chapel in the north transept of Westminster Abbey, and is now badly damaged. Its complete form was shown, fortunately, about 1723 in John Dart's *Westmonasterium or the history and antiquities of the Abbey Church of St. Peter's, Westminster*.[61] All that now survives is the (amended) plinth, the figure on the gadrooned sarcophagus above, and those of two weeping boys (of the Green-Coat Hospital, Westminster), kneeling, one at each side.

The figure of the Duchess (Pl. 104), in a richly figured and fringed gown, is not well done – she lies too heavily on her right arm, on a tasselled cushion (the left tassel, shown by Dart, has disappeared). There is, however, a similarity in pose to the tomb (No. 29) of Lady Mary Newdigate (d.1693) at Harefield, Middlesex. Lady Mary's right arm rests on an almost identical cushion, and the curtains above, parted to the sides and held by large knots, are almost as shown by Dart for the Duchess's tomb. The monument to the Duchess was probably done within a year or so of her death, although her will, made five years before she died, was not granted probate until 1704. It is not known how much Gibbons charged.

28. *Henry Newdigate, St Giles, Ashtead, Surrey, 1693*

Henry Newdigate died in 1629, and just as the ninth Duke of Rutland had a monument by Gibbons erected to the memory of the seventh Duke forty years after his death, so it was here. Sir Richard Newdigate (1644–1710), the second Baronet, entered into a contract[62] with Gibbons on 22 July 1693. Surprisingly, whilst the monument was to have a table of white marble with black letters and to be 5 ft high and 3 ft or more wide 'if Mr Gibbons think's', a sum of only £10 was specified, of which the sculptor had already received £5. Nairn and Pevsner describe[63] the monument as 'shockingly rough. The only charitable explanation is that it was made deliberately anachronistic.' The low cost may in part be explained by other work Gibbons undertook for the family. It is interesting, but not directly relevant, that one of Sir Richard Newdigate's younger sons, Francis Newdigate (1684–1723), married Millicent Pole, the daughter of Samuel Pole who had arranged for Gibbons to erect the monument to German and Anne Pole (No. 7) at Radbourne, Derbyshire.

60. Stewart, *op. cit.* (Note 15 above), p. 125.

61. *c.*1723, II, p. 5, reproduced by Stewart, *op. cit.*, and by Green, *Gibbons*, Pl. 242.

62. Contract, Warwickshire County Record Office; also illustrated in *Wren Society*, XII, Pl. 51.

63. Ian Nairn and N. Pevsner, *The Buildings of England: Surrey*, 1962, p. 84.

29. *Lady Mary Newdigate, St Mary, Harefield, Middlesex, 1693–4*

64. Warwickshire
County Record
Office, MSS. CR
136, B 2446C; 2447.

Sir Richard Newdigate's first wife was Mary Bagot (1646–92), a daughter of Sir Edward Bagot of Blithfield, Staffordshire. Gibbons wrote to Sir Richard from London on 6 September 1694[64] in respect of his wife's monument. The spelling is poor, perhaps a legacy from the early years in Holland.

I ombly thanck You for Youer great faver and Extrorney ponuallity I recevfd the fifty pounds wich I shall allwaes Aknoligs as a pertickeler faver, as for the grait I will not imply the Smich till I hear Youer Comands. I shoeld thnick that it shoeld be of it self and goe round the monnemint but housoever I will send to my man hoem is not kom hoem to bring A gost Akount off bocch the monnemints. A ganst I am favered wich en Anser from You . . .

He indicates in the margin that his 'wiffe begs her sarvis to the Ladie and Youer honred Sealf.' The 'Ladie' is presumably a reference to Sir Richard's second wife, Henrietta Maria Wigginton.

The monument at Harefield shows Lady Newdigate in a Roman robe reclining on her right arm on a cushion set on a gadrooned sarcophagus. Draped stone curtains are flanked by Doric columns and pilasters with winged cherubs above the cornice and a half dome canopy, topped with a gadrooned urn. The inscription on the tablet recalls the birth and death dates of her husband (1644 to 1710) and on a lower stage her own 'Conjugal Virtues' and descent. There is no documentation to establish whether the adjacent monument to Sarah Newdigate (first wife of the third baronet) who died in 1695 is by Gibbons. It is, as Pevsner observes, 'of indifferent quality'.

30. *Charlotte Theophila Mostyn, St Mary, Nannerch, Flintshire, North Wales, d.1694*

65. Bodleian Library,
Oxford, Gough
Maps, 44, f. 117.

The imposing gadrooned sarcophagus, dominant urn and weeping *putti* (Pl. 105) alone might well suggest the hand of Gibbons: the supporting evidence is slight, an engraving of the monument in the Bodleian Library, Oxford,[65] by Simon Gribelin, bearing the legend 'G. Gibbons fec. S. Gribelin Sculp'. At the top is 'In Ecclesia Nannerch in Com. Flint': then follows the Latin inscription on the monument itself, which is also translated beneath it: 'Upon a marble gravestone at the foot of the monument. Here lieth ye body of Charlotte Theophila (a wife of Richard Mostyn of Penbedw) daughter and coheir of John Digby of Gothurst in Com. Bucks. She departed this life, Mar. 17. 1693/4.'

31. *Dorothy, Lady Clarke, All Saints, Fulham, d.1695*

Again the evidence for Gibbons's involvement, as with the Mostyn tomb, is slight: a reference in Brewer's *Beauties of England*.[66] This monument centres around a 4 ft high white marble urn with a flame above its gadrooned cover, which also has heavy drapery at each side, tied in bows. Above, two winged cherubs hold a simple diamond 'hatchment' of a coat of arms, while a thin black linear tablet rises behind it. On the plinth is an inscription, and another coat of arms of *fleur de lys* and crossed swords. There is a proportion and dignity to the composition.

66. Vol. X, Part IV, p. 101.

32. *Robert Cotton, St Mary, Conington, Cambridgeshire, d.1697*

Whilst the encomiums on monuments are often exaggerated, there is perhaps truth in those that commemorate youth. Robert Cotton, the only son of Sir Robert Cotton of Hattley St George, Cambridgeshire, and grandson of the founder of the Cotton Library (now at the British Library), died on 9 April 1697 aged 'fourteen Years 3 months & 7 days'.

The inscription on his tomb, which may have been composed by John Evelyn, a family friend, notes him as:

> . . . a Youth of very great Hopes,
> the Vivacity of his Wit was wonderfull
> His Questions & Answers were discerning, nice & pleasant
> With all this he was Religious, Compassionate, Charitable.

The well-cut lines descend in measured phrases about this 'Joy of his Parents': they commissioned Gibbons to provide the monument, the only one on which, to my knowledge, the sculptor cut his name, 'G. Gibbons, Fecit', on the surface of one of the short horizontal palm fronds adjacent to the left bottom of the oval. Gibbons shows Robert Cotton in Roman dress with long hair to his shoulders. His cloak sweeps outside the oval at the right, and two cherubs (with the coat of arms between their fat faces) gaze down on a well-carved cascade of lilies, peonies and poppies. The inscription is draped, with two drops from the knots, and two doves standing on coronets at each side, above a gadrooned shelf and plinth (Pl. 107). One would like to think that if ever Gibbons contemplated monuments to any of his five sons (alas, none are known), many of whom probably died young, the result would have been as sensitive as this monument to Robert Cotton.

33. *Statue of Sir John Moore, Christ's Hospital,*
(now) Horsham, c.1696–8

In December 1694 the Court of Christ's Hospital, then in Newgate Street, decided to erect a statue of their principal benefactor, Sir John Moore (Pl. 109). He was President of the Hospital and Master of the Grocers' Company. The rebuilding of the Hall at the hospital in 1682 was due to Sir John's munificence, and he made a generous donation of £10,000 for the writing and mathematics schools, designed by Wren and Hawksmoor. The Orders of the Court show that its treasurer sent Sir John a note from 'Mr Gringlin Gibbons, the bearer, who desires to have his robes' in order to assist with the likeness.

After a year had passed with no word of the statue the vigilant clerk to the Court asks for the cause of delay, and Gibbons is asked to appear before them. He does so on 3 January 1697 and says that he can proceed to finishing without a sitting. Sir John agrees to this and the sculptor implies he will finish 'in a month after'.

Some twenty months pass and the next Court minute of 25 October 1698 records that Gibbons appeared again and asked for the £60 balance of the £90 due for the marble statue. The Court, almost as casually, stated that the likeness was not recognised by anyone who knew Sir John and that Gibbons should amend it. After some testy discussions he agreed to do so and asked that three members of the Court should be 'be Judges of it' and that he would wait for his money 'until they shall have certified that it is well done'. Mr Cartwright, Mr Smith and Major Aunier were so appointed and on 16 November 1698 they reported that Gibbons had amended the statue 'to their very good satisfaction' and the Court agreed that the outstanding £60 should be paid within a month.

The statue is now in a niche on the north front of Big School at Christ's Hospital, which moved to Horsham, West Sussex, in 1902. Flanking it is *Charles II* (1676), and *Edward VI* (1682) is on the south front. Sir John is expressionless, in his heavy wig, with his left hand on his breast. He is in a weighty robe which he holds with his right hand. The Court's early worries point again to the fact that whilst Gibbons had a lucrative trade in monuments and statues, his real skill lay in the creation of fine panels in soft yielding wood.

34. *Dr William Holder and his wife Susanna (d.1688),*
St Paul's Cathedral, Crypt, 1698

Susanna Holder was Sir Christopher Wren's only sister and she is commemorated on her husband's tablet (Pl. 110) which is near to that of the architect. Dr Holder (1616–98) was a Fellow of the Royal Society who died on 24 January 1697/8. He had specialised

in speech and in deafness, subjects in which Wren was also interested. As a theologian, musician and mathematician, skills recorded in the precise Latin text on the tablet ('Theologicis, Mathematicis Et Arte Musica'), Dr Holder took up the living of Therfield, Hertfordshire; he was also a Canon Residentiary of St Paul's, which his brother-in-law laboured on over so many years, and which has fine wood-carving by Gibbons. Holder's wife, Susanna, according to the inscription:

applyed her self to the Knowledge of Medicinal Remidies wher in God gave so great a blessing that thousands were happily healed by her no one ever miscarried. King Charles II[D], Queen Catherine and very many of ye Court had also experience of her successful hand.

William and Susanna Holder had married in 1643 and therefore she had 'XLV yeares happily and honourably passed in conjugall state and cares'.

A little of the fronding has broken at the top of the monument and the coat of arms has faded, but otherwise it is close to Gibbons's drawing, preserved at the Fitzwilliam Museum, Cambridge.[67]

67. Green, *Gibbons*, Pl. 231.

35. *Theophilus Hastings, seventh Earl of Huntingdon, St Helen, Ashby-de-la-Zouch, Leicestershire, 1698–9*

There is a series of letters in the Harleian Manuscripts in the British Library[68] which communicate the seventh Earl's interests in monuments to his early ancestor, the second Earl, and to his parents. What is of interest, however, when notice was drawn to them in 1963 by Dr J. Douglas Stewart, is the Earl's own monument. The Earl writes to Mr Cromp in the Herald's Office on 10 September 1698 to say: 'I have now made a perfect agreement, with Mr Gibbons the Carver, in Bow Street for the monument which if made according to the modell, I shall like very well; I therefore desire you, to doe me the kindness to Call on him to see in what forwardnesse it is in, and what your judgment is of itt; particularly as to the armes . . .'. After adjustment of the arms, which the Earl was not anxious to have carved until the rest of the monument was done, work proceeded and was near completion by the summer of 1699. The Earl wrote on 31 July of that year to Cromp and asked him to 'overlooke the Cutting of the Letters and the Cotes of Armes'.

68. British Library, Harleian MSS. 4712, ff. 366, 368–9, 375, 379, 384.

The monument is high in the Hasting Chapel of St Helen's Church at Ashby-de-la-Zouch. It consists of two Corinthian columns supporting an elaborate cornice; between them is a tablet with the inscription surrounded by carved foliage; winged cherubs are above, and Mr Cromp's supervision was directed evidently to the three shields topped by coronets on the lower stage, which are scrolled to a central cherub's head. It is modest but satisfying.

36. *Henry Somerset, first Duke of Beaufort, St Michael,*
Great Badminton, Gloucestershire, c.1700

69. Child's Bank, Fleet Street, London. Ledger U3, 1688–1732, ff. 34, 130.

Without the assistance of Quellin (who had died in 1686) or John Nost, who had set up on his own in about 1690, this is still a very accomplished memorial by Grinling Gibbons and his team. In the Dowager Duchess of Beaufort's bank account[69] are three payments, totalling over £1,000, which relate to it:

			£
1699	3 September	'Pd Grimlin Gibbons	250
1701	1 November	'Pd Mr Grimlin Gibbons	750
1701	6 November	'Pd Mr Grimlin Gibbons	53.15s

A payment made before death (in 1699) presupposes that some thought had been given to the monument's execution.

Henry Somerset had been third Marquess of Worcester until his elevation to the dukedom in 1682. In 1657 he married Mary, daughter of the first Lord Capell, and five sons and four daughters were born to them. As one of the twelve commissioners who were deputed in May 1660 to invite the return of Charles II from exile abroad – the 'Restoration' – he had many important positions. As Lord President of Wales, for example, he was frequently on progress there, and in 1672 he was made a Knight of the Order of the Garter. He carried the crown of the Queen Consort at the coronation of James II, adhering steadily to the King's cause against the Duke of Monmouth in 1685, and against the Prince of Orange in 1688. Indeed, as a staunch Tory he refused the oath of allegiance when the Prince became William III. In his seventieth year he caught a fever and died at his great house at Badminton on 21 January 1700. John Evelyn described him in his diary as 'A person of great honour, prudence and estate', and so it was that he was buried in the Beaufort chapel at St George's Chapel, Windsor, and was commemorated there by Gibbons's resplendent monument. It had been borne in mind that amongst other things the Beaufort title, as noted in its patent, observed the Duke's 'noble descent from King Edward III by John de Beaufort, eldest son of John of Gaunt, Duke of Lancaster, by Catherine Swinford his third wife'. Whilst the 'noble descent' had not been unsullied, there was need to honour it, and, equally, a concern by the eighth Duke of Beaufort, when he enlarged the chapel at Badminton in 1874, to move the memorial of his illustrious ancestor to it.

The first Duke's monument (Pl. 111) rears up 25 ft on the north side of the chancel at Badminton, a few yards away from the great house he had created. For those interested in what the monument looked like at Windsor the eighteenth-century bookseller Joseph Pote drew it out in his *History and Antiquities of Windsor Castle*, and Pote's illustration

70. Vol. II, p. 458.

was later reproduced in 1913 in W. H. St John Hope's account of Windsor Castle.[70]

Whilst the tomb is perhaps less elegant than the Campden one at Exton (No. 20), which also cost £1,000, it is very impressive and the *putti* offering the crown give a stylistic clue to Gibbons's authorship of the others (e.g. No. 37). The reclining figure (Pls. 112–113), shown wearing a lace cravat and cuffs, with the George of his order over Garter robes, is resting on a tasselled cushion. This is incised with acanthus as on other Gibbons monuments. On the black marble background and above the figure's head two *putti* are proffering a starry crown (Pl. 112), the reward of virtue. They are set against a white marble incised cloud bearing three cherubs' heads, all below an elegant array of parted curtains. Even the fringed pelmet beneath the cornice (Pl. 112) is portrayed realistically. Four Corinthian columns, the surfaces of which bear relief acanthus scrolling (Pl. 113), support the enriched frieze and moulded cornice, on which are displayed two draped gadrooned and flaming urns and the coat of arms, supporters and the ducal coronet; the coronet sits on a tasselled cushion of variegated black marble over a bold gadrooned base (Pl. 115).

The figure, resting on its sarcophagus, which also has a gadrooned base, is above a panel bearing a carved 'St George slaying the dragon' (Pl. 116), a masterly piece of virile carving. At each side stand two beautifully carved female figures of Justice (*left*) and Prudence (the latter was said by Pote, incorrectly, in his account of Windsor to be Knowledge). On the finely incised plinth is a Latin inscription of the Duke's many achievements, including the commemoration of his marriage and the names of his children. His Duchess outlived him by fifteen years, dying in January 1715 in her eighty-fifth year. She too is buried at Badminton.

37. *Thomas Belasyse Earl Fauconberg, and the Hon. Henry Belasyse, St Michael, Coxwold, North Yorkshire, c.1701*

Thomas Belasyse came from a family seated at Newburgh Priory at Coxwold in North Yorkshire, an Augustinian house which Henry VIII had sold at the Dissolution to one of his chaplains, Anthony Belasyse. The title of Fauconberg was created as a barony in 1627, followed by a viscountcy in 1642. Thomas, as second Viscount, was created first Earl Fauconberg in 1689. He had married well, taking as his second wife in 1657 Mary, the daughter of the Lord Protector, Oliver Cromwell. The death in 1656 of his first wife Mildred Saundeson had not only allowed him to marry again but now to ingratiate himself with the new regime, headed by his powerful father-in-law. He was sent as Ambassador to the Court of Louis XIV, but at Cromwell's death he turned hurriedly to support the restoration of Charles II to the throne.

His 'loyalty' was rewarded with ambassadorships to Rome and Venice, but he fell from grace during the reign of James II. Ever resourceful, he again worked his way into favour, was re-elected as a Privy Councillor, and created an Earl by William III. He died without issue on 31 December 1700.

The Earl's monument at Coxwold, like that by Gibbons to the seventh Earl of Rutland at Bottesford (No. 18), commemorates in part one who had died fifty years earlier than his son. Henry Belasyse had died in 1647, five years before his own father, the first Viscount, and so the title passed to Henry's son Thomas, second Viscount and then first Earl. The monument (Pl. 117) shows both as standing figures, the father (*left*) in a Roman tunic and toga declining with a raised left hand the coronet held by his son. Above their heads the five cherubs on their incised cloud, proffering a starry crown, are again to be seen, as on the documented Beaufort tomb (No. 36) among others. No written evidence has been found, but this stylistic trait allows a strong case to be made for the Fauconberg tomb being a work by Gibbons, *c*.1701.

38. *Statue of Sir Robert Clayton, St Thomas's Hospital, London, 1701–2*

In 1701 the Governors of St Thomas's Hospital, in the manner already practised by those of Christ's Hospital (to whom Sir Robert was also generous), decided to honour their President and principal benefactor, Sir Robert Clayton. He was a London scrivener who had acquired the manor of Bletchingley in Surrey in 1677. His rise was rapid in London circles, as an alderman, sheriff and then dubbed as knight; in 1679 he was appointed Lord Mayor, and for several years after was a Member of Parliament. It is perhaps ironic that the splendid figures of Sir Robert and his wife on Robert Crutcher's signed monument, *c*.1707, in the church of St Mary, Bletchingley, are far more satisfying than Gibbons's attempt at a likeness.

The hospital records show that a proposal to commission a statue was made in October 1700, but that six months elapsed until, on 20 June 1701, 'it was agreed by the Governors that Mr Grinling Gibbons should cut the statue in the best statue marble and set it up in the lower quadrangle on a pedestal of the same marble, before the following Christmas'. Gibbons was to receive £50 down and a further £150 when the statue was finished; the records are a little ambiguous on this point as it is unclear whether a total of £150 or £200 was finally intended. The statue was finished by June 1702 when the Governors viewed it, and being satisfied, ordered the balance due to be paid. Sir Robert died in 1707 and the inscription was added a year or so later.

The statue (Pl. 118) has been moved several times and is now backed by modern buildings. It has been given new hands on two occasions. Clad in a heavy mayoral robe, the figure is impressive and solid. It is, however, as with the figure of Sir John Moore, a

work which satisfied convention rather than giving a powerful demonstration of the sculptor's skill.

39. Equestrian statue of William III, College Green, Dublin, 1700–1

It is only possible to judge this statue from engravings and photographs as it was almost completely destroyed in 1929. The 'Dublin Assembly Roll' for 1700[71] noted that certain merchants and aldermen then in London 'agreed and articled with one Grinilin Gibbons of London, esquire ... for makeing and erecting his majesties statue ...', for which they were to pay him £800 in four instalments: £200 in hand, duly paid, £200 four months after the said articles, dated 20 June 1700, £200 more when the statue was shipped and £200 'when all shall be finished'. The statue was unveiled on College Green, Dublin, on 1 July 1701, the anniversary of the Battle of the Boyne. It was frequently mutilated. In 1836 the monarch was unseated by a bomb. Among the first on the scene was the Surgeon General, Sir Philip Crampton, summoned by a message that an important personage had fallen from his horse in front of the Bank of Ireland.

The sculptor John Smyth had to replace the head, a leg and the left arm, the new head being based on a bust by John Nost. In 1907 it was observed by Frederick O'Dwyer in his *Lost Dublin* that: 'the horse seemed quite unlike other animals of his race, and the rider despite the serenity of countenance did not look altogether at home in the saddle'.

The *William III* was again damaged by explosion in 1929. The remains of the statue were then melted down for scrap except for the (later) head which, together with a number of fragments of the superb marble plaques which decorated the base of the statue, is now in the collections of the Dublin Civic Museum.

40. Mrs Mary Beaufoy, North Aisle, Westminster Abbey, 1705

By the time Daniel Defoe was writing of the City of London in the first edition of his *Tour* (1724–6) he could indicate that:

It is become such a piece of honour to be buried in Westminster-Abbey, that the body of the church begins to be crowded with the bodies of citizens, poets, seamen, and parsons, nay, even with very mean persons, if they have but any way made themselves known in the world; so that in time, the royal ashes will be thus mingled with common dust, that it will leave no room either for king or common people, or at least not for their monument, some of which also are rather pompously foolish, than solid and to the purpose.[72]

Defoe notes further that the Beaufoys, or 'De Beau-foe' as he calls them, were a Norman family who had settled at Guy's Cliffe, Warwickshire, 'retaining the latter part of their sirname, but without the former to this day'.[73]

71. John T. Gilbert, *Calendar of Ancient Records of Dublin*, VI, Dublin, 1896, p. 235. I am indebted to David J. Griffin of the Irish Architectural Archive, Merrion Square, Dublin, for information and illustrative material about the monument. See also Green, *Gibbons*, Pl. 19.

72. Cole & Browning, eds., *op. cit.* (Note 39 above), I, p. 363.

73. *Ibid.*, II, p. 85.

Gibbons's monument to Mrs Mary Beaufoy (Pl. 119), who had died in 1705, might be held to satisfy Defoe's criterion of 'pompously foolish'. She was a plain lady, and the awkward pose of kneeling on a cushion set above a gadrooned base, and in a loose, awkwardly draped robe, does little to help the first impression. The *putto* to the left weeps, dutifully; that to the right is angelic and indifferent. Above, three cherubs hold over Mrs Beaufoy's head a starry crown (now damaged) backed by a swirling cloud, a modification of the arrangement on other Gibbons monuments (Nos. 36–37). The Beaufoy monument is not signed, but the inscription claims it is by: 'Mr Grinling Gibbons'. The square pilastered frame is similar in ornamental detail at the top to that of the Earl Fauconberg and his father at Coxwold (No. 37), *c.*1701. The festooned urn which presumably once adorned it is missing.

41. *Admiral Sir Cloudesly Shovell, South Aisle, Westminster Abbey, 1708*

The inscription on this imposing tomb records that it was erected on Queen Anne's orders, but that did little to silence later critics. Joseph Addison noted in the *Spectator* in 1710[74] that the monument (Pls. 120–1) had

74. No. 26, 30 March 1710.

very often given me great offence. Instead of the brave rough English admiral, which was the distinguishing character of that plain gallant man, he is represented on his tomb by the figure of a beau, dressed in a long periwig, and reposing himself on velvet cushions under a canopy of state. The inscription is answerable to the monument; for instead of celebrating the many remarkable actions he had performed in the service of his country, it acquaints us only with the manner of his death, in which it was impossible for him to reap any honour . . .

The Admiral, who had been born in 1650, had had a distinguished career. Often with Sir John Narborough (see No. 42, below), he was active in South Sea voyages, at the Battle of Solebay, the burning of ships in Tripoli harbour, in actions in Ireland as well as having many administrative duties as admiral and commander-in-chief of the fleet. The inscription records his death, after shipwreck, in October 1707. He had been cast on the shore barely alive, but a woman who coveted an emerald ring on his hand 'extinguished his flickering life', declaring it on her deathbed thirty years later.[75]

75. *Dictionary of National Biography*, LII, p. 159.

> . . . Being Shipwreckt
> On the Rocks of *Scylly*
> In his Voyage from *Thoulon*
> In the 57th year of his Age
> His fate was lamented by all
> But Especially the
> Sea faring part of the Nation
> To whom he was

A Generous Patron and a worthy Example

His body was flung on the shoar

And buried with others in the sands

But being soon after taken up

Was plac'd under this Monument

Which his *Royall Mistress* has caused to be Erected

 To Commemorate

His Steady Loyalty and Extraordinary Vertues.

The Queen was following in her earlier intent, of rewarding those who had fought for England as she had rewarded the Duke of Marlborough (with the promise of a house: Blenheim Palace), but her 'reward' to the dead Sir Cloudesly was only his monument. The Queen's Warrant Book[76] records a payment of £332 10s. made in March 1709, some six months after the Lord Chamberlain's Warrant for payment, of 8 September 1708.

The reclining figure in Roman costume rests on the left arm on a cushion, set on a base which does not have the usual gadrooning. Four black marble Corinthian columns rise, two at each side, with a *putto* seated on top of each group, and between them draped and knotted curtains hang from a baldacchino canopy, topped with the crest of a lion *couchant*. The arrangement of the canopy is similar to those on the monument to George Stepney (d.1707), also in the Abbey (but only attributed to Gibbons), that to Archbishop Sharp (d.1714) by (?) Francis Bird (York Minster), and that to Sir William Boughton (d.1716), at Newbold-on-Avon, Warwickshire, by Gibbons's apprentice, John Hunt.

On the centre panel of the plinth (Pl. 121) the Admiral's flagship *Association* is shown crashing in heavy seas on to the rocks. The panel should be compared to that on the Narborough monument (No. 42) illustrated below (Pl. 122). To the sides of the central panel are two smaller panels with trophies of arms. A later critic than Addison, Horace Walpole, said of it all: 'Men of honour dread such honour.'

76. PRO, Treasury Warrants, Queen's Warrant Book, XXIV.

42. *Sir John and James Narborough, St Clement, Knowlton, Kent, 1707–8*

Sir Cloudesly Shovell's wife, Elizabeth, had been previously married to Sir John Narborough who had died in 1688 at the age of forty-eight from a fever caught in St Domingo. He had been sent as a commissioner of the navy to recover treasure from a wreck, a coincidence in view of Sir Cloudesly Shovell's own death by shipwreck. There were born to Sir John and Elizabeth two sons, John and James, who died in 1707 in action with Sir Cloudesly, their step-father (in view of Elizabeth's second marriage). She erected the monument to them at Knowlton. It is assumed to be by Gibbons in view of the striking similarity of the panel to that of No. 41 above. (Pls. 121–2). The monument has flaming

urns, weepers and acanthus finials in the usual Gibbons style. However, there is the outside possibility that Lady Shovell used another sculptor and obtained permission to copy the relief of her husband's stricken flag-ship.

43. *Admiral George Churchill, South Aisle, Westminster Abbey, 1710*

Gibbons's drawing for this monument (with a letter from him dated 1 June 1710) survives[77] (Pl. 123). The letter reads:

Honred Sr.

June the i
1710

I beleave that the oltrasione i have maid in the Pettestoell for to gain A larger Tabell is Verry well and will doe Verry well [the last five words are crossed through] I have sent the hoell as oltred in the loere part becos You may see it All togesser and Abouef that I maid the Loever part only off that as was intended to see the diffrens this will be much Longer and deper and will Contin as much as You will want, Sir I ombly thanck Mr Portman and I will be as Expedises as I kan. I hain Received fifty pounds.

Sir, I am Youer ombell
oblegent Sarvant
Grinling Gibbons

Admll Churchills Tomb
in Westminster Abbey
[in a different hand]

The monument (Pl. 124) follows the drawing more or less exactly. A large black marble urn with flaming finial is set against a spherical headed niche, atop a shaped base with relief foliage carving and two single winged cherubs. Two obelisks are set against the wall at each side and two *putti*, the left one weeping (as on the Beaufoy monument, No. 40), stand before them. Between is a gadrooned sarcophagus with a Latin inscription which records the fact that George Churchill was the son of Sir Winston Churchill (d.1688), an ardent Royalist, impoverished by the Civil War, and so younger brother of John Churchill, later first Duke of Marlborough. 'He was apparently rendered odious by his rapacity and incompetence' (according to *The Dictionary of National Biography*) but had served in the navies of Charles II and William III, rising to the rank of admiral.

It is interesting that the design for the Churchill monument is almost the same as that of the monuments to Sir John and Lady Nicholas at St Mary, West Horsley, Surrey (1703–4), and to Francis, Earl of Bradford at St Andrew, Wroxeter, Shropshire (1708). The Nicholas monument has two obelisks, but the Bradford one has only two mourning *putti* kneeling left and right of a reredos background, with an arch on pilasters and a large urn inside. Neither is documented, but the urn on the Bradford tomb is very similar in design to Lady Clarke's at Fulham (No. 31).

Other monuments will of course emerge as from the Gibbons shop, but for the moment we only know, finally, of that to James Brydges, first Duke of Chandos, and two of his three wives, *c.*1717.

44. *James Brydges, first Duke of Chandos, St Lawrence, Whitchurch, c.1717*

'Princely Chandos', whose lavish home, Cannons, at Edgware survived in great splendour until 1747, is commemorated in a standing figure in Roman dress flanked by the kneeling figures of his first and second duchesses, Mary Lake (d.1719) and Cassandra Willoughby (d.1735). Mary, the first duchess (left) has her hands folded across her breast, but Cassandra extends her left hand in the manner of the figures of the Duchess of Somerset (No. 27) and Mary Beaufoy (No. 40).

The monument (Pl. 125) of veined white marble has pilasters either side of the Duke with the same stylised flower on the frieze as on the monument to Mary Beaufoy. The monument has a date on the escutcheon under the figure of Mary Lake 'An Dom 1717'. Secondly, the Duke wrote to Gibbons on 10 January 1718[78] challenging his bill:

To Mr Gibbons

Sr. I have ye fav. of yours & must own I think ye demand you make for ye monument & statues to be excessive high, however since you say, you have never yet in any dealings you have had had any abatement made you in yr prices, I have directed Mr Zollicoffe[79] to pay you ye 350£ remainder of yr bill. You'l forgive me if I can't but add that I believe there never was so much reason from ye workmanship to allow of an abatement in this case – from ye judgment of every one who has seen ye figures.

In view of the fact that the Duke did not die until 1744, he had made preparations well in advance. At the same time Gibbons was almost seventy years old and probably had little to do with the actual making of the figures: indeed, there are superficial resemblances to those on Nost's monument to Sir Thomas Spencer at Yarnton, Oxfordshire, a variation of his finer (signed) one of 1698 to John Digby, Earl of Bristol at Sherborne Abbey, Dorset. Over the Duke's figure is the family coat of arms, and over each of his wives, his coat with the family arms of each lady.

When the monument was made in 1717, a 'repository' was provided beneath each figure, but after Duchess Cassandra's death there was not sufficient space 'behind the figures and the marble slabs, on which one epitaph is cut, for the coffins'. The marble receptacle below the portal and the figures had, for some reason, not been made deep enough to encase the three coffins in their repositories. A new monument room of 26 ft

78. Huntingdon Library, California, see C. H. C. & M. I. Baker, *The Life and Circumstances of James Brydges, First Duke of Chandos*, 1949, pp. 413–14.

79. Bartholomew Zollicoffre, the Duke's secretary.

by 24 was therefore built, completed in about 1735 and designed to take the length of all the coffins. By this time Gibbons had been dead for fourteen years, outlived by his irascible patron who stands so imperiously at Whitchurch.

The long series of monuments by Gibbons and his team are of course of varying quality. Among them we may note the lively contributions of Arnold Quellin and speculate further at the input of John Nost, Francis Bird and the few good apprentices such as John Hunt. Nevertheless, many of the monuments do little to advance our appreciation of their makers. Their work was often no more than adequate, with a good depiction of the full-size human figure seeming, on occasion, almost beyond them. The reclining effigies of, for example, the Duchess of Somerset (No. 27), Sir Cloudesly Shovell (No. 41) and the kneeling figure of Mrs Mary Beaufoy (No. 40) are unconvincing and even awkward. The various small groups of weeping *putti* and winged cherubs are however often beautifully sculpted and well stanced. The various bas-reliefs and carvings on the large monuments such as those commemorating the third Viscount Campden (No. 20) and the first Duke of Beaufort (No. 36) are also sensitive and effective, with Gibbons rising above the level of a mere lack-lustre tradesman.

Reference has been made in the citation of various contracts to the work being conducted according to a model. To 'sketch' in wax or clay was an accepted technique – Michelangelo and Giovanni Bologna are two Renaissance figures to have adopted it – and these sketches were often then worked up more permanently in plaster or terracotta. Some kind of scaling and mechanical transfer of the shapes to the marble or stone was usual: it was an early practice, in use by Greek artists, and known as pointing, which 'consisted in establishing with the greatest precision parallel points on the model and the marble block'.[80]

Following these drawn outlines the sculptor then worked at hewing off the surplus marble on the four faces of the block, by drilling and using several kinds of heavy broad and claw chisels. As work progressed, smaller flat chisels were used for the fine striations, and all uneven surfaces had to be smoothed with abrasives. Some subtleties in modelling could be achieved almost entirely by the use of flat and fine tooth chisels and various punches. The drill was especially useful, in skilled hands, for the depiction of the free flowing wigs atop so many resplendent figures (Pl. 113).

Finally, I would note two or three schemes with which Gibbons was involved. In 1678 by command of Charles II Wren designed an ambitious mausoleum to commemorate Charles I.[81] Stephen Wren in *Parentalia*[82] said that it was formed as 'a Rotundo, with a beautiful Dome & Lantern, a circular Colonade without, of the *Corinthian* order, resembling the *Temple* of *Vesta*'. It was to cost £43,663 2s, a vast sum of money for the time, and stand at the east end of St George's Chapel:

80. R. Wittkower, *Sculpture, Processes and Principles,* 1977, p. 30.

81. R. A. Beddard, 'Wren's Mausoleum for Charles I and the Cult of the Royal Martyr', *Architectural History*, 27, 1984, pp. 36–47.

82. *Parentalia,* 1750, pp. 331 and 351–2.

In the Middle-niche fronting the Entrance was designed the Kings Monument, after this manner. Four Statues, Emblems of heroick Virtues, standing on a square Basis of Plinth and pressing underneath prostrate Figures of Rebellion, Heresy, Hypocrisy, Envy etc. support a large Shield on which is a Statue erect of the Royal Martyr in modern Armour. Over his head is a Group of Cherubims, bearing a Crown, Branches of Palm and other devices. There are two draughts of this Statuary Design (*By the eminent Artificer*, Mr Gibbons), one adapted for Brass-work, the other for Marble, as should have been most approved.

Stephen Wren assumed the drafts[83] were by Gibbons, as is stated in *Parentalia* in a marginal note, but the mighty scheme was put on one side for lack of funds. This must have been a considerable disappointment to Wren and to Gibbons.

As befitted officers of the King's Works, Wren, Hawksmoor and Gibbons were called on again when Queen Mary died in 1694. A catafalque had to be prepared for the state funeral. Gibbons charged £99 8s. 7d.[84] for an elaborate canopy, obelisks, carved *putti*, shields, eight great candlesticks, each 5 ft 8 ins high, and even for carving the letters on the Queen's coffin. A marble memorial was later designed by Wren and Gibbons (Pl. 106) to rise over the Queen's tomb in Henry VII's chapel in Westminster Abbey, but again this was never executed. When William III died in 1702 the scheme was revived,[85] only to be discarded again, along with designs submitted by Daniel Marot and Nicholas Hawksmoor.

A happier solution may attend the marble monument to the memory of the earlier statesman, Cardinal Wolsey. This is in a high niche on Tom Tower at Christ Church, Oxford. In 1711 Canon Stratford of Christ Church wrote at least twice (on 2 and 7 July) to Edward Harley. In his first letter he notes that the Bishop of Winchester had been pleased to tell him that George Clarke was empowered 'to agree with Gibbons for a statue for Cardinal Wolsey, and that Gibbons had sent to have the measure of the niche.' On 7 July Harley is told that, 'The Bishop of Winchester has agreed with Gibbons for one hundred guineas for Wolsey's statue in marble; it is to be placed in the niche that is in the passage to the hall stairs. I have by this post sent the dimensions of the niche.'

Like most good schemes this one lay largely inactive until in 1719 Canon Stratford reported that 'Cardinal Wolsey's statue has come down and a very fine one it is but we think it is made to look the wrong way'. Its inscription shows it was given in 1719 by Sir Jonathan Trelawney, Bishop of Winchester. The slightly unnerving end to the tale must be Vertue's statement[86] that the Wolsey statue was by Francis Bird. It may well be that by 1719, when Gibbons was seventy-one years old, he handed on the commission to his erstwhile assistant. If not, it stands as his last work.

Despite any shortcomings in skill, Gibbons, as Master Sculptor to the Crown, had to be involved in the making of monuments. Demand for them was unremitting, in order to satisfy the edicts set out in 1700 by Sir Henry Chauncy:[87]

83. Illustrated *Wren Society*, V, Pls. 41–2, and Green, *Gibbons*, Pls. 39a and b.

84. PRO, Works 5/47.

85. The drawing is in the British Library, Dept. of Prints and Drawings, illustrated in Green, *Gibbons*, Pl. 93.

86. Vertue, *Notebooks*, III, p. 34.

87. Sir Henry Chauncy, *Hertfordshire*, 1700.

Monuments serve for four uses or ends:
1. They are Evidence to prove Descents and Pedigrees.
2. To shew the time when the party deceased.
3. They are examples to follow the Good, and eschew the Evil.
4. Memorials to set the living in mind of their Mortality . . .

As John Webster's *Duchess of Malfi* was mindful, there was still 'fashion in the grave', even when eyes were 'fixed upon the stars' and minds were 'wholly bent upon the world'.

The Plates

2

2. *Grinling Gibbons*, painting by Sir Godfrey Kneller, *c.* 1690

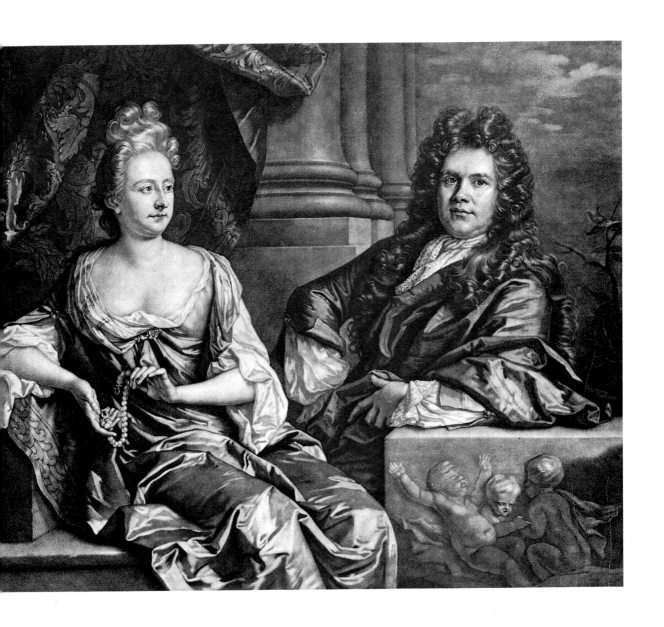

3. 'Grinling Gibbons and his wife Elizabeth', mezzotint by John Smith, *c.* 1691

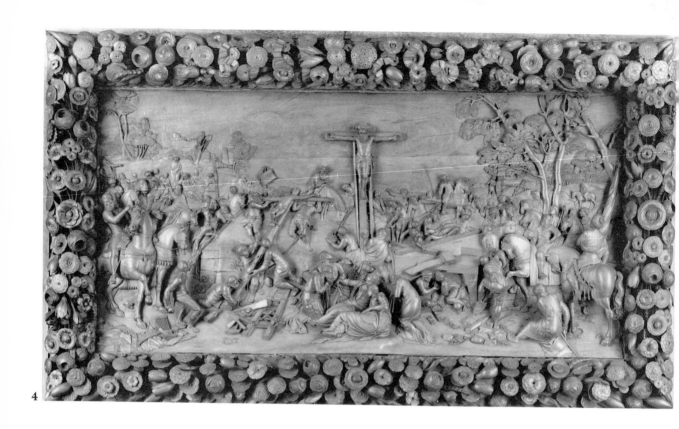

4

4. *The Crucifixion*, wood-relief after Tintoretto, *c.* 1671

5. *St Stephen Stoned*, wood panel, *c.* 1670

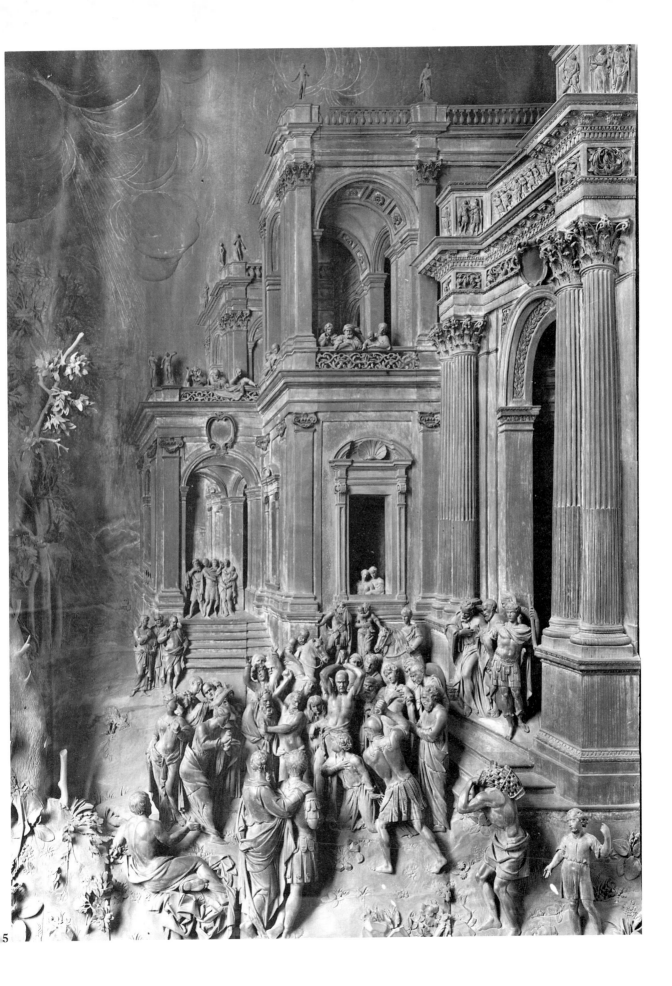

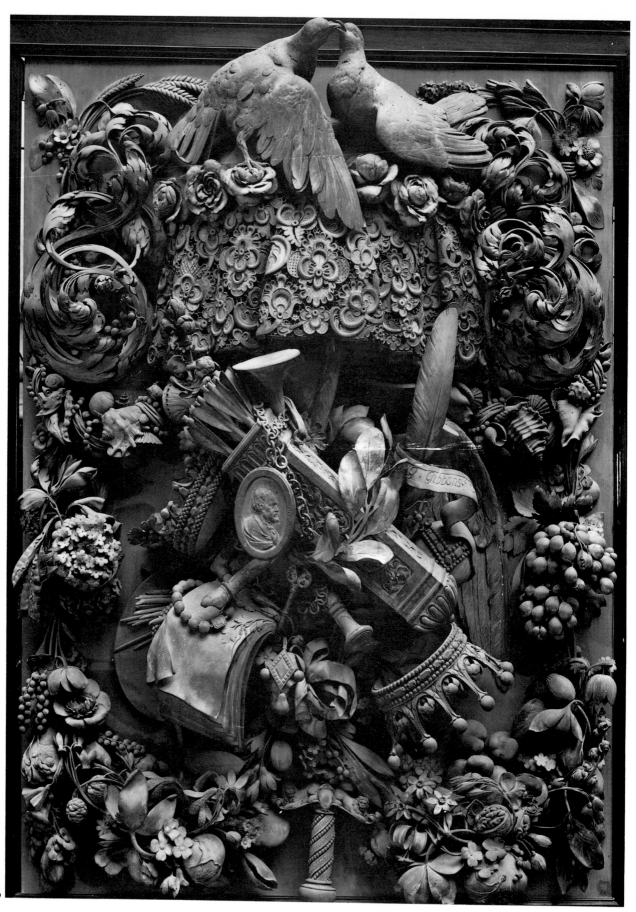

7

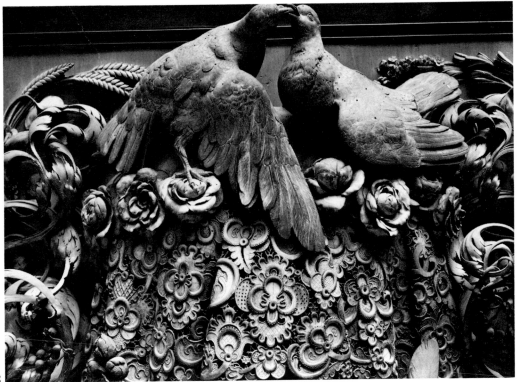

8

6. The Cosimo Panel, sent by Charles II as a gift to Cosimo III, 1681–2

7–8. The Cosimo Panel, details of centre right and upper sections

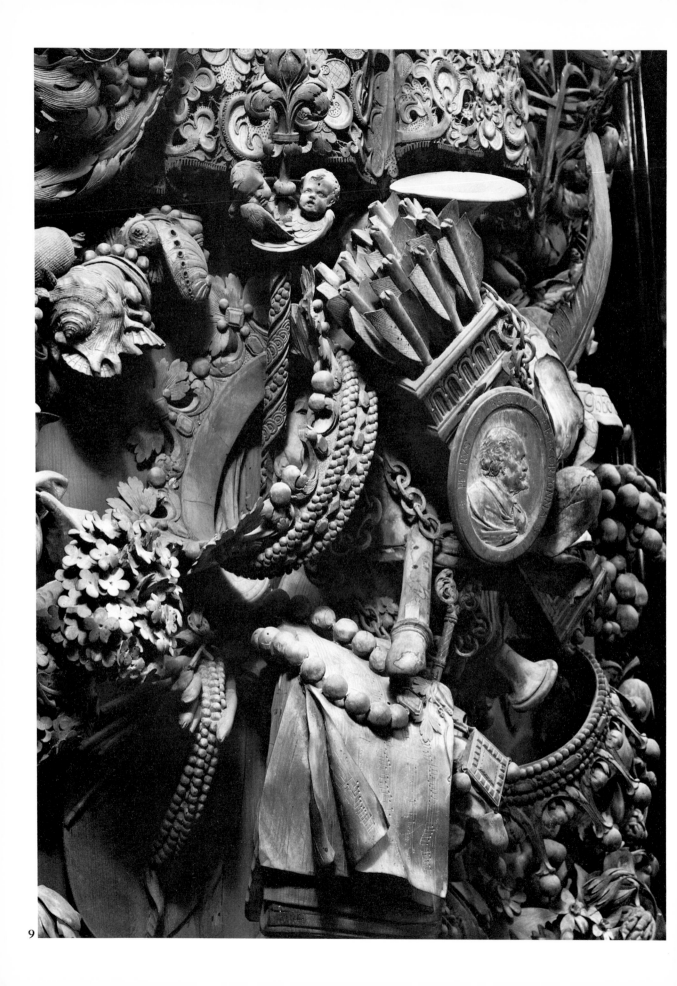

9

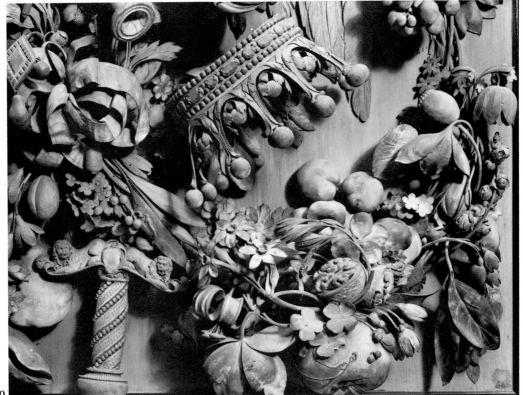

10

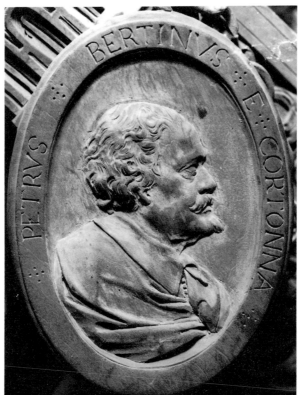

11

9–11. The Cosimo Panel, three details of centre section

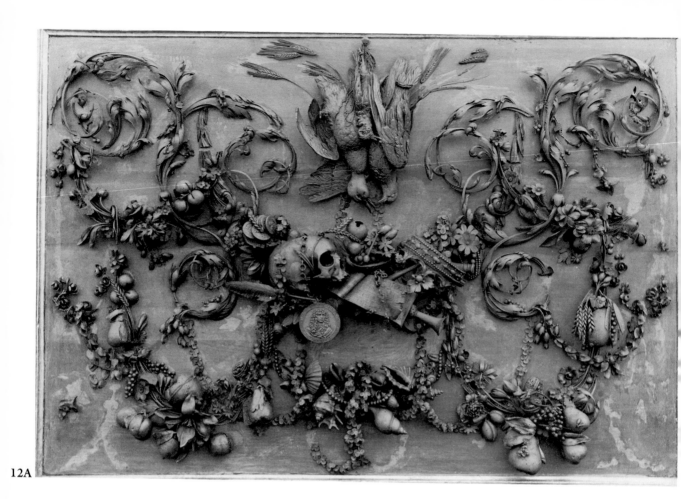

12A–B. The Modena Panel, and a detail showing the carved portrait of Gibbons, *c.* 1685

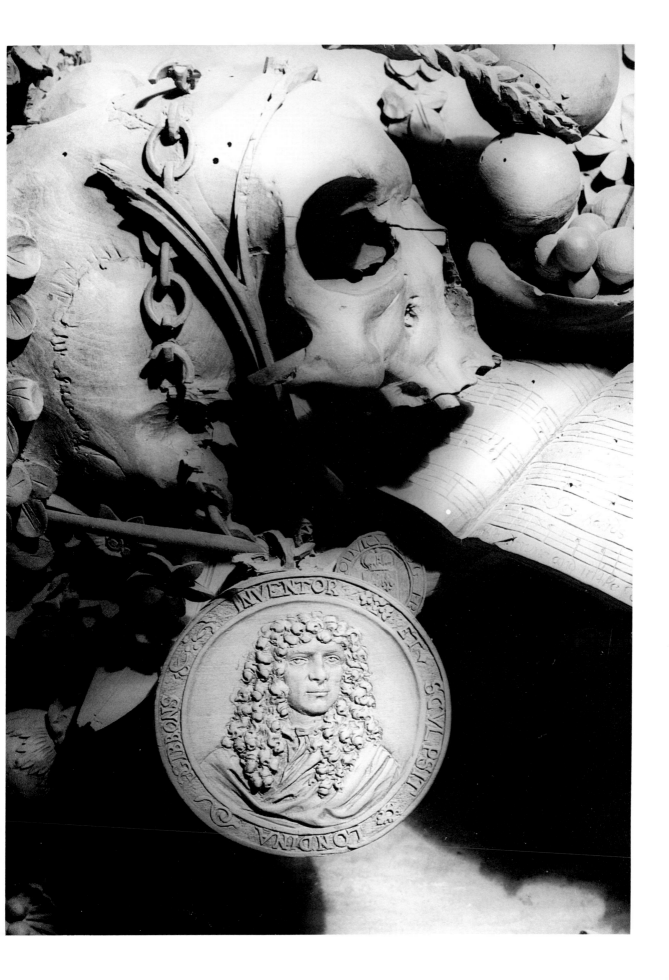

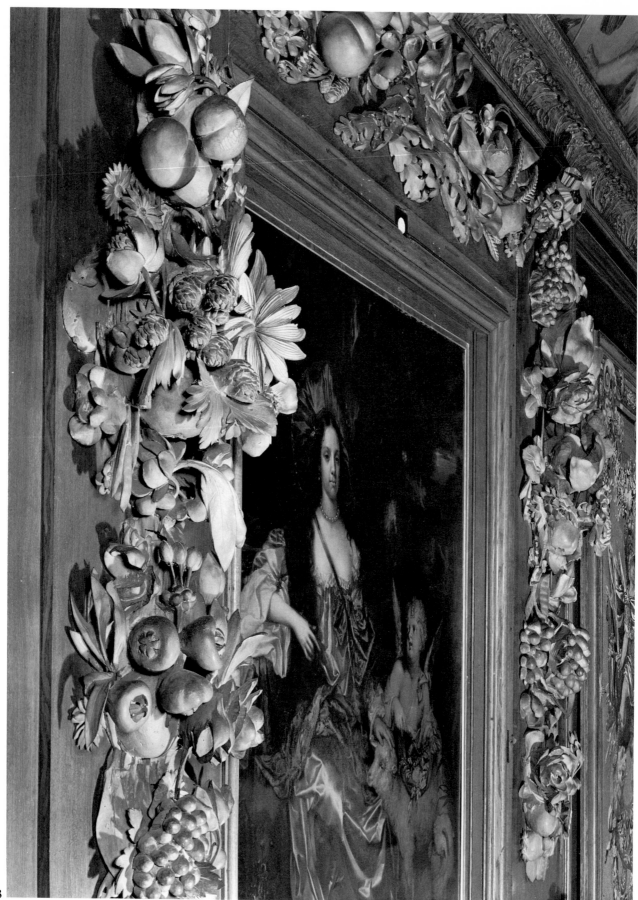

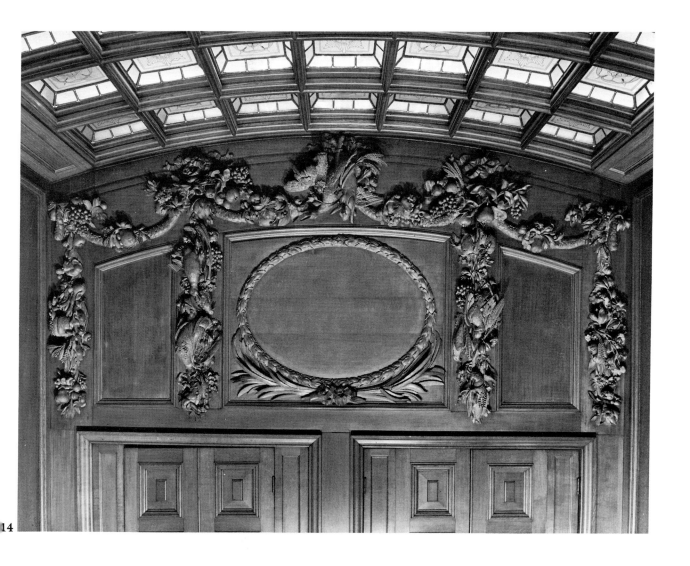

14

13. Windsor Castle. Detail of carving in King's Eating Room, 1677–8

14. Windsor Castle. Carvings in east alcove of King's Eating Room, 1677–8

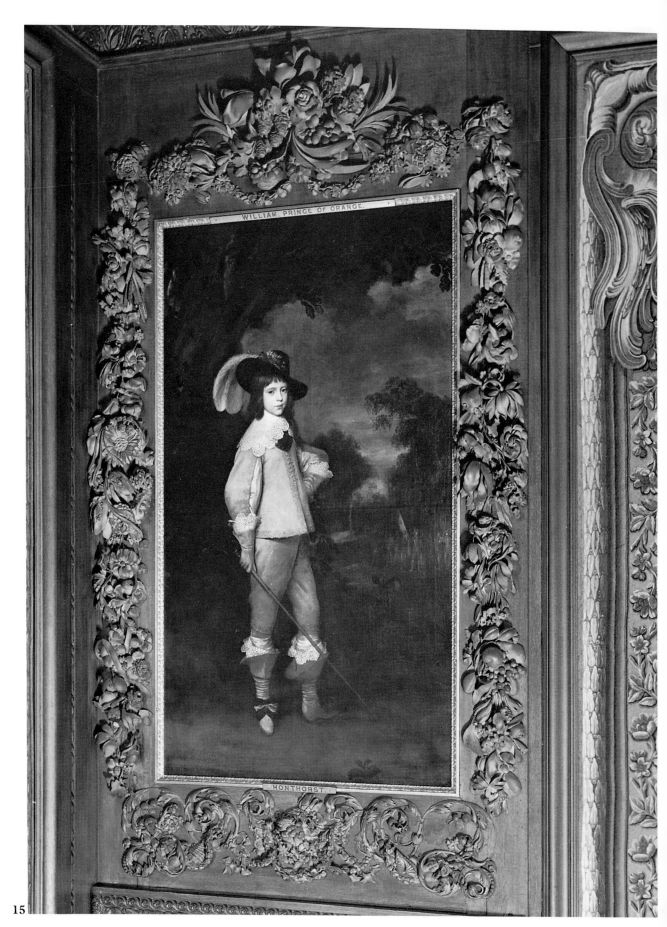

15

15–16. Windsor Castle. Two overdoor carvings in Queen's Audience Chamber, 1677–8

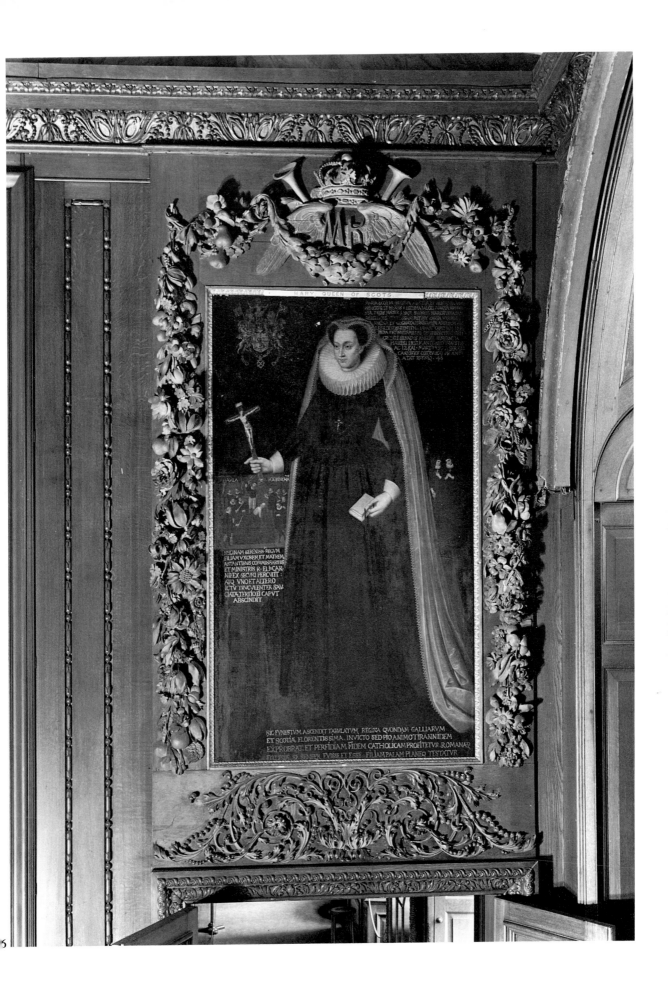

17

18

19

17–18. Windsor Castle. Pedestal of equestrian statue of Charles II, marble, 1679

19. Windsor Castle. Pedestal of sundial, *c.* 1679–80

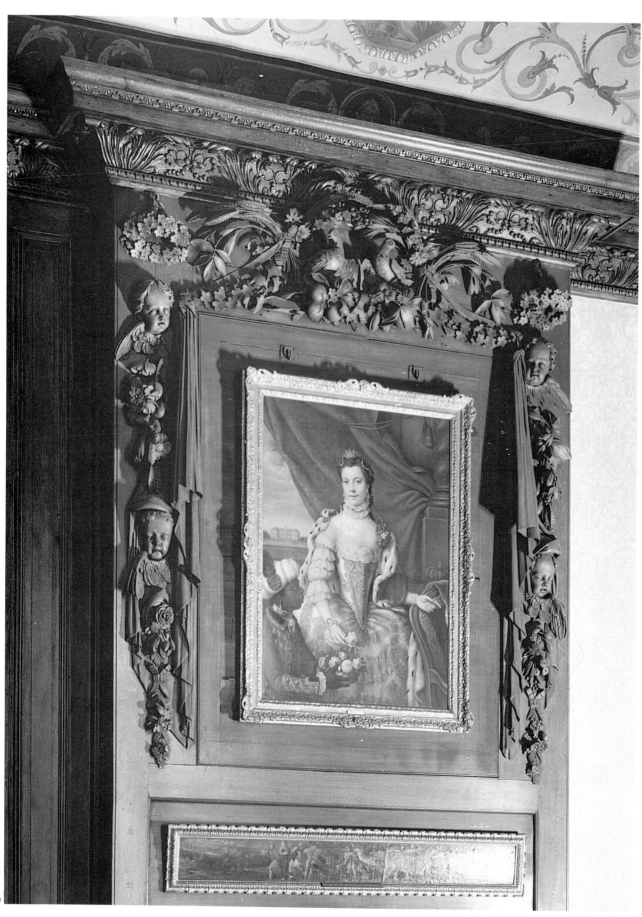

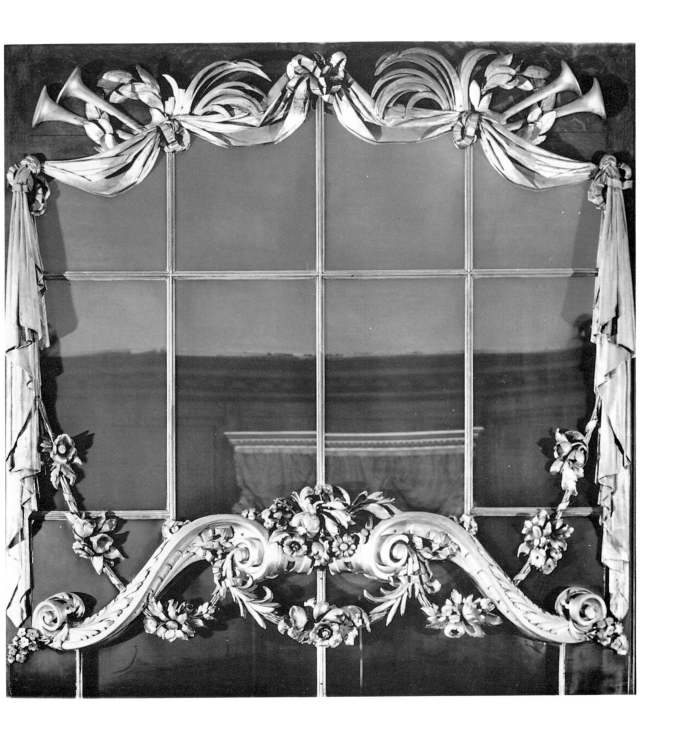

20. Kensington Palace. Carved wood overmantel in King's Presence Chamber, *c.* 1690

21. Kensington Palace. Carved and gilded overmantel in Queen Mary's Gallery, *c.* 1690

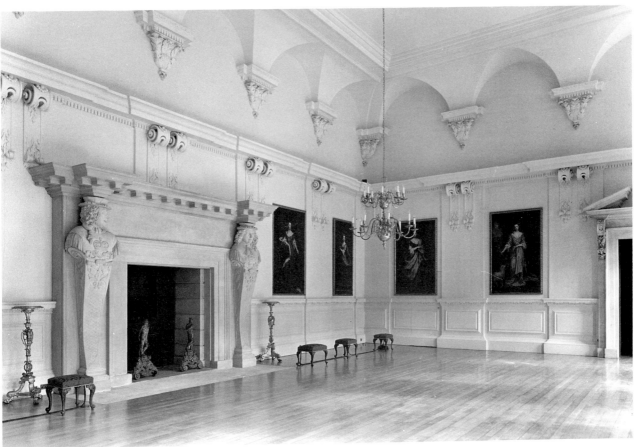

22. Hampton Court. King's bedchamber, *c.* 1700

23. Hampton Court. Oak door frame carving in King's Chamber, *c.* 1700

24. Hampton Court. Yeoman's chimneypiece in Guard Chamber, 1718

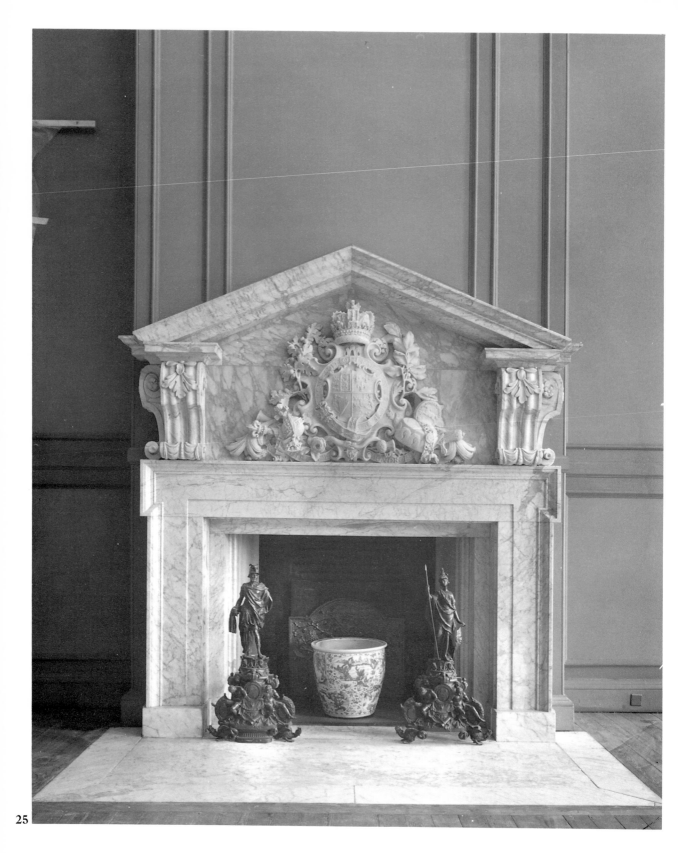

25

25. Hampton Court. Music room chimneypiece by Gibbons and Benjamin Jackson, *c.* 1718

26. Trinity College Library, Cambridge, 1676–92

27. Trinity College Library, Cambridge. Coat of arms of William Lynett, 1691

26

27

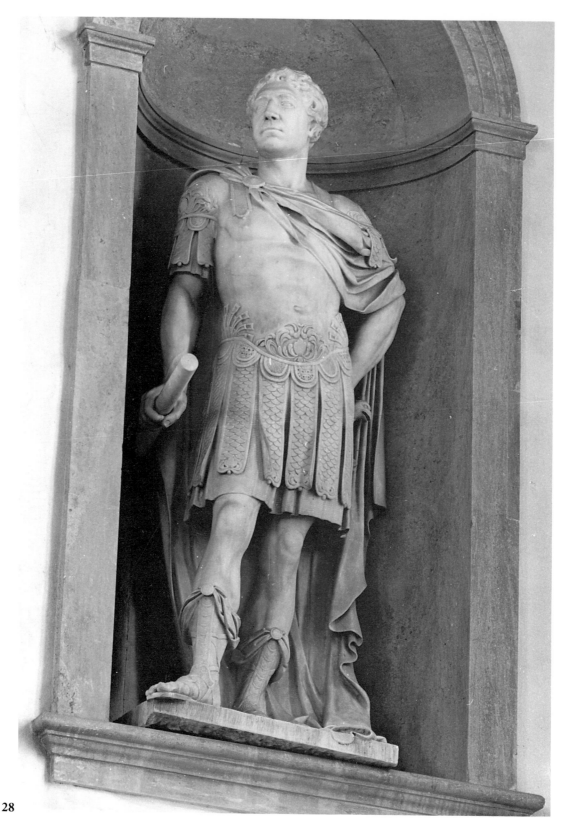

28

28. Trinity College Library, Cambridge. Marble statue by Gibbons of Charles Seymour, sixth Duke of Somerset, 1691

29. St Paul's Cathedral Choir. Engraving showing Gibbons's organ-case, 1706

30. St Paul's Cathedral. Engraving showing Gibbons's organ-case on the Choir Screen, *c.* 1720

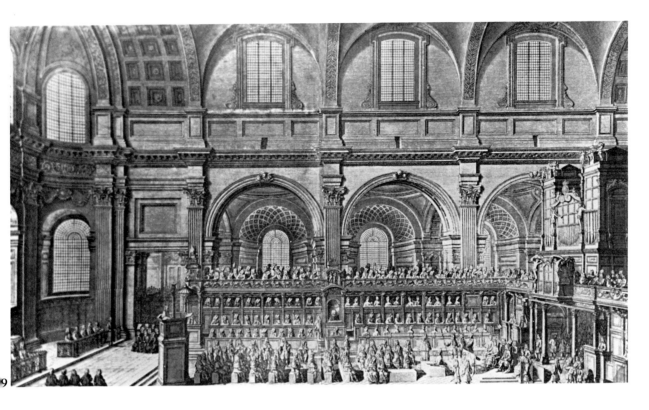

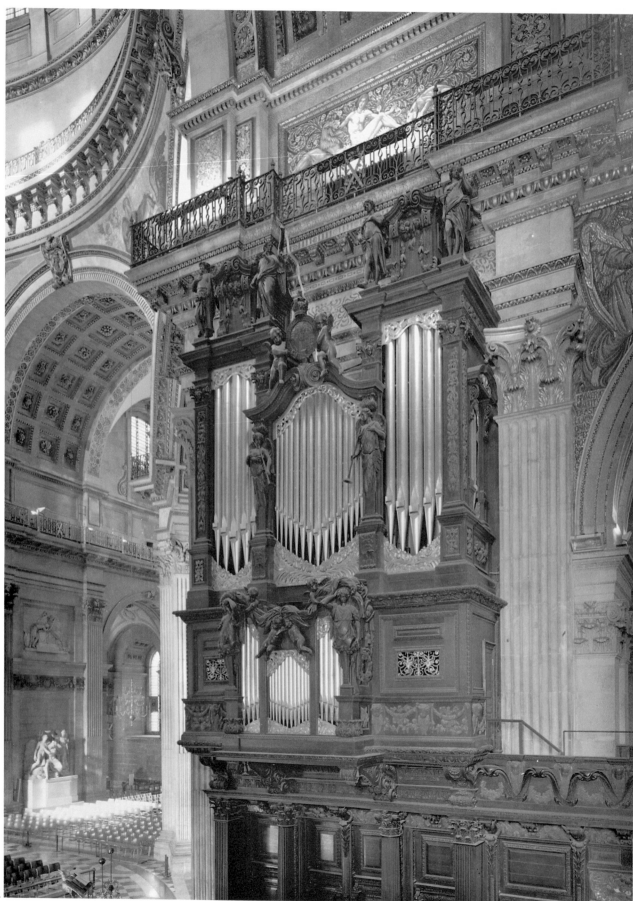

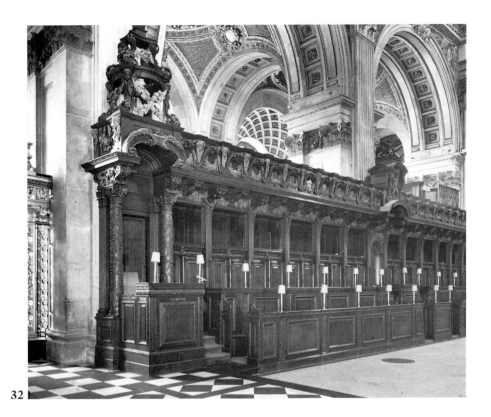

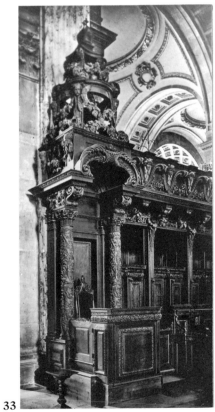

31. St Paul's Cathedral. Part of Gibbons's organ-case, as now relocated

32–33. St Paul's Cathedral. Choir stalls, south side, 1696–7

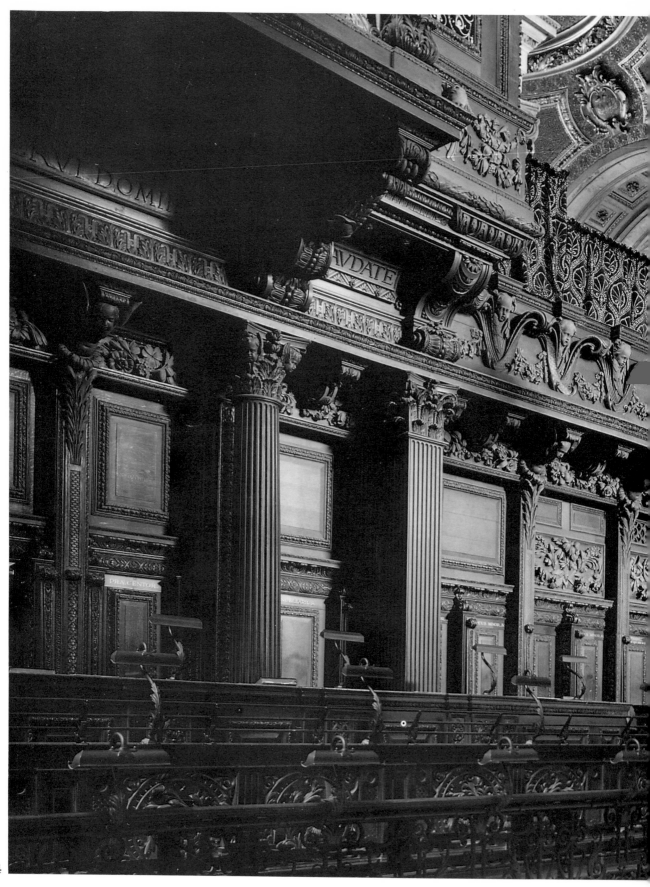

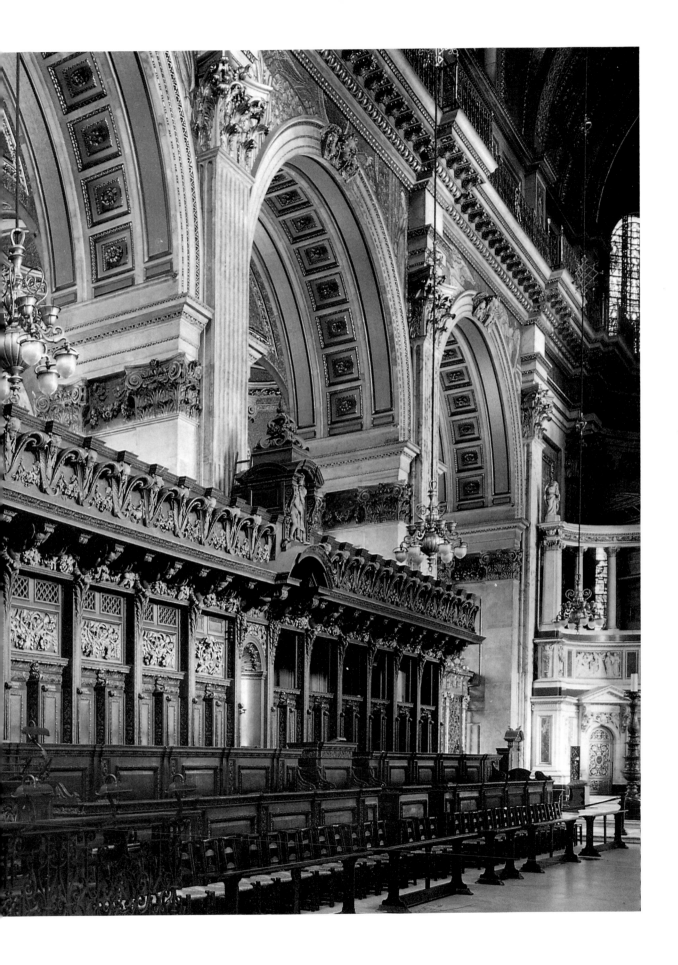

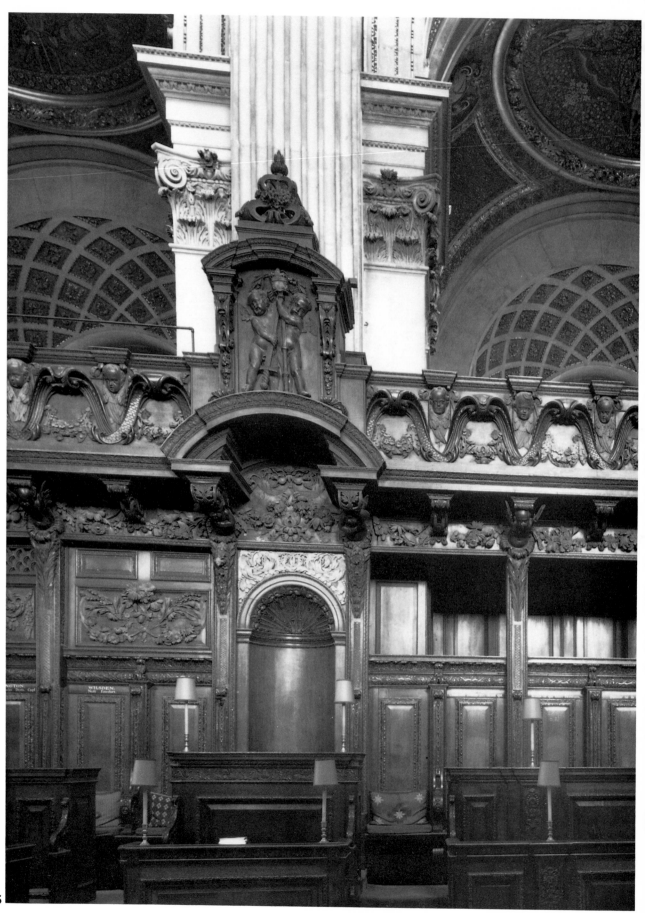

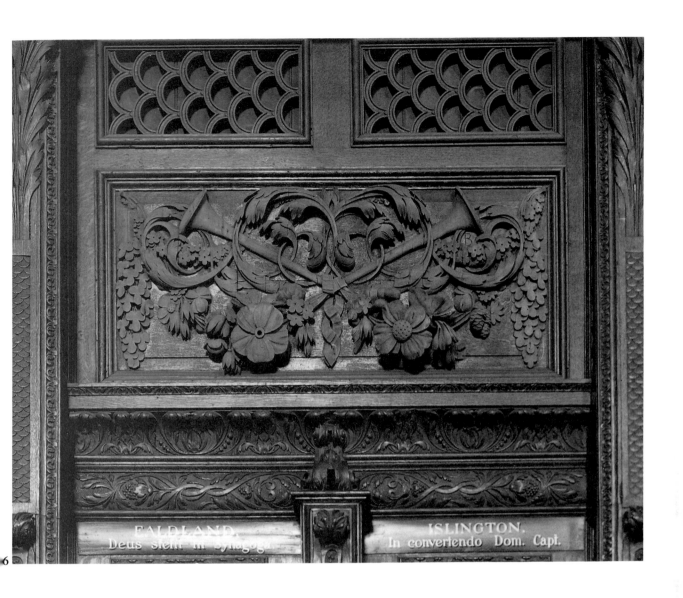

EALDLAND.
Deus stent in Synagoga

ISLINGTON.
In convertendo Dom. Capt.

34–36. St Paul's Cathedral. Choir stalls, north side, 1696–7

35 shows the Lord Mayor's stall

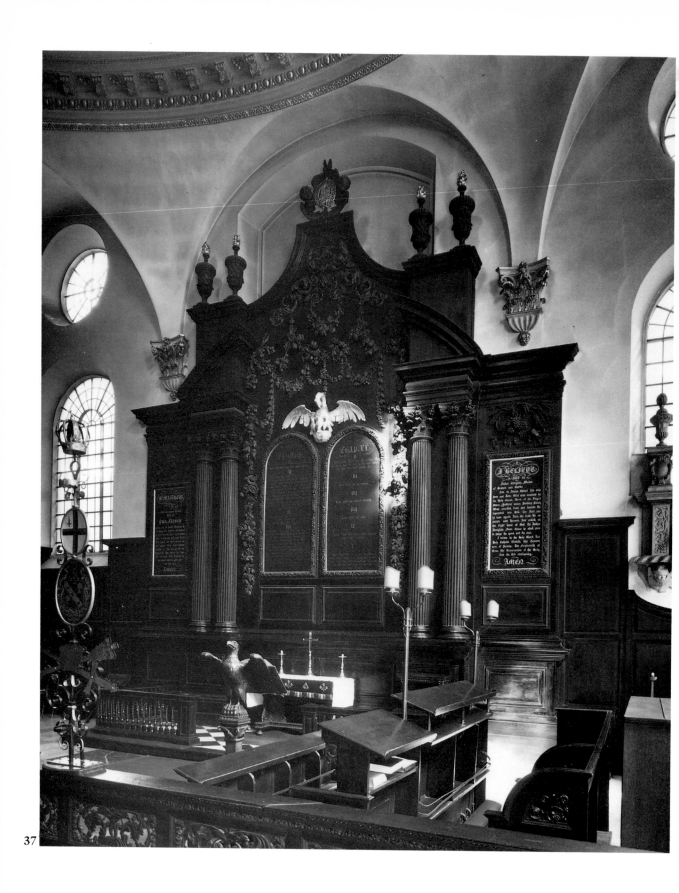

37

37. St Mary Abchurch, London. Carved reredos by Grinling Gibbons, 1681–6

38. St James's, Piccadilly. Detail of reredos carved by Gibbons, *c.* 1684

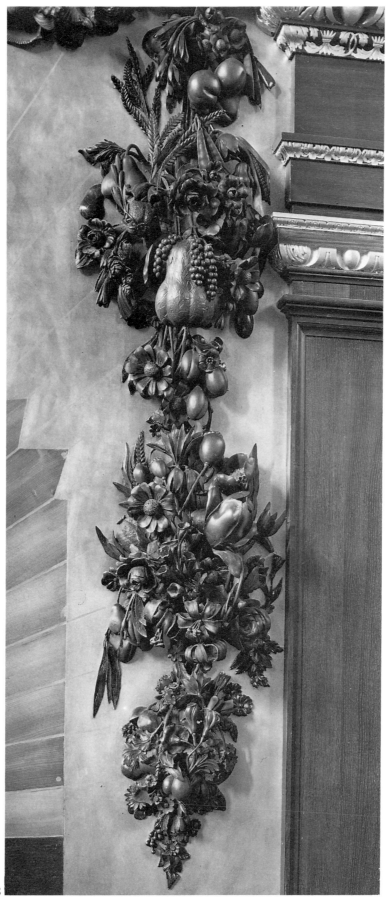

38

40

39. St James's, Piccadilly. Marble font by Gibbons, *c.* 1685

40. Two designs for *Entablatures to Great Rooms*, by Gibbons, *c.* 1692

41

41–42. Two projects for chimneypiece and overmantel at Hampton Court, by Gibbons, *c.* 1692

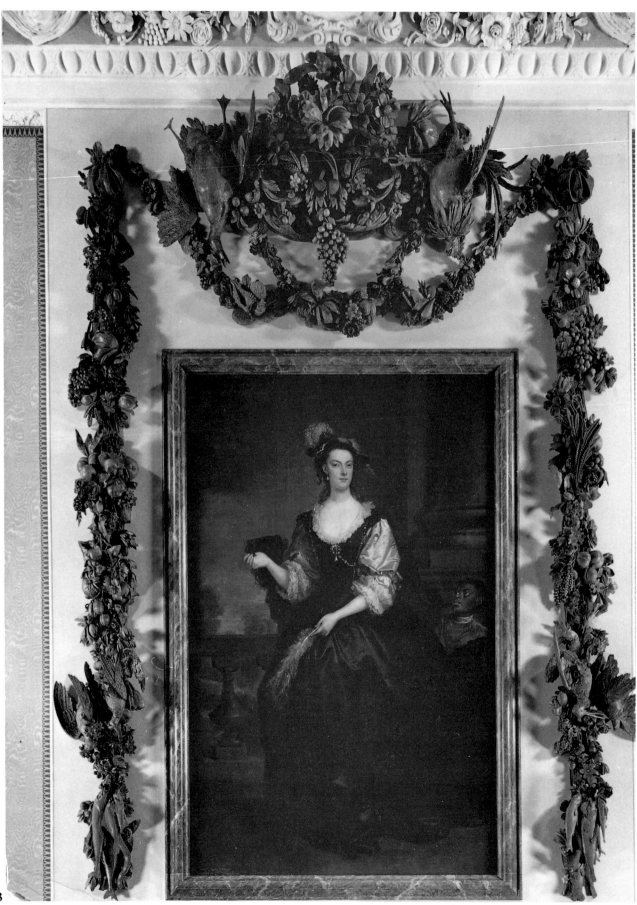

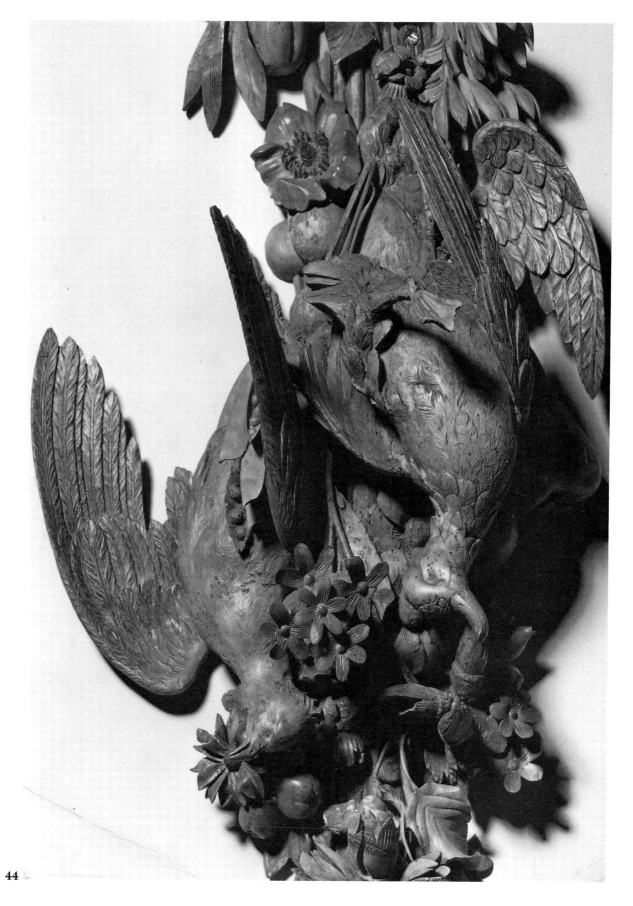

43–44. Sudbury Hall, Derbyshire. Carved overmantel by Gibbons, with detail, *c.* 1677

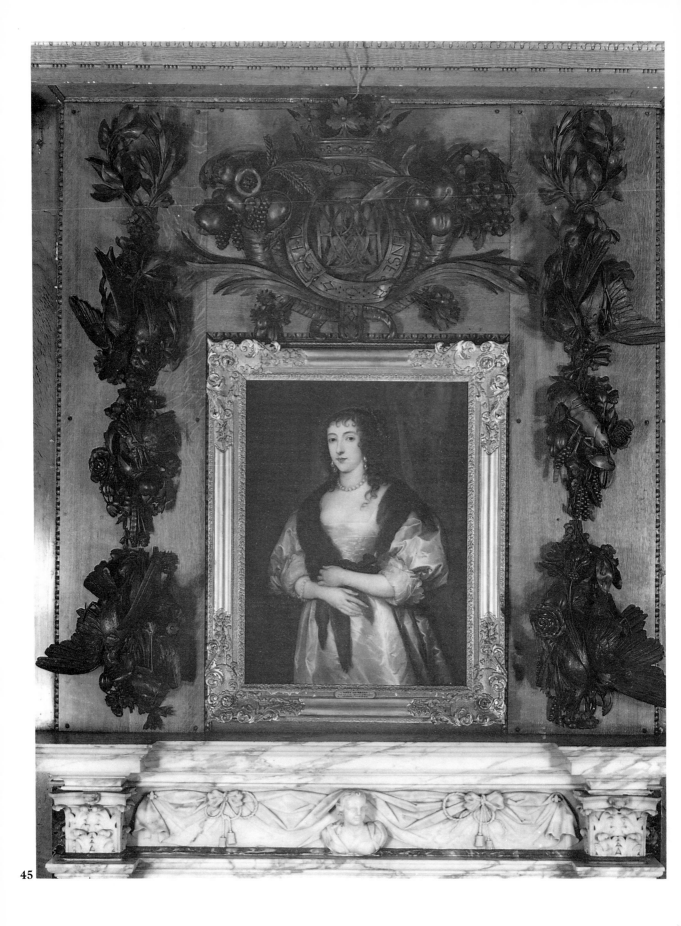

45

45–46. Badminton House, Gloucestershire. Carved overmantel by Gibbons, *c.* 1683

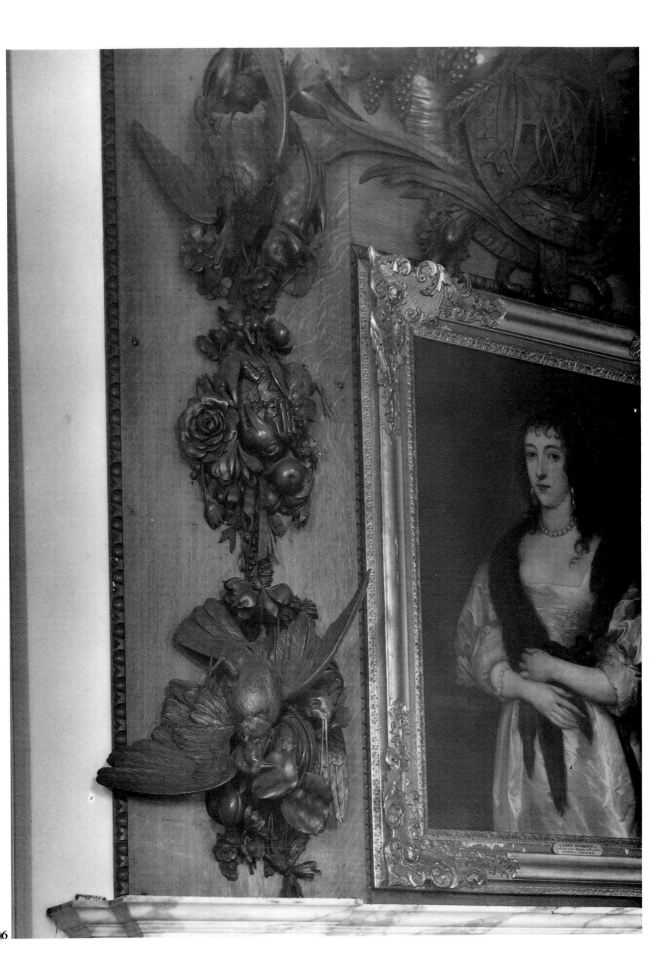

LADY HERBERT
ANTHONY VANDYKE

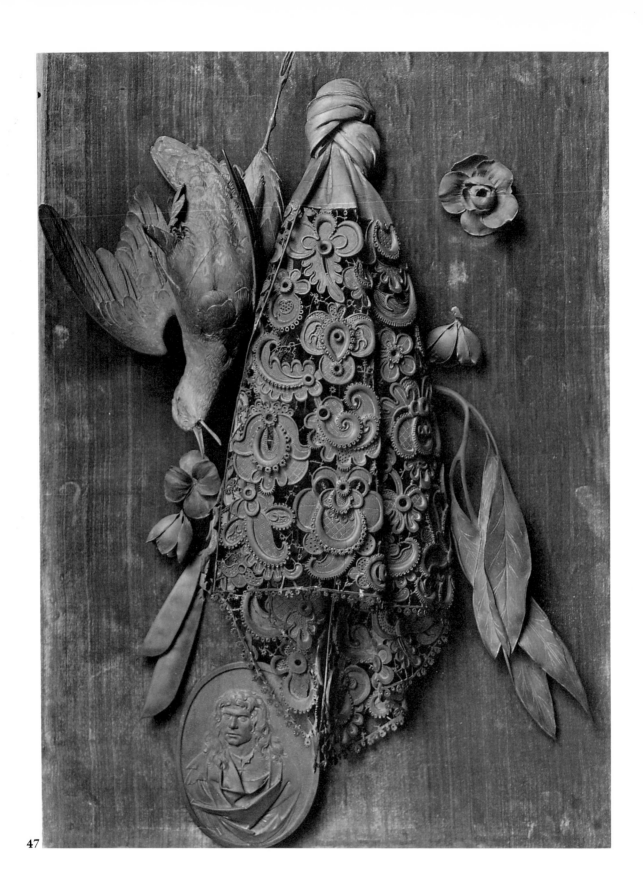

47

47. Chatsworth, Derbyshire. Point cravat by Gibbons, carved to simulate lace, *c.* 1685

48. Belton House, Lincolnshire. Detail of the Gibbons carving, *c.* 1688

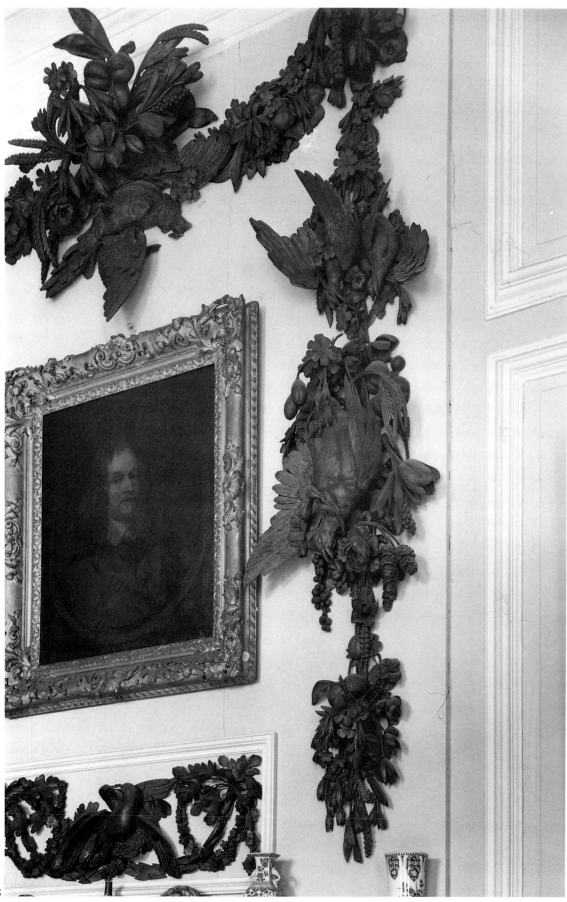

49

49–50. Amsterdam Stadthuys. Two details of marble carving by Artus Quellin 1, *c.* 1650

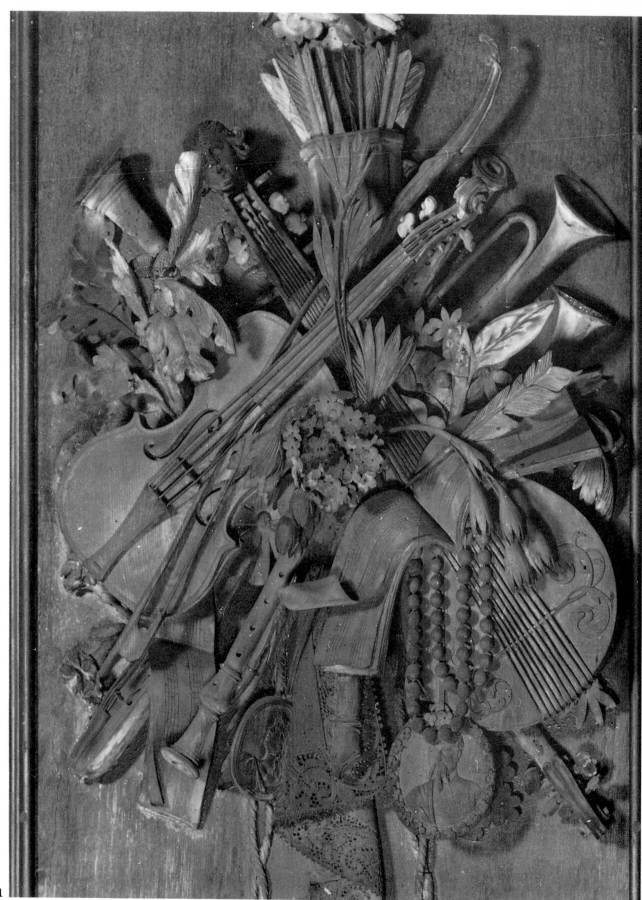

51

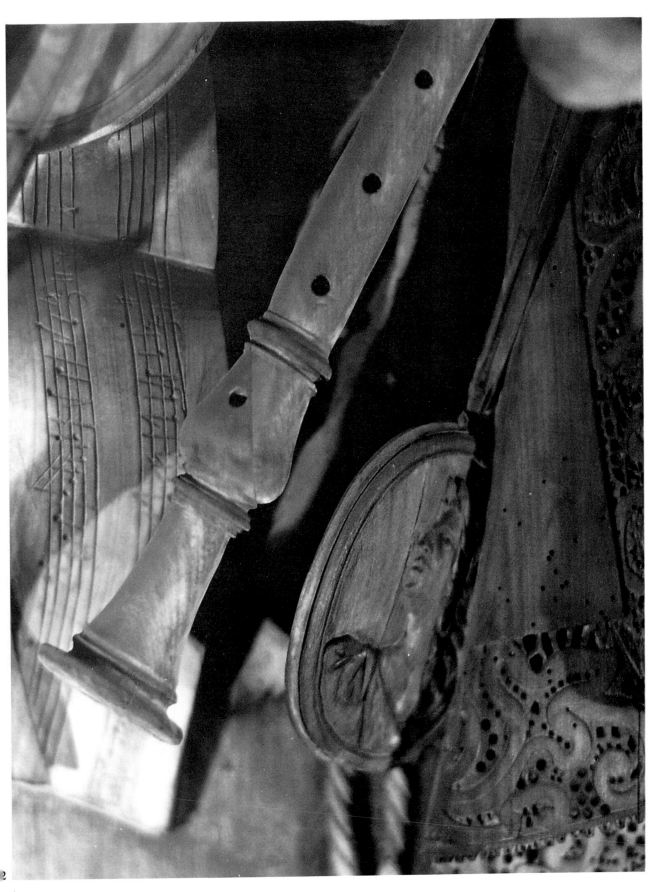

51–52. Petworth House, W. Sussex. Two details of Gibbons's trophy in the Carved Room, *c.* 1692

53

53. Petworth House, W. Sussex. Detail of trophy, showing Star of the Order of the Garter, *c.* 1692

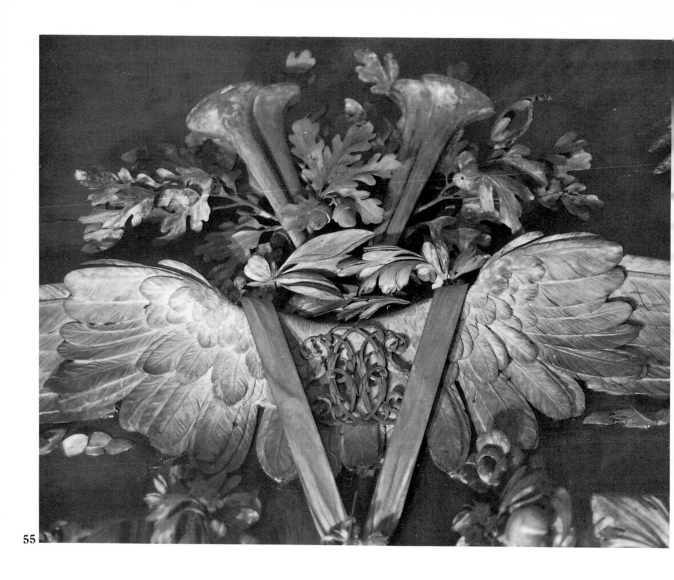

54–55. Petworth House, W. Sussex. Details of Gibbons carvings, showing basket of flowers and ducal cypher, *c.* 1692

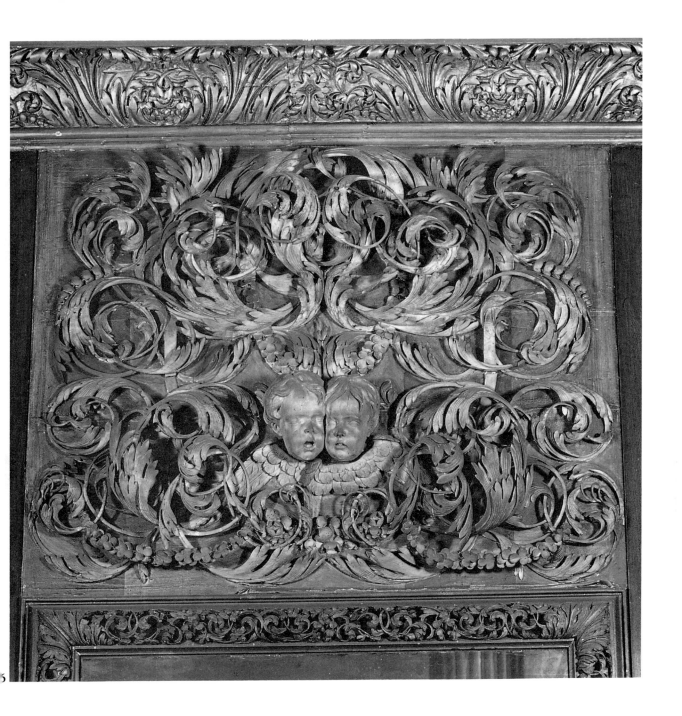

56. Petworth House, W. Sussex. Carved acanthus, *c.* 1692

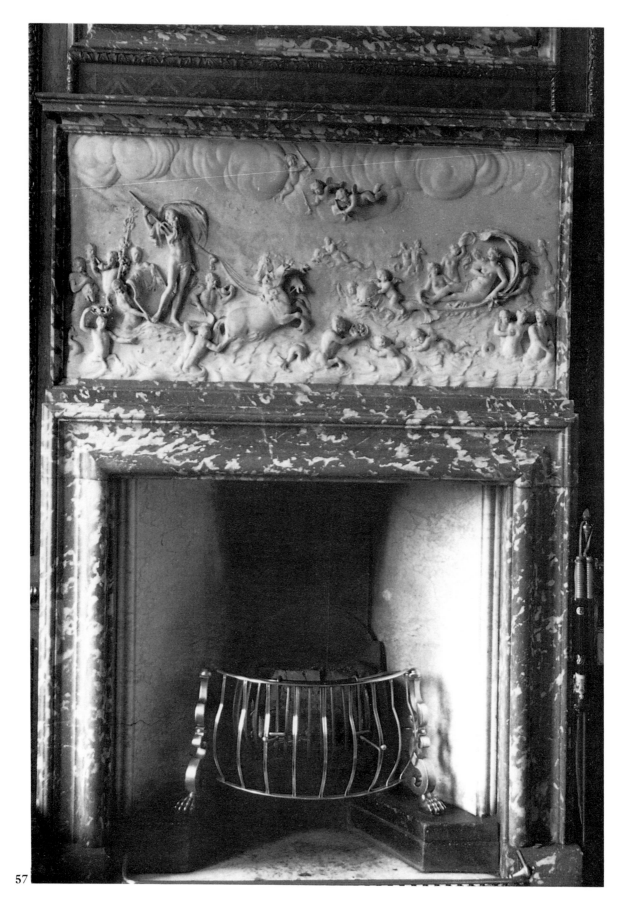

57

57–59. Dalkeith House, Lothian. Neptune and Galatea overmantel and two details, *c.* 1701

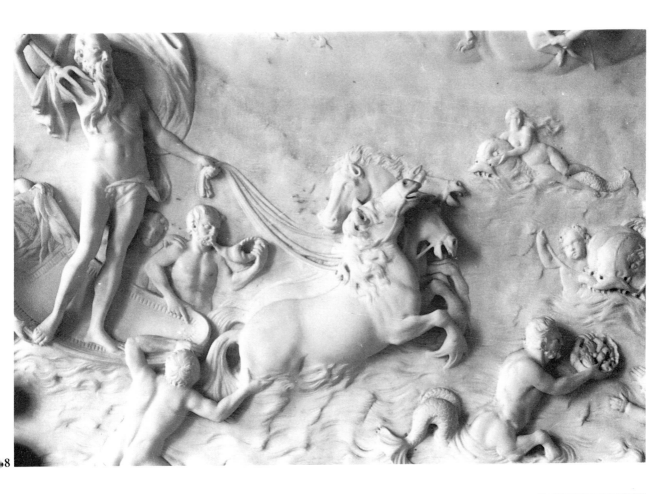

58

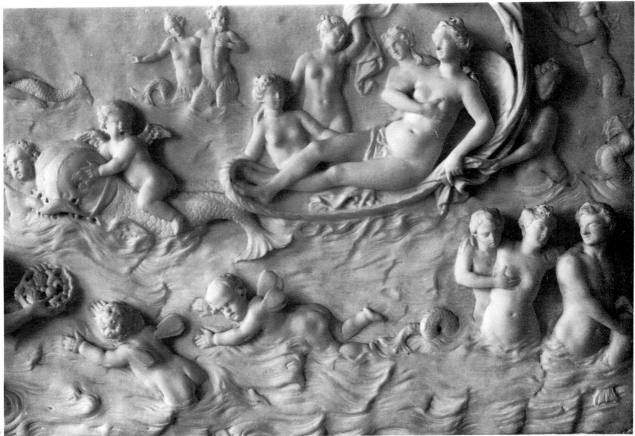

59

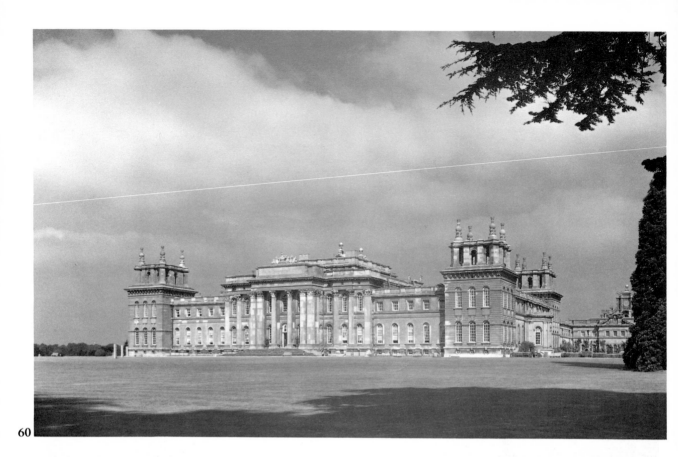

60

61

60–61. Blenheim Palace, Oxfordshire. Exterior from the south-east and a detail of Gibbons's lantern and finials

62. Blenheim Palace, Oxfordshire. Gibbons's martial trophy, stone, *c.* 1710

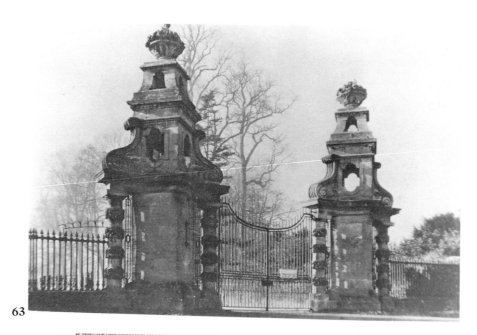

63

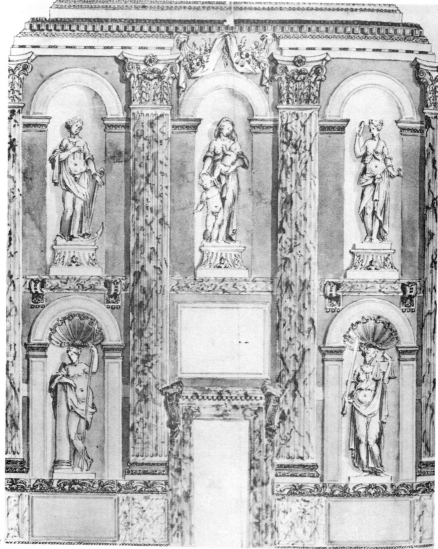

64

63. Blenheim Palace, Oxfordshire. Stone piers of Hensington Gate, by Gibbons, *c.* 1709

64. Blenheim Palace, Oxfordshire. Design for saloon, *c.* 1707

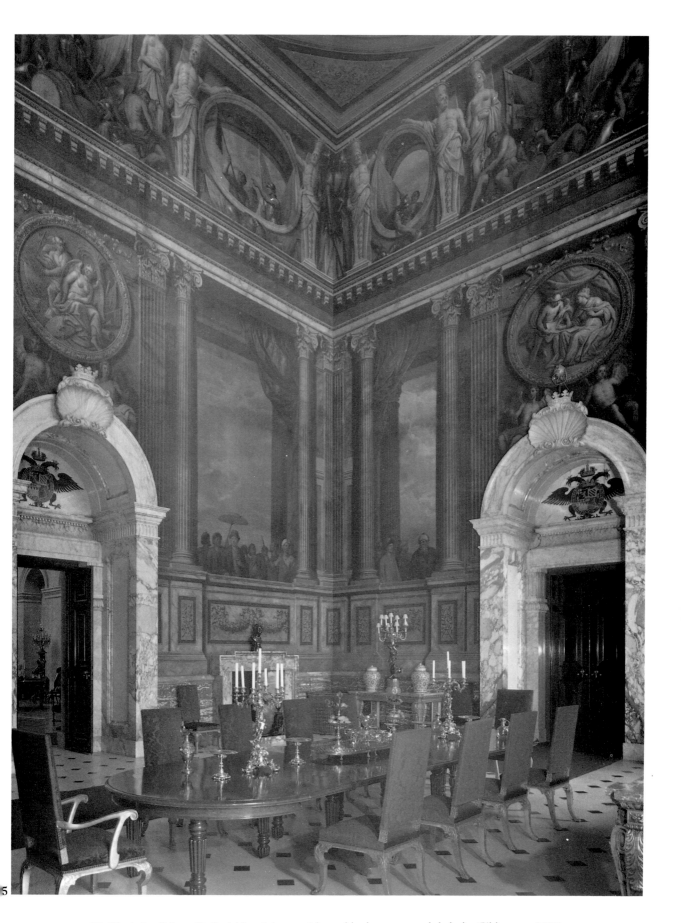

65. Blenheim Palace, Oxfordshire. Saloon, with marble doorcases and dado by Gibbons, *c.* 1712

66

67

66. Detail of Chancery document recording dispute between Gibbons and his partner Arnold Quellin, 1683

67. All Saints, Sutton, Bedfordshire. *Sir Roger Burgoyne*, d.1677, marble

68. St Editha, Tamworth, Staffordshire. *The Ferrers Monument*, *c.* 1681, marble

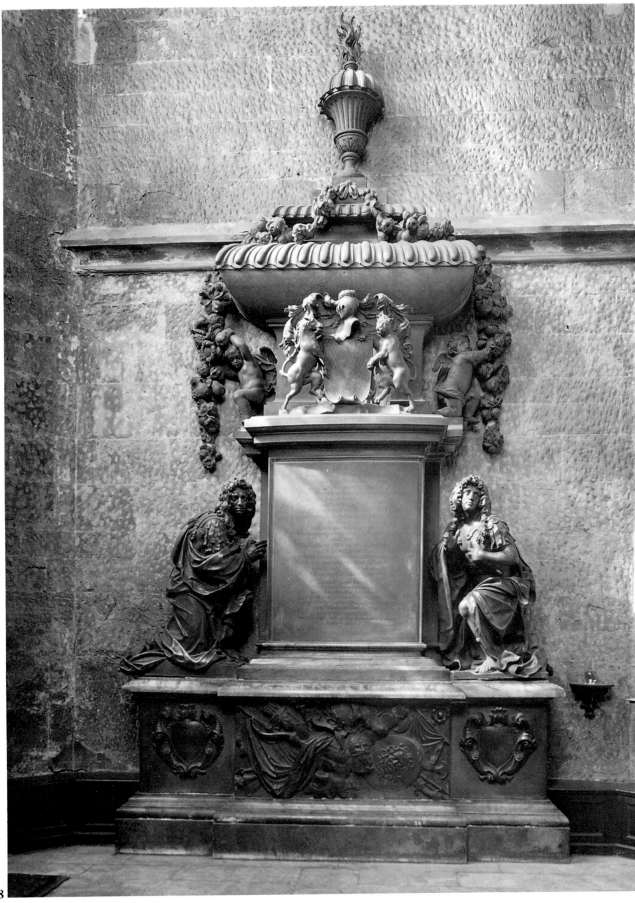

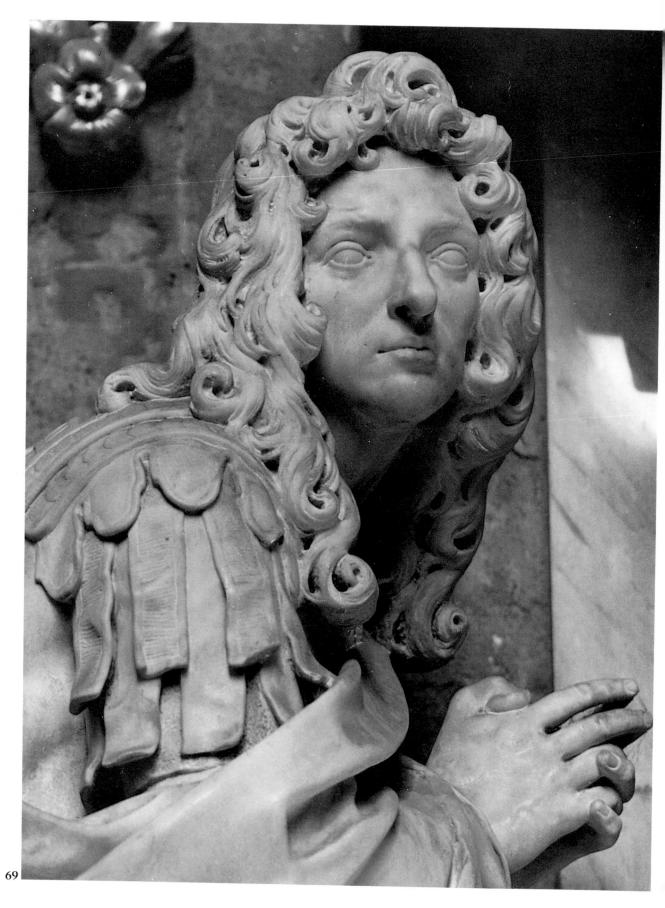

69

69–70. *The Ferrers Monument.* Two details of John Ferrers, d.1680, and his son, Sir Humphrey, d.1678

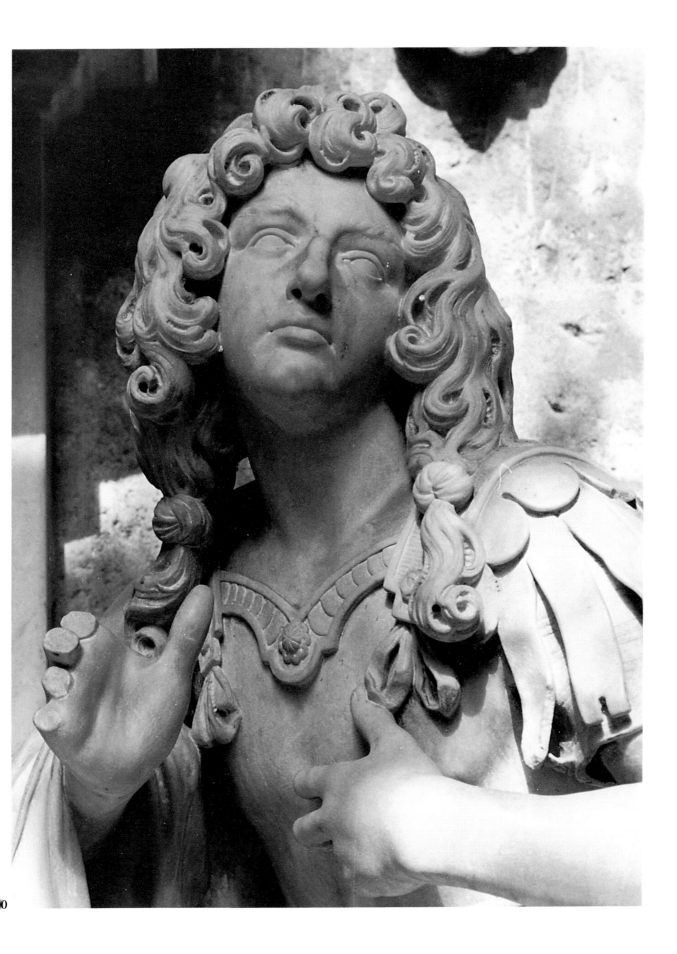

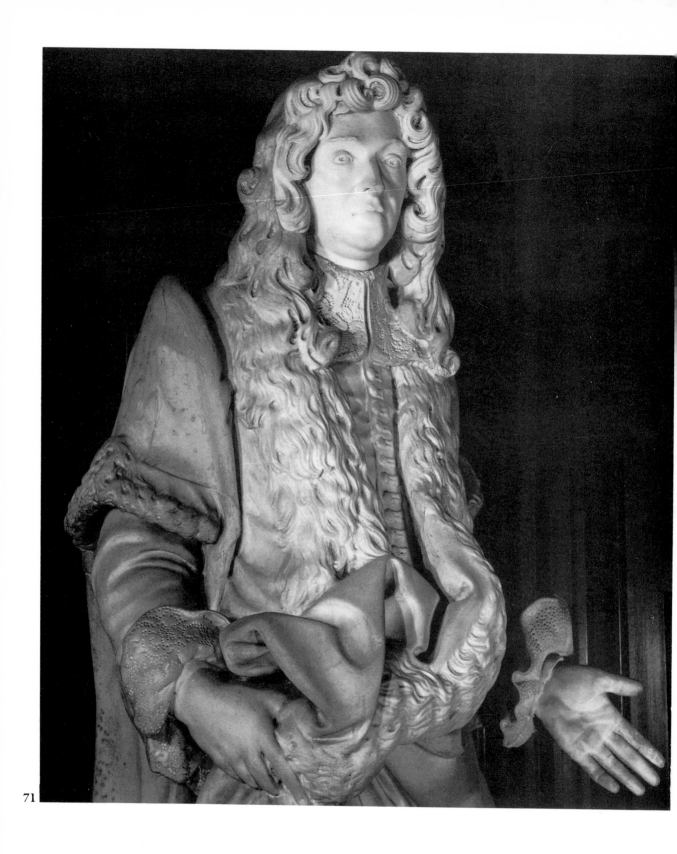

71

71. Grocers' Hall, London. *Sir John Cutler*, 1681–2, by Arnold Quellin, detail

72. Westminster Abbey. *Thomas Thynne*, d.1682, by Arnold Quellin, detail

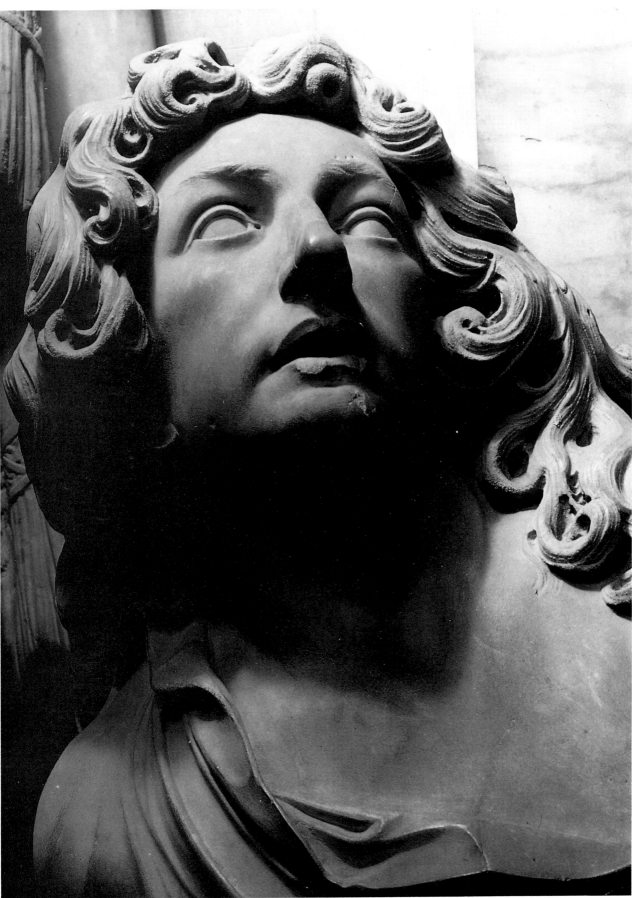

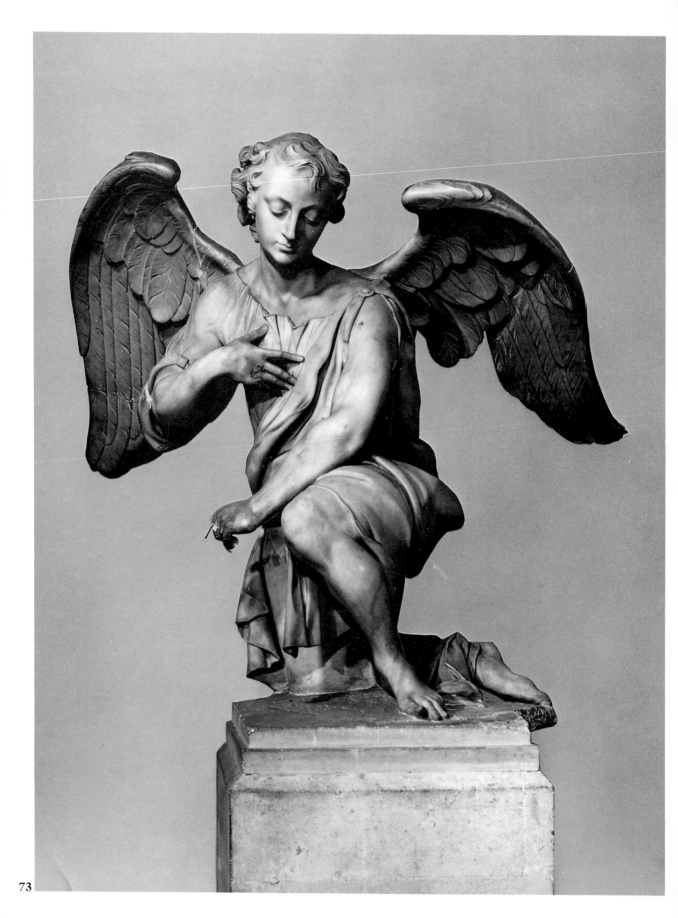

73

73–74. St Andrew, Burnham-on-Sea, Somerset. Two carved angels, 1686, marble

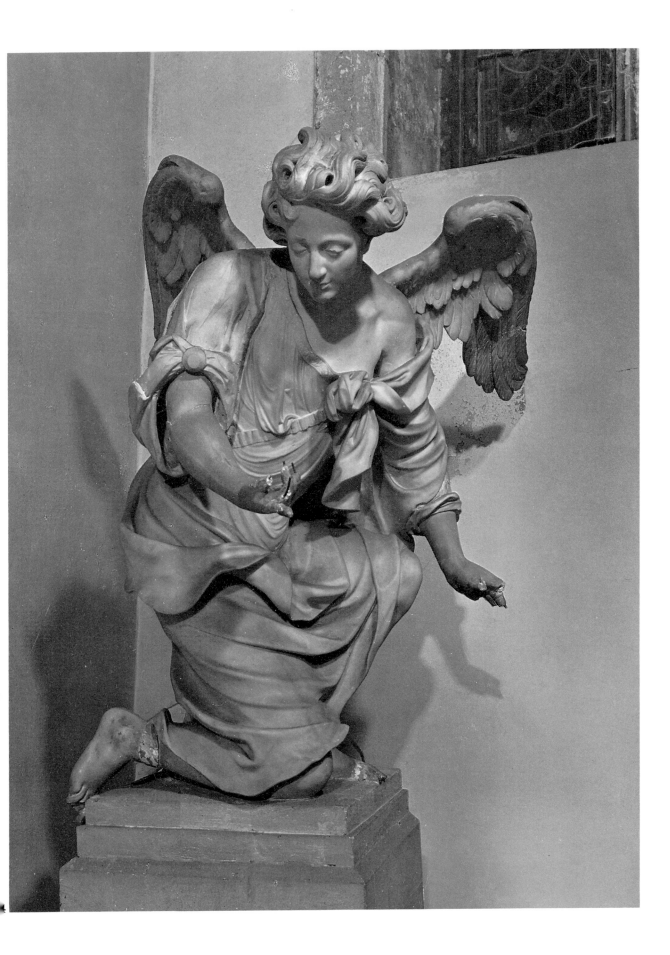

75

76

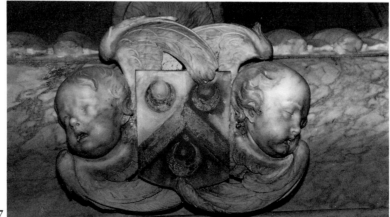

77

75. St Multose, Kinsale, Co. Cork. *Robert Southwell*, d.1677, detail

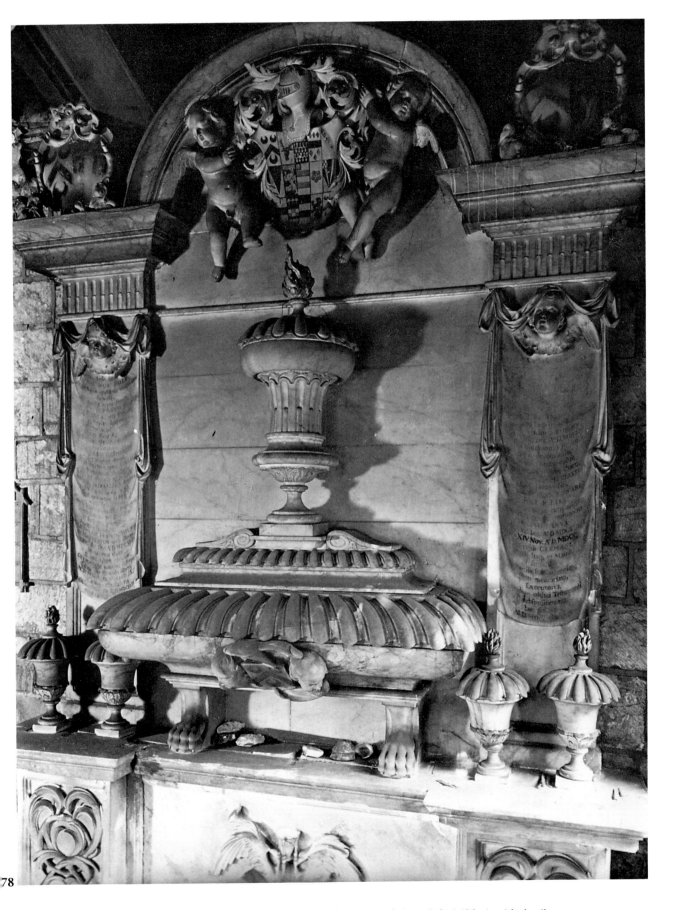

76–78. St Andrew, Radbourne, Derbyshire. *German and Anne Pole*, 1683–4, with details

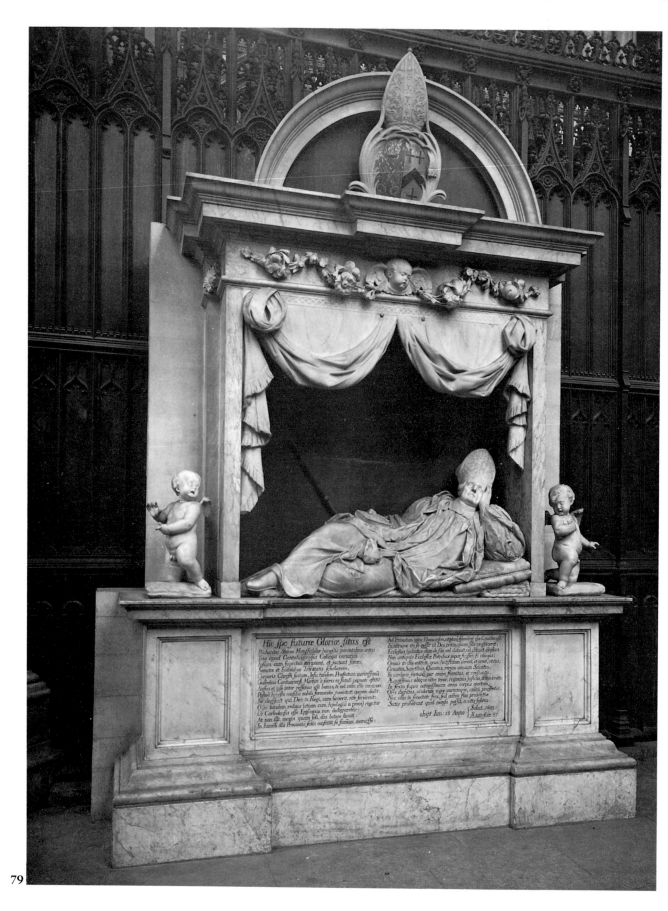

79

79–80. York Minster. *Archbishop Richard Sterne*, d.1683

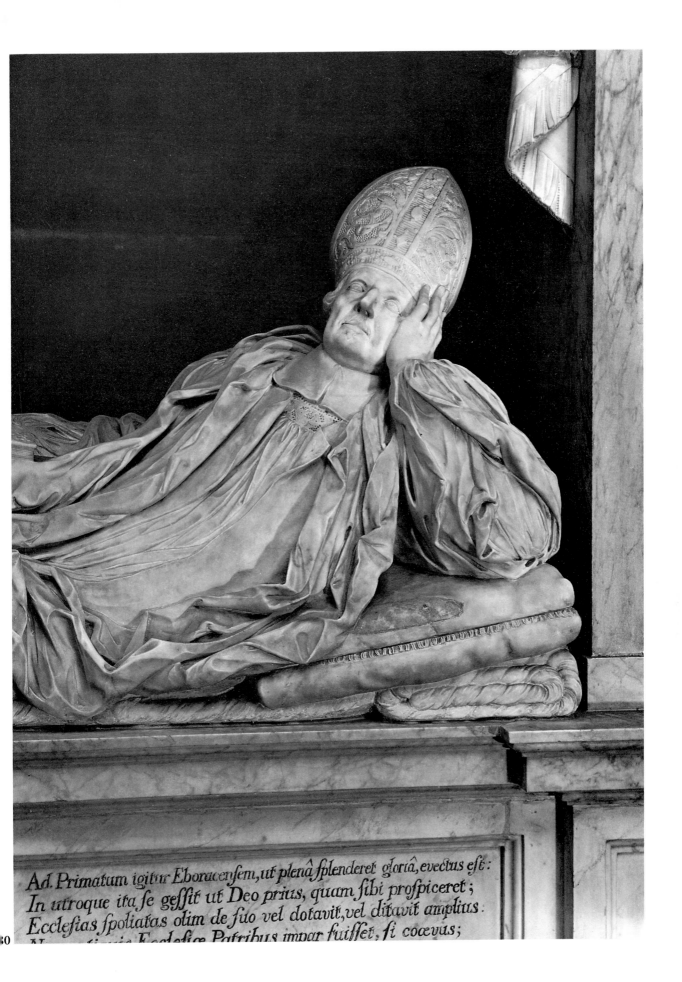

Ad. Primatum igitur Eboracenſem, ut plenâ ſplenderet gloriâ, evectus eſt:
In utroque ita ſe geſſit ut Deo prius, quam ſibi proſpiceret;
Eccleſias ſpoliatas olim de ſuo vel dotavit, vel ditavit amplius:
Ne antiquis Eccleſiæ Patribus impar fuiſſet, ſi coævus;

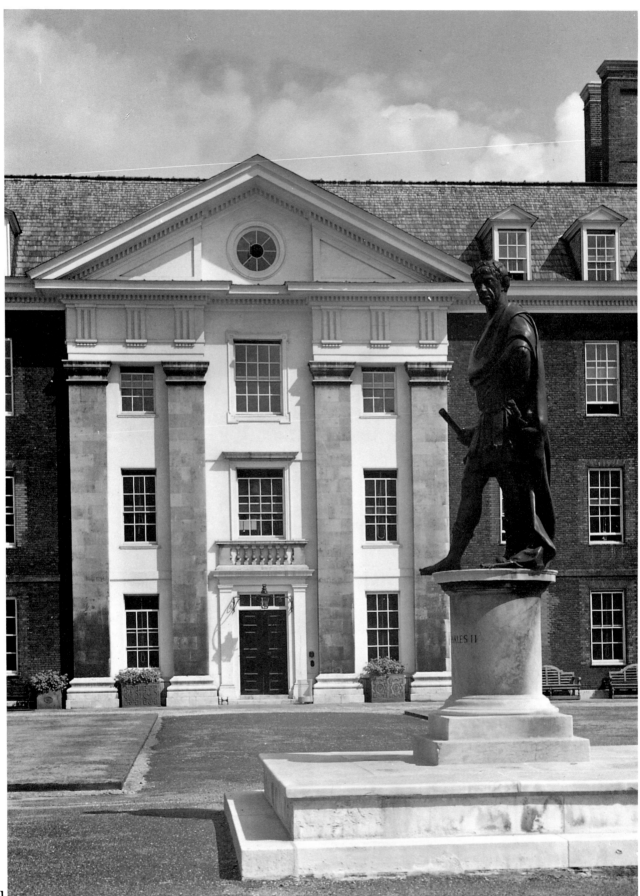

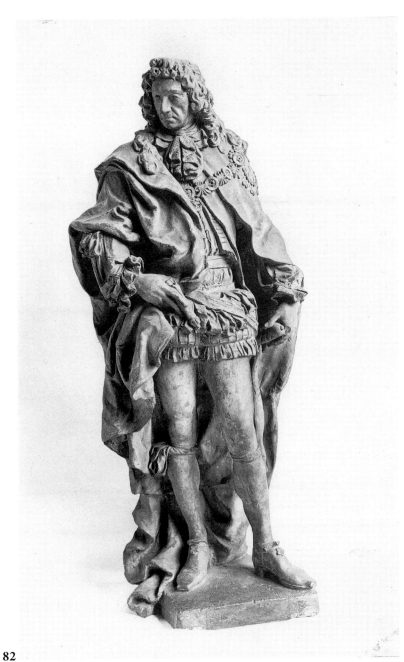

82

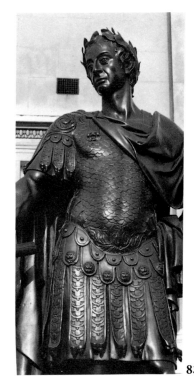

83

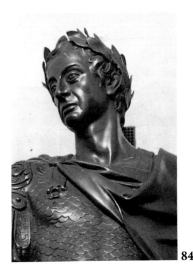

84

81. Royal Hospital, Chelsea. East front with statue of Charles II, 1676, bronze

82. *Charles II*, terracotta model by Arnold Quellin, 1685

83–84. Whitehall (now in front of National Gallery). *James II*, 1686–7, bronze

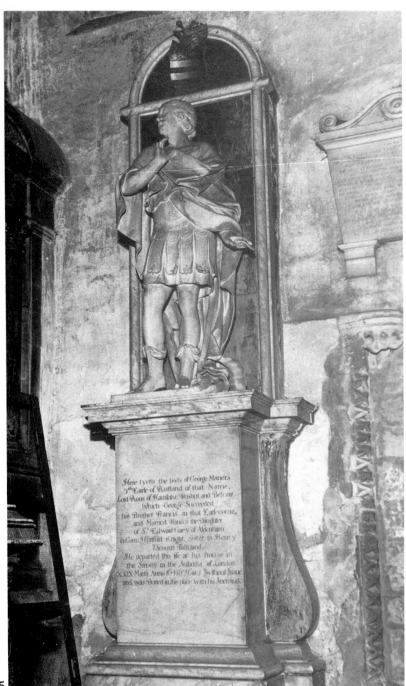

85–86. St Mary the Virgin, Bottesford, Lincolnshire. *Seventh Earl of Rutland*, d.1641

87–88. St Mary the Virgin, Bottesford. *Eighth Earl of Rutland*, d.1679, with detail of skull

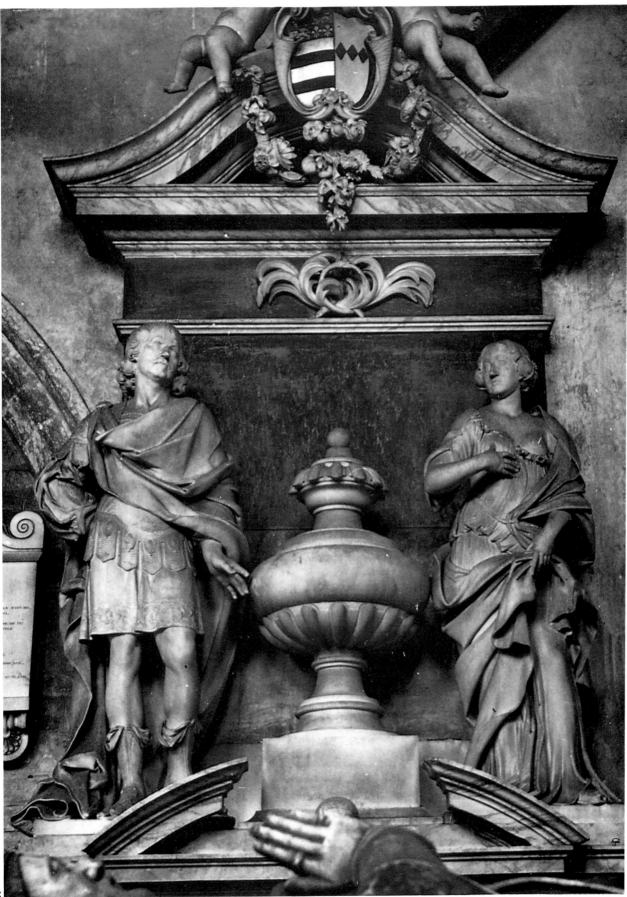

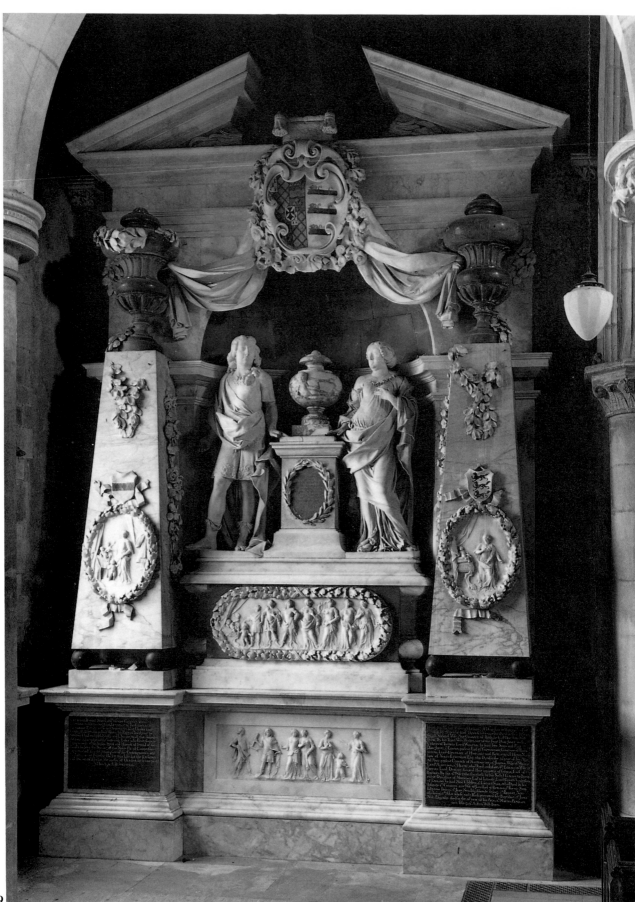

89

90

91

89–91. St Peter and St Paul, Exton, Rutland. *Third Viscount Campden*, d.1682, with details of two oval reliefs commemorating his first two wives

92

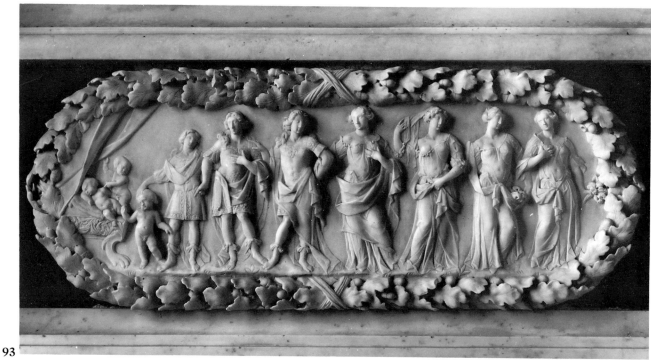

93

92–93. St Peter and St Paul, Exton, Rutland. *The Campden Monument*, details of two long reliefs commemorating, respectively, the children of Viscount Campden's third and fourth wives

94. Jesus College Chapel, Cambridge. *Tobias Rustat*, d.1693, detail

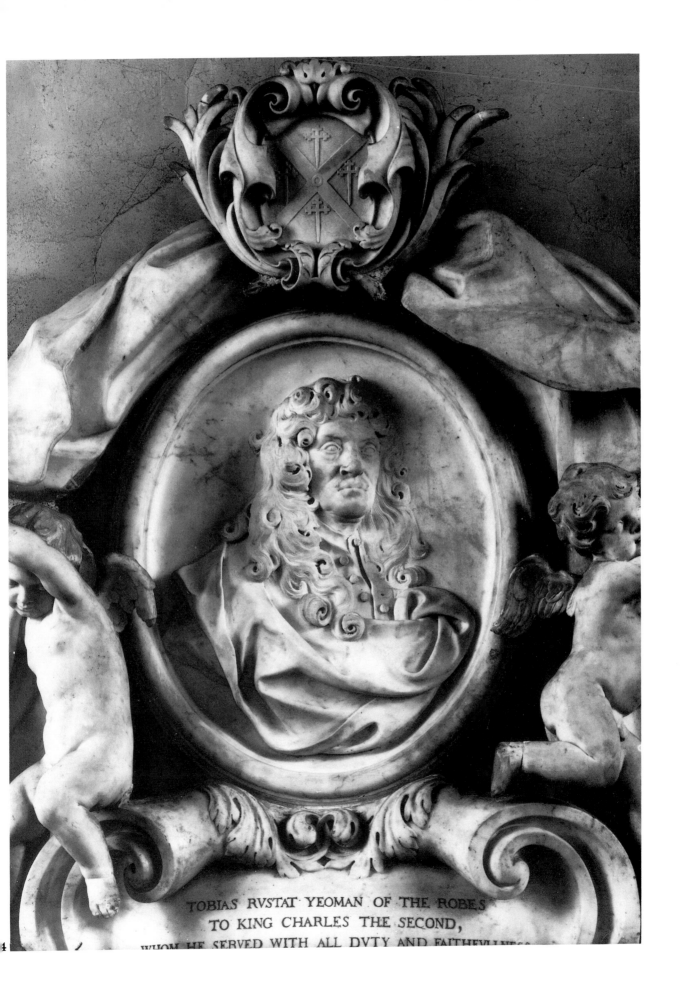

TOBIAS RVSTAT YEOMAN OF THE ROBES
TO KING CHARLES THE SECOND,
WHOM HE SERVED WITH ALL DVTY AND FAITHFVLNESS

95

96

98

95–96. Amsterdam Stadthuys. Details of marble carvings by Artus Quellin I, *c.* 1650

98. Tower of London. Horse by Gibbons, 1688, wood

97. St Mary Magdelene, Croome d'Abitot, Worcestershire. *Fourth Lord Coventry*, d.1687

99

100

99. Rochester Cathedral. *Sir Richard Head*, d.1689, marble

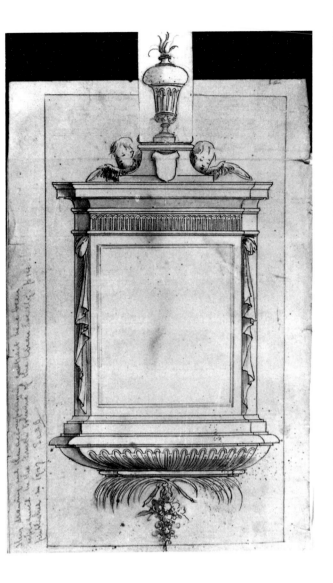

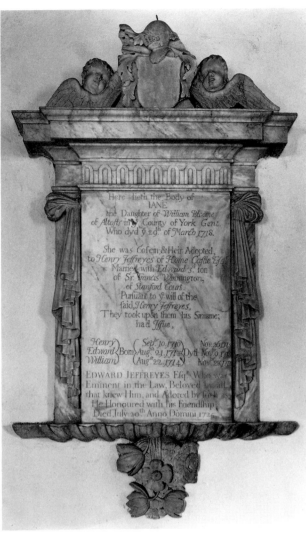

Here lieth the Body of
IANE
the Daughter of *William Bloome*
of Altofts in y County of York Gent.
Who dyd y 2d of March 1718.

She was Cosein & Heir Adopted,
to *Henry Jeffreyes* of Home Castle Esq.
Married with *Edward* 3d son
of Sr *Francis Winnington*,
of *Stanford Court*.
Pursuant to y will of the
said *Henry Jeffreyes*,
They took upon them his Surname;
had *Issue*,

Henry (Sept. 10.1710) Nov. 26 1713
Edward Born Aug. 21.1712 Dyd Nov. 9.1713
William (Aug. 22.1714) Nov. 23 1713

EDWARD JEFFREYES Esq. Who was
Eminent in the Law, Beloved by all
that knew Him, and Adored by such as
He Honoured with his Friendship,
Died July 20th Anno Domini 1725.

100–102. St Kenelm, Clifton-on-Teme, Worcestershire. *Elizabeth Jeffreyes*, d.1688; drawing; *Jane Jeffreyes*, d.1718

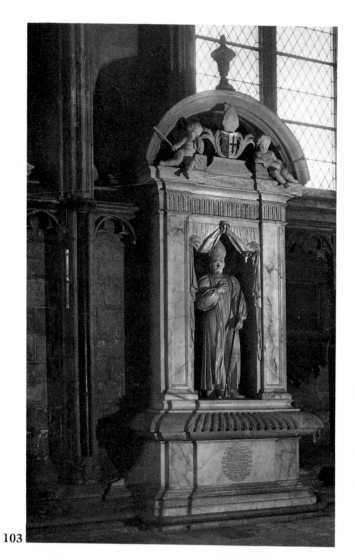

103

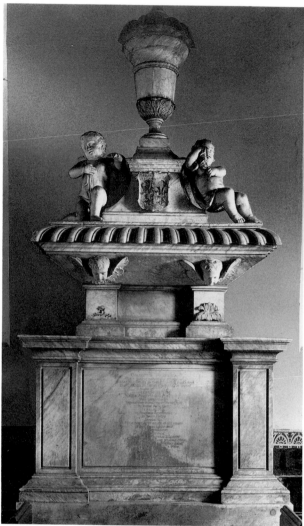

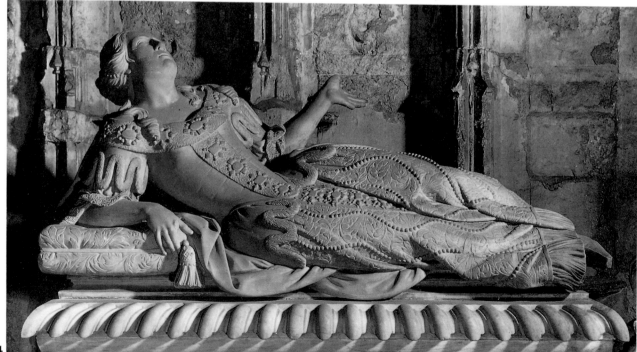

104

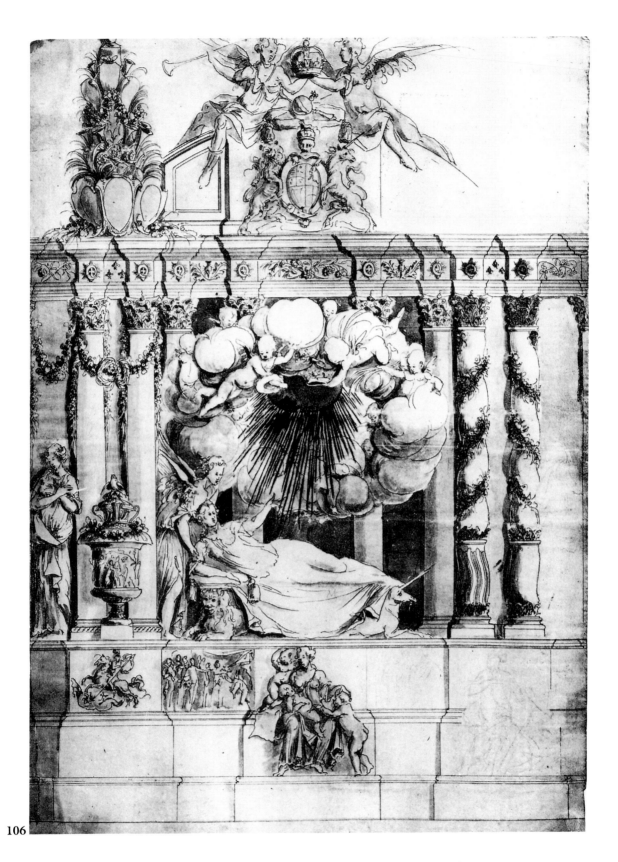

106

103. York Minster. *Archbishop Thomas Lamplugh*, d.1691, marble

104. Westminster Abbey, St Michael's Chapel. *Sarah, eighth Duchess of Somerset*, d.1692

105. St Mary, Nannerch, Flintshire. *Charlotte Mostyn*, d.1694, marble

106. Proposed monument to Queen Mary II, 1695

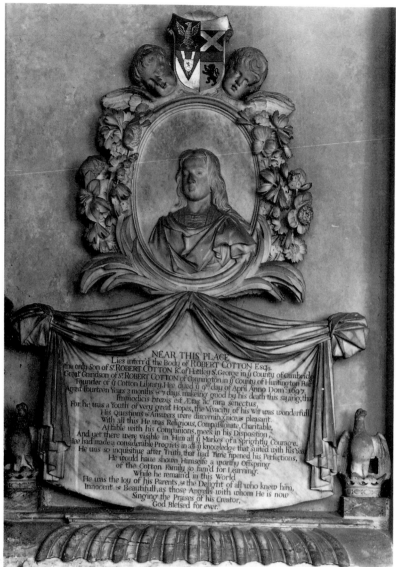

NEAR THIS PLACE
Lies interr'd the Body of ROBERT COTTON Esq.
the only Son of S.t ROBERT COTTON K.t of Hattley S. George in y.e County of Cambridge
Great Grandson of S.t ROBERT COTTON of Connington in y.e County of Huntington Bar.t
Founder of y.e Cotton Library, Hee dyed y.e 9.th day of April Anno Dom.i 1697.
Aged fourteen Years 3 months & 7 days, makeing good by his death this saying, that
Immodicis brevis est Ætas ac rara senectus,
For he was a Youth of very great Hopes, the Vivacity of his wit was wonderfull,
His Questions & Answers were discerning, nice, & pleasant.
With all this He was Religious, Compassionate, Charitable,
Affable with his Companions, meek in his Disposition,
And yet there were visible in Him all y.e Markes of a Sprightly Courage,
Hee had made a considerable Progress in all y.e knowledge that suited with his Years
He was so inquisitive after Truth, that had Time ripened his Perfections,
He would have shown Himselfe a worthy Offspring
of the Cotton Family so fam'd for Learning.
While he remain'd in this World
He was the Joy of his Parents, & the Delight of all who knew him,
Innocent & Beautifull, as those Angells with whom He is now
Singing the Praises of his Creator,
God Blessed for ever.

107 1

107–108. St Mary, Conington, Cambridgeshire. *Robert Cotton*, d.1697, marble

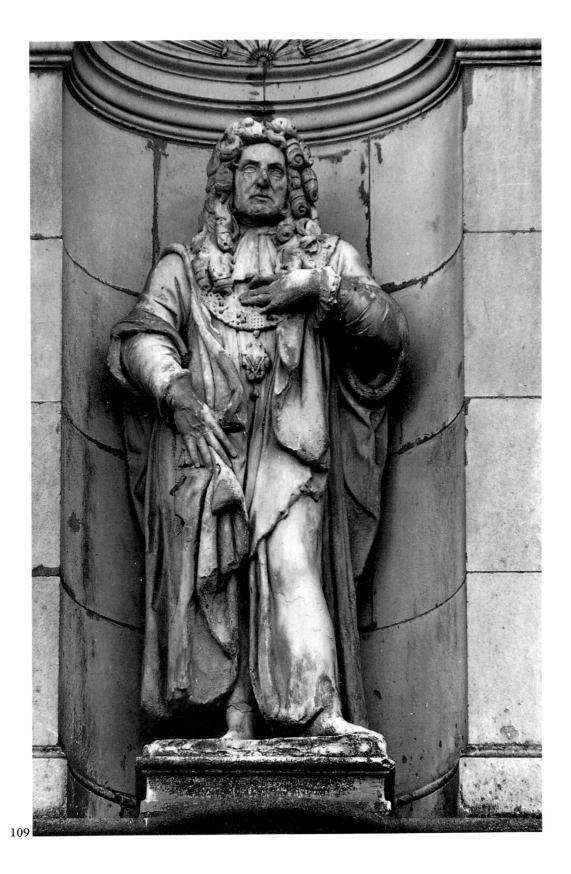

109

109. Christ's Hospital, London (now Horsham, W. Sussex). *Sir John Moore*, 1697–8, marble

110. St Paul's Cathedral Crypt. *Dr William Holder*, d.1698 and *Susanna Holder*, d.1688, marble

111. St Michael, Badminton, Gloucestershire. *Henry Somerset, first Duke of Beaufort*, d.1700, marble

11

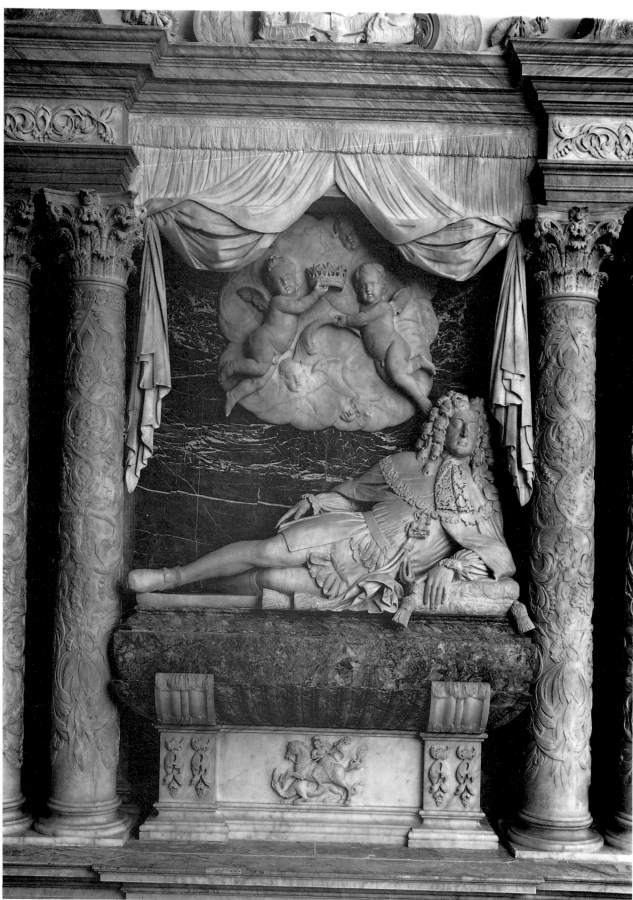

112

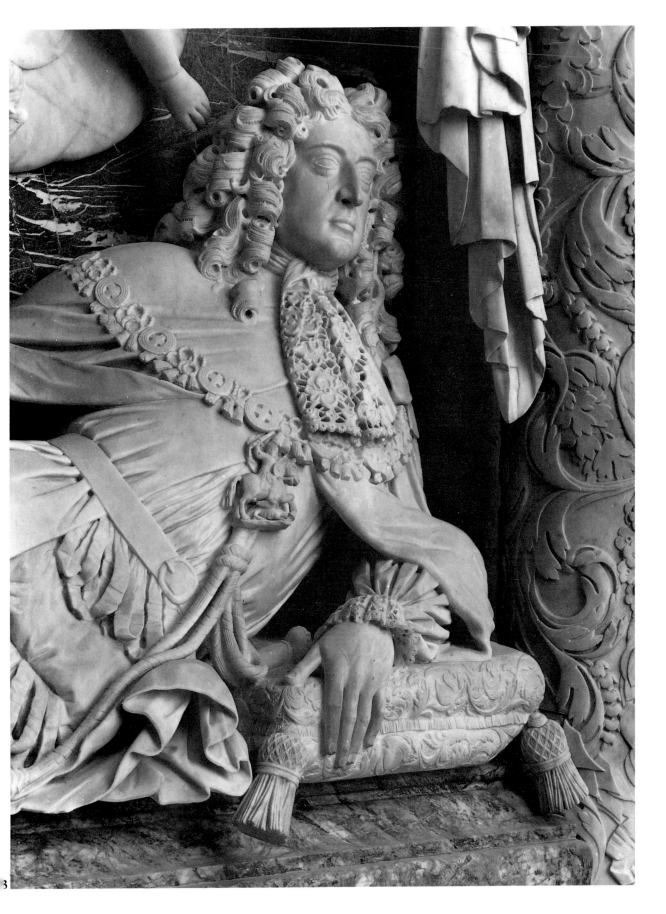

112–113. St Michael, Badminton. Details of reclining effigy of first Duke of Beaufort

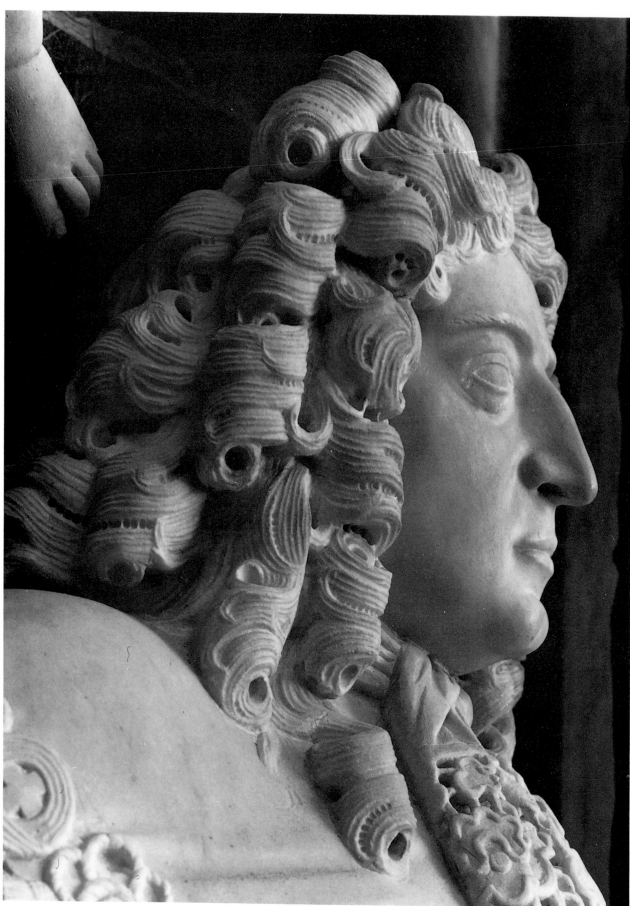

115

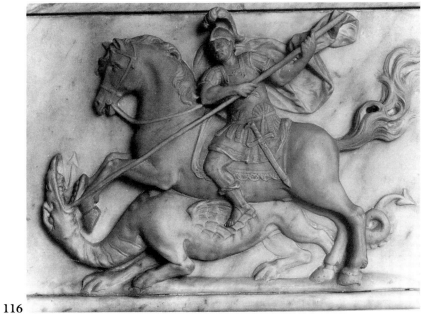

116

114–116. St Michael, Badminton. Details of head of first Duke of Beaufort, his coat of arms, and the Garter George

117

1

117. St Michael, Coxwold, Yorkshire. *Earl Fauconberg*, d.1700, and his father, the *Hon Henry Belasyse*, d.1647, marble

118. St Thomas's Hospital, London. *Sir Robert Clayton*, 1701–2, detail

119. Westminster Abbey. *Mrs Mary Beaufoy*, d.1705, marble

Near this Place lyes the Body of Mrs MARY BEAUFOY,
the only Daughter & Heir of Sr. HENRY BEAUFOY, of Guyscliffe,
near Warwick, by the Honoble. CHARLOTTE LANE eldest Daughter
of GEORGE Lord Viscount Lanesborough, and now the Widdow
LADY BEAUFOY, who caus'd this Effigies to be made and Erected
at her owne charge in Memory of her dear Daughter, the loss of whom
... she does very much lament.

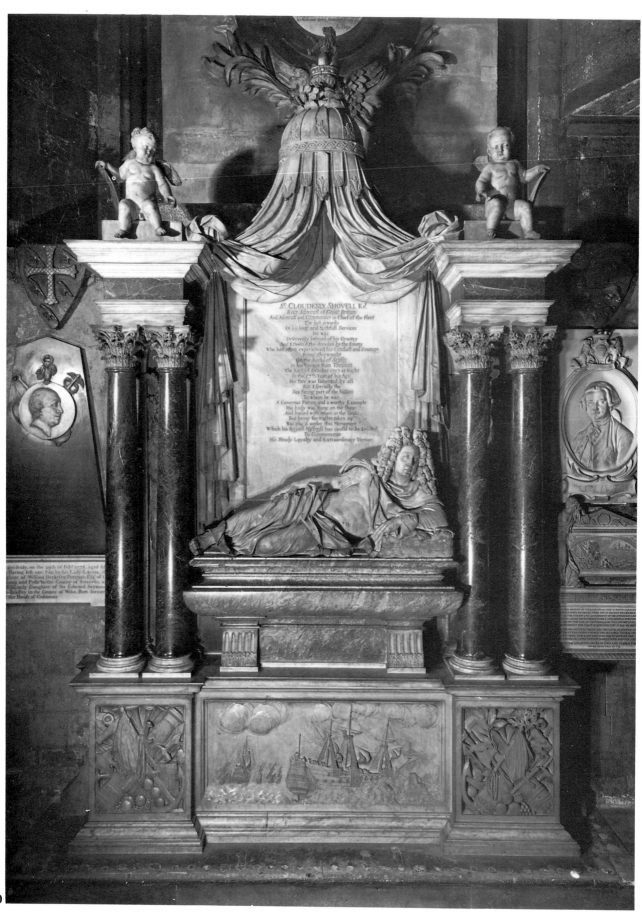

120

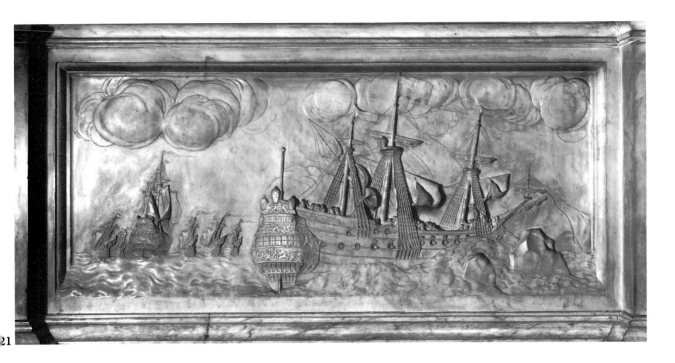

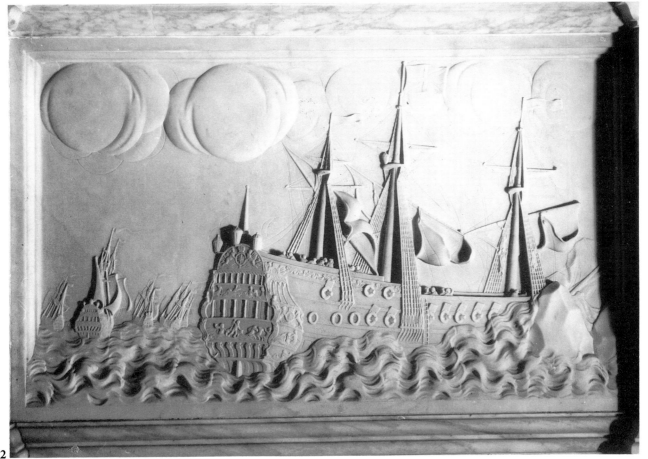

120–121. Westminster Abbey. *Admiral Sir Cloudesly Shovell*, d.1707, with detail of his flagship *Association*, marble

122. St Clement, Knowlton, Kent. *The Narborough Monument*, showing relief of the *Association* (*see* Pl. 121)

This was in tended
for the Inscription

S·D·M·

123

123–124. Westminster Abbey. Design for monument to *Admiral George Churchill*,
d.1710, and detail thereof in marble

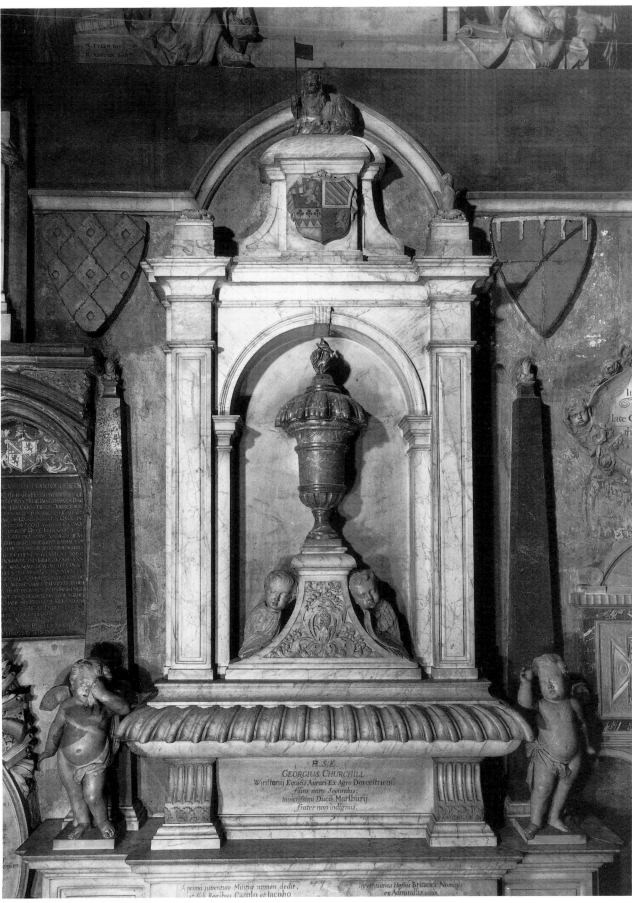

B. S. E.
GEORGIUS CHURCHILL
Winftonij Equitis Aurati Ex Agro Dorceftrienfi
filius natu Secundus,
Invictiffimi Ducis Marlburij
frater non indignus.

A prima juventute Militiæ nomen dedit,
at fub Regibus Carolo et Iacobo

Infeftiffimos Hoftes Britanni Nominis
ex Admiralliis unus

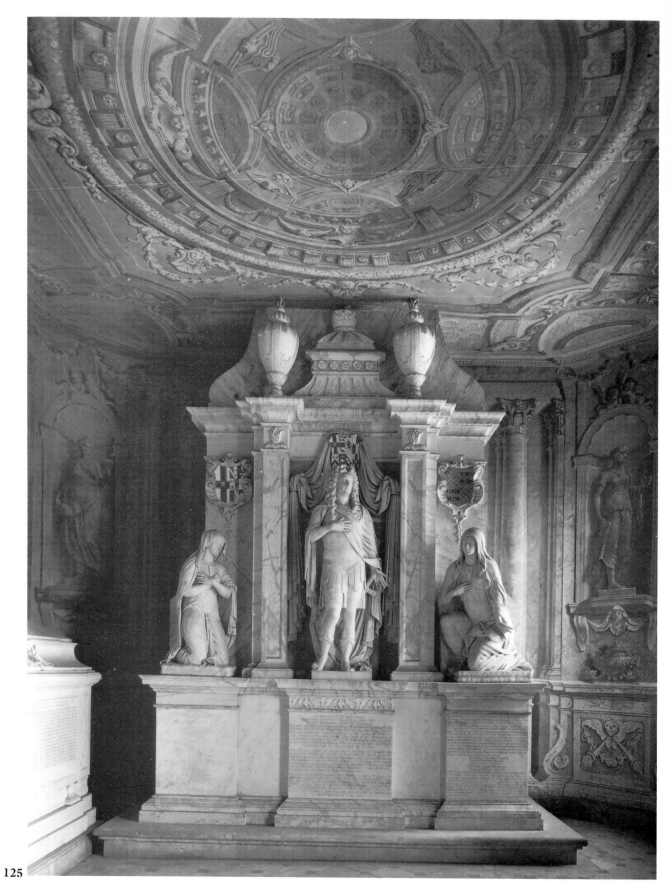

125. St Lawrence, Whitchurch, Middlesex. Monument to first Duke of Chandos and two of his wives, marble, *c.* 1717

Notes on the Plates

Notes on the Plates

PORTRAITS

1. 'Grinling Gibbons' (1648–1721), drawing, red and black chalk heightened in white by Sir John Baptist Medina (1659–1710), 9 × 6¾ ins, c. 1686. *British Museum, Dept. of Prints and Drawings,* No. 1852-2-14-375 (Photograph: Museum)

Inscribed in upper right corner 'J. Medina/Dᶜ' and on the old mount, by George Vertue: 'J. Medina Egues ad vivum delin' and 'G. Gibbons Sculptor &' (not completed).

Medina came to England from Brussels in 1686 and practised as a portrait painter in London. He left for Edinburgh in 1688 and apart from one further visit to England (? 1704) stayed there until his death. (See: E Croft-Murray and P. Hulton, *British Museum: Catalogue of British Drawings,* 1960, I, p. 447 & Pl. 238).

2. *Grinling Gibbons,* oil on canvas, by Sir Godfrey Kneller (?1646–1723), 48 × 39 ins, c.1690. *Hermitage Museum, Leningrad* (Photograph: Museum)

The original version of this portrait was acquired from Sir Robert Walpole's collection at Houghton Hall, Norfolk, by the Empress Catherine of Russia and is now in the Hermitage Museum. A copy is in the National Portrait Gallery, London, No. 2925, acquired 1937, and a further copy in the collection of the Viscount Galway, Serlby Hall, Notts. The portrait was much engraved, principally by John Smith (c.1652–1742) (reversed, c.1690–1700).

Gibbons is shown with his left hand resting on a female sculpted bust on a table, with callipers in his right hand. See David Piper, *Catalogue of Seventeenth-Century Portraits in the National Portrait Gallery, 1625–1714.* Cambridge, 1963, pp. 136–7.

3. Grinling Gibbons, and his wife Elizabeth (d. 1719), mezzotint by John Smith, after a lost painting, c.1691, by John Closterman. *Colonial Williamsburg, Virginia* (Photograph: Museum)

According to George Vertue the painting was 'Closterman's first peice that gain'd much Credit'. Professor J. Douglas Stewart has suggested (*The Burlington Magazine,* CXXIII, November 1981, p. 690) that the original portrait may have been destroyed when Gibbons's house, the King's Arms, Bow Street, London, collapsed in 1702, a fact noted by Vertue (*Notebooks,* III, p. 10). He further suggests the portrait in compositional terms recalls Van Dyck's *Daniel Mytens and his Wife* (at Woburn Abbey). See: Malcolm Rogers, 'John and John Baptist Closterman: A Catalogue of their Works', *Walpole Society,* XLIX, 1983, p. 247.

WOOD-CARVINGS: CROWN AND CHURCH

4. Wood-relief. *The Crucifixion,* after Tintoretto, pearwood, 56 × 32 ins. *The National Trust,* Dunham Massey, Cheshire. (Photograph: The National Trust)

David Green (*Gibbons,* p. 34) wrote of this panel: 'There is no spontaneity, nothing of Gibbons as we know him,' and, further, there are none of the 'festoones' Evelyn described in

his diary on 18 January 1671. Writing in 1925 (*Country Life*, 7 November), H. Avray Tipping considered that 'frame and panel were made for each other'. We do not know exactly when the panel entered the collection of the Earls of Stamford at Dunham Massey. The attribution needs to be regarded with caution as a work by Gibbons.

5. *St Stephen Stoned*, limewood and lancewood panel, $73 \times 48\frac{1}{2} \times 12$ ins, *c*.1670. *Victoria and Albert Museum, London* (Photograph: Museum)

Horace Walpole stated, unconvincingly, in the light of more recent knowledge, that this was the panel Gibbons was working on when discovered by Evelyn. Vertue asserted that it hung in the gallery of Gibbons's London house in Bow Street. A writer in *Notes and Queries* (series IV, III, p. 504) stated that Charles II had bought it although even the imaginative Walpole desisted at this. He tells us that the 'Stoning' was acquired from Gibbons by the Duke of Chandos (see Pl. 125). It was sold at the Cannons demolition sale in 1747 when it was bought by Mr Gore, maternal great-grandfather of J. G. Rebow to whom it descended finally in 1839. He removed it to Wyvenhoe Park (recording these facts in a letter to *The Builder*, 1862, p. 861). At Mr Rebow's death it was acquired for £300 by the Victoria and Albert Museum. (Tipping, *Gibbons*, p. 51; *Country Life*, 7 November 1925).

6. The Cosimo Panel, limewood, 55×42 ins, 1681–2. Sent by Charles II as a gift to Cosimo III, Grand Duke of Tuscany. *Palazzo Pitti, Florence* (*Museo degli Argenti*) (Photographs, 6–11, Gabinetto Fotografico, Soprintendenza Per I Beni Artistici E Storici di Firenze)

This is Gibbons's finest work and was duly signed by him (Pl. 7). A careful analysis of the panel's symbolism is given by Mary Webster and R. W. Lightbown, 'Princely Friendship and the Arts: a relief by Grinling Gibbons', *Apollo*, XCIV, September 1971, pp. 192–7.

The panel was in the conservation department of the Uffizi in 1966 where it was flooded and half buried in mud. It was restored, 1967–71, and returned to the Bargello Museum. In 1975 it came to the Pitti Palace and was blackened with smoke in the serious fire there, May 1984. Whilst the panel is now irretrievably darkened it was otherwise undamaged: it has remained at the Pitti Palace on display since 1984.

7. The Cosimo Panel, detail of centre right section.

The signature 'G. Gibbons Invent' (the 't' may be part of the 'n') is carved on a scroll below the exquisitely feathered goose quill. Webster and Lightbown (*op. cit.*, note to Pl. 6) have shown the panel left England in the ship *Woolwich* on 3 August 1682 and arrived at Leghorn on 17 November. On arrival the case containing the panel was opened in the Lazaretto and left for a month 'to give it an airing for fear of the plague'. It was then delivered to the British envoy in Florence, Sir Thomas Dereham. He presented it to the Duke in December, 1682

In Dereham's letter of 22 December (in which he enclosed one from the Duke) to the Secretary of State (now PRO, S.P. 98/16) he stated that 'since fame is the Aime and Reward of all virtuosi ...' he was sure that the Grand Duke's applause would give 'no small comfort' to Gibbons and to the architect Hugh May (d. 1684). Webster and Lightbown suggest that May helped Gibbons with the choice of symbolical motifs scattered throughout the panel. The Grand Duke's letter (16 December, in Italian) stated the panel to be: '... an admirable thing, it assuredly surpasses the imagination that a man may arrive at such refinement, delicacy and perfection of work ...'.

8. The Cosimo Panel, detail of upper section

Two doves, symbols of peace and love, are perched high on the cascade of point-lace at the simulation of which, in limewood, Gibbons excelled. An overdoor in the First George Room, Burghley House, Northamptonshire (where there are payments to Gibbons in the accounts) has a similar pair of doves and sword hilt with lions. The sword provides 'a strong central axis, so introducing an emphasis on symmetry which prevents the composition from becoming a jumble of *objets* (Webster and Lightbown, *op. cit.*, note to Pl. 6 above).

9–11. The Cosimo Panel, three details of central section

The Grand Duke's coronet is serene and untumbled, befitting the 'conqueror of royal hearts', at the left centre of the crowded composition. A medallion portrait of Pietro da Cortona (1596–1669), inscribed on the rim 'Petrus·Bertinus·E·Cortonna', was calculated to please the Grand Duke. It is based on a representation on a silver coin by C. J. F. Cheron (1643–*c*.95) of which there is an example in the Bargello Museum, Florence (Webster and Lightbown, *op. cit.*, note to Pl. 6 above, p. 195). Cortona had returned to Florence in 1641 to work for Duke Ferdinand in completing the 'Four Ages' and large ceilings of the ducal apartments in the Palazzo Pitti.

12. The Modena Panel, limewood, *c*.1685. *Galleria Estense, Modena* (Photograph: Soprintendenza Per I. Beni Artistici E Storici Di Modena E. Reggio Emilia)

There is no documentation for this panel, other than the medallion portrait of Gibbons at the left centre, carved with the legend 'GIBBONS INVENTOR ET SCULPSIT LONDINA'. It is assumed that the panel was sent by Mary of Modena, or her husband, the future James II (perhaps as Duke of York for the coronet (*right centre*) appears to be a ducal one) to Alfonso IV, Duke of Modena. The relief is a 'symbol of Death's triumph over the Arts'; whilst less brilliant than the Cosimo Panel, help with symbolism may again have been given by Hugh May (d. 1684).

13. Windsor Castle, Berkshire. King's Eating Room overmantel, detail of the Gibbons carving 1677–8 (Photographs: Royal Collections, 13–19, *reproduced by gracious permission of H.M. the Queen*)

In 1677 Gibbons and the then Master Sculptor and Carver in wood, Henry Phillips (fl. 1661–93), submitted their first bill including 'several sorts of Carved workes by them performed upon the Chimney-peeces, Pedestalls and picture fframes of . . . his Maties . . . Eateing Roome'. Surrounding Jacob Huysman's portrait of Charles II's Queen, Catherine of Braganza, above the overmantel, Gibbons took up the theme of the *Feast of the Gods* which Antonio Verrio had painted on the ceiling above.

14. Windsor Castle, Berkshire. King's Eating Room, detail of carvings in the east alcove

At each end of the Eating Room, to east and west, are alcoves with skylights. The last were probably inserted by Anthony Salvin in the 1860s. They illuminate superb wood-carvings. The execution is of a high standard, for here Gibbons was performing (as he was to do later in the Cosimo Panel, Pl. 6) for Charles II, who had done much to encourage the precocious talent which John Evelyn had drawn to his attention.

15. Windsor Castle, Berkshire. Queen's Audience Chamber, detail of the Gibbons carving, 1677–8

Surrounding Honthorst's portrait of William, Prince of Orange, Gibbons has headed the array of limewood carving with large roses, palms and

hops and leaves of willow. More flowers, pea-pods and fruits form the side-drops. The foliated scrolling at the bottom seems a little awkwardly placed and is probably the result of nineteenth-century refixing of the carvings.

16. Windsor Castle, Berkshire. Queen's Audience Chamber, detail of the Gibbons carving, 1677–8

In the competent drops at either side of the portrait of Mary, Queen of Scots are the usual pea-pods, sunflowers, martagon lilies, forget-me-nots, and large double poppies. Again the foliated scrolling of acanthus looks awkwardly placed above the door and obviously represents the moving and reassembly of carvings during the early-nineteenth-century rephrasing of the castle by Sir Jeffry Wyatville. It should be assumed that the carved letters 'MR' at the head of the frame are a Victorian addition.

17–18. Windsor Castle, Berkshire. Two views of carvings by Gibbons on the pedestal of the equestrian statue of Charles II, marble, 1679

On 24 July 1680 John Evelyn recorded in his *Diary*: 'Went with my Wife and Daughter to Windsor . . . There was erected in the court the king on horseback, lately cast in copper, and set on a rich pedestal of white marble, the work of Mr Gibbons, at the expense of Toby Rustate . . .'.

The equestrian statue of Charles II was entrusted to Josiah Ibach. One of the horse's hooves is signed: 'Josias Ibach Stadti Blarensis 1679 fudit'. Rustat paid Ibach £1,300 (in two sums of £1,000 and £300). Gibbons charged for the panels in his 1679–80 accounts: 'Car-veing and Cutting ye IIIIr white Marble Pannells of the Pedistall of his Mats Statue on horseback . . ., 400 l.'

19. Windsor Castle, Berkshire. Pedestal of sundial, c.1679–80

Included in Gibbons's bill for carving the marble panels for the pedestal supporting the equestrian statue of Charles II (Pls. 17–18) is: '. . . for cutting & carving ye Mouldinges & ornaments for ye pedistall of ye large Diall in ye North Terrace'. The sundial, with its 'large double horizontall dyall' by Henry Wynne, is a hand-some piece of stone-carving with ribboned swags and bold acanthus leaves.

20. Kensington Palace. King's Presence Chamber, overmantel, c.1690. (Photographs: Royal Collections, 20–21, *reproduced by gracious permission of H.M. the Queen*)

Gibbons's work may have been designed in the first instance for the King's Gallery and after being transferred to the King's drawing room in 1721 was placed in the Presence Chamber in 1724. This had been altered for George I and includes William Kent's ceiling (1724) painted in the Pompeian manner.

The carving shows both bright and sorrowing cherubs, two each side of the portrait of Queen Charlotte with wheat, fruit and flowers and draped folds, headed by two doves perched on more fruit and flowers under the enriched cornice.

21. Kensington Palace. Queen Mary's Gallery, gilded overmantel by Gibbons, one of a pair, c.1690

The framework on which Gibbons's carving was set was provided by the Dutch cabinet-maker Gerrit Jensen, and overmantels were gilded by Verrio's colleague, René Cousin. The over-mantels are much restored, but the design is interesting with bold scrolls at the feet. The folded drapes at each side are encountered again at Hampton Court.

22. Hampton Court, Middlesex. King's bed-chamber, c.1700 (Photograph: Department of the Environment, *Crown Copyright Reserved*)

This fine room, part of Sir Christopher Wren's remodelling of the palace for William III, has a painted cove and ceiling by Antonio Verrio telling the story of Diana and Endymion, wood-carvings in frieze and overmantel by Gibbons and a marble chimneypiece by John Nost. The fine carving around the doorcases is shown in Pl. 23. Some of the Hampton Court doorcases (e.g., the Banqueting House) were enriched with six carved mouldings.

23. Hampton Court, Middlesex, King's Chamber, door frame carving, oak, *c*.1700 (Photograph: National Monuments Record)

24. Hampton Court, Middlesex. Guard Chamber, 1718 (Photograph: A. F. Kersting)

Gibbons was much occupied in the series of state rooms at Hampton Court, but on the King's death in 1702 work ceased and was not considered again until George I wanted suitable accommodation for the Prince and Princess of Wales and their children. In July 1716 John Vanbrugh visited the house with the Prince of Wales to discuss the refurbishing of six rooms. The works were completed by 1718; it is assumed that the chimneypiece with the unusual feature of life-size figures of yeomen of the guard as caryatids was Gibbons's work. (See: H. M. Colvin, ed., *History of the King's Works*, V, 1976, p. 178)

25. Hampton Court, Middlesex. Music room chimneypiece by Grinling Gibbons and Benjamin Jackson, *c*.1718 (Photograph: A. F. Kersting)

Whilst there is no precise documentation for the chimneypieces in the various rooms refurbished under John Vanbrugh's direction, 1716–18, this one is likely to be a joint achievement. In September 1718 Gibbons was paid £533 for carved work in six rooms, including the 'Music Chamber', and the Master Mason Benjamin Jackson

received £617 'for white and veined marble, Egyptian marble, fire hearths, coving stones and workmanship in the Musick Room &c'. (See: H. M. Colvin, ed., *History of the King's Works*, V, 1976, p. 178)

26. Cambridge, Trinity College Library. Interior, 1676–92 (Photograph: A. F. Kersting)

Christopher Wren took a great deal of trouble over the interior arrangement, natural lighting and furnishing of the Library. Many of the tables, bookrests and stools he designed survive, and although marble paving was used for the middle alley, the cells between each bookcase were floored in wood to make less dust. Gibbons carved many features in the library in the early 1690s under the patronage of Charles Seymour, sixth Duke of Somerset, a Trinity man, and Chancellor of the University from 1689 (Pl. 27).

27. Cambridge, Trinity College Library. Gibbons's statue of Charles Seymour, sixth Duke of Somerset, 1691. (Photograph: Courtauld Institute of Art, University of London)

Wren's design was altered to include a niche at the south end to contain Gibbons's statue of the duke. The statue in roman armour is not a good one but is similar to the bronze one of James II (Pl. 83) now in front of the National Gallery, London. He charged £245 for the Duke's statue, for the limewood coats of arms (Pl. 28) and an unspecified number of 'bustos' (nine named and others unnamed). (See: Margaret Whinney, *Grinling Gibbons in Cambridge*, 1948, p. 8)

28. Cambridge, Trinity College Library. Gibbons's carving of the coat of arms of William Lynett D.D., limewood, 1691 (Photograph: A. F. Kersting)

The coat of arms is set at the top of one of Cornelius Austen's cedar bookcases, which stand out from the library walls (Pl. 26).

Each benefactor who is commemorated had given £28 towards the cost of the bookcases (the Bishop of Coventry gave £50) and the carvings were provided by Gibbons at a charge of £5 each. Five benefactors including Lynett paid for their own coats of arms.

29. St Paul's Cathedral. Engraving of the interior of the Choir, by Robert Trevitt, 1706, *Guildhall Library, London* (Photograph: Library)

Inscribed 'On a Day of General Thanksgiving, 31 December 1706, for victory at the Battle of Ramillies, Queen Anne and Members of both Houses of Parliament assembled in St Paul's'.

The Cathedral is shown almost complete, with the great organ, its case carved by Gibbons across the choir screen (Pl. 30), and the south range of stalls.

30. St Paul's Cathedral. Engraving of the interior looking to the choir, *c.*1720, *Guildhall Library, London* (Photograph: Library)

Inscribed 'The Inside of the Cathedral Church of St Paul's, London. Printed and sold by Henry Overton, at the White Horse without Newgate'.

The engraving shows clearly the dominant position of the organ, called by Wren 'a box of whistles', set across the entrance to the choir.

31. St Paul's Cathedral. Organ-case, carved by Grinling Gibbons, 1696–7 (Photograph: A. F. Kersting)

The entire organ-case was carved by Gibbons and his team, a riotous display of trumpeting angels, *putti*, scrolls and cartouches. Unfortunately, in 1872, the magnificent planning of Wren's architectural masterpiece was distorted by the splitting of the organ-case in two and placing the two cases facing each other across the aisle at the western end of the choir. The acoustics were ruined and much of the case itself lost. The effect overall is rendered more complicated by the erection in 1958 of the new

altar and baldacchino. (See: Green, *Gibbons*, Pl. 134)

32–33. St Paul's Cathedral. Choir stalls, south side, 1696–7 (Photographs: A. F. Kersting)

At the east end is the superb Bishop's stall (Pl. 33) for Bishop Henry Compton (1632–1713), a riot of flowers and *putti* surmounted by the Bishop's mitre, with every virtuoso swirl approved by Wren.

Gibbons charged £36 for the seat (*Wren Society*, XV, p. 32).

34–36. St Paul's Cathedral. Choir stalls, north side, 1696–7 (Photographs: A. F. Kersting)

On the north side the centre of the range (Pl. 35) contains the Lord Mayor's stall. It copies in outline the domestic stall of the Bishop on the south side facing it. The *putti* hold the sword and mace, above an enriched hood. There is a sketch by Gibbons (*Wren Society*, II, Pl. 29) for a variant of this stall showing urns and drapes which were not executed. A detail of the carving over the stalls is shown in Pl. 36.

37. St Mary Abchurch, London, 1681–6. Reredos with carvings by Grinling Gibbons (Photograph: A. F. Kersting)

The reredos by Gibbons (his bills survive at the Guildhall Library, MS. 3295) is a splendid composition of double Corinthian columns supporting a broken pediment enriched with limewood carvings. The gilded pelican and nest surmount two segmental headed text boards. Four flaming urns lead the eye to the royal arms at the shaped top. This small domed church was bombed in 1940, and restored carefully, 1948–53.

38. St James's, Piccadilly, London. Detail of the Gibbons carving on the reredos, limewood, *c.*1684 (Photograph: A. F. Kersting)

The church was built by Wren at the expense

of Henry Jermyn, Earl of St Albans, and was consecrated on 13 July 1684. The organ, made by Renatus Harris, in an enriched case by Gibbons, had been originally at the Catholic chapel in Whitehall Palace. It was given to St James's in 1691 by Queen Mary. John Evelyn visited the church in December 1684 and noted the 'flowers & garland about the walls by Mr Gibbons in wood ... There was no altar any where in England, nor has there been any abroad, more handsomely adorn'd.'

39. St James's, Piccadilly, London. Marble font by Grinling Gibbons, *c.*1685 (Photograph: A. F. Kersting)

When the church was consecrated in 1684 it still needed many fittings. In 1685 'an unknown person piously inclined' gave the font carved by Gibbons. His share in it we owe to the inscription on an engraving of the font by George Vertue, dated 1718. This reads: *'Opus Grinlini Gibbons Ære jam perenniori sculpsit Georgius Vertue* 1718'. The pedestal is in the form of the trunk of an apple tree with standing figures of Adam and Eve. The bowl is enriched with cameo-reliefs of Noah's Ark, the baptism of

Christ (shown here) and the baptism of the eunuch of Candace by St Philip.

40. Two designs for *Entablatures to Great Rooms,* by Grinling Gibbons, *c.*1692. *Sir John Soane's Museum, London* (Photograph: A. C. Cooper Ltd)

The upper illustration is almost identical to the carved frieze in the King's bedchamber at Hampton Court (Pl. 22), and the lower one was probably for use in the state rooms of the same palace, as it incorporates a crown between two cherubs' heads and below a 'W' and 'M' cypher. If this is so, the drawing would precede the Queen's death in 1694.

41–42. Two projects for a chimneypiece and an overmantel at Hampton Court, Middlesex, by Grinling Gibbons, *c.*1692. *Sir John Soane's Museum, London* (Photographs: A. C. Cooper Ltd)

The full quality of Gibbons's skill as a draughtsman is here with just enough lines and shading to give spirit and verve to the compositions. That surrounding the overmantel frame (Pl. 42) has an outer frame of gilded strapwork headed by a dove within a chaplet of palm leaves.

WOOD-CARVINGS: COUNTRY HOUSES

43–44. Sudbury Hall, Derbyshire. Overmantel by Gibbons in the drawing room, with a detail of the left drop (Pl. 44), limewood, *c.*1677 (Photographs: The National Trust (43); John Bethell (44))

George Vernon's account book includes an entry for 1677: 'Mr Gibbons had for ye carved work on ye drawing room chimney £40'. With the termination of the drops in fish and an eel, the display is more suited to an eating room, but the lack of such a formal room in many seventeenth-century interiors does not make this

unusual in its present setting, as specified in the payment.

45–46. Badminton House, Gloucestershire. Overmantel carving by Grinling Gibbons in the dining room, pearwood, *c.*1683 (Photographs: A. F. Kersting)

There is good reason to think that this carving was commissioned by the first Duke of Beaufort to commemorate the acquisition of his title in 1682. The cresting includes the garter encircling a cypher in which the eight letters representing

'Beaufort' are intertwined with great ingenuity (Pl. 46). At either side are drops of game birds, fruit and flowers.

There are two payments in 1683 and 1684 to Gibbons noted in the first Duke's bank account (Child's Bank, London).

47. Chatsworth, Derbyshire. Point cravat by Gibbons, limewood, c.1685, *Trustees of the Chatsworth Settlement* (Photograph: Geoffrey Beard)

Horace Walpole wrote that Gibbons had worked at Chatsworth (which is not correct) and continued: 'he presented the Duke with a point cravat, a woodcock and a medal with his own head ...'.

This enchanting fragment (a similar one which belonged to Walpole is now in the Victoria and Albert Museum; Green, *Gibbons*, Pl. 50) was perhaps part of a greater whole or a piece left from the similar carving of the Cosimo and Modena panels (Pls. 6, 12). The medallion portrait of Gibbons is similar to the drawing of him by Sir John Baptist Medina (Pl. 1).

48. Belton House, Lincolnshire. Marble Hall, detail of the Gibbons carving, limewood, c.1688 (Photograph: A. F. Kersting).

It should be noted that the evidence connecting Gibbons with this Belton carving is slight. In the 1738 inventory of Viscount Tyrconnel's house at Arlington Street, London is the entry: 'A fine piece of carving in a panel by Gibbons'.

As a detailed examination of the family archives has been undertaken for the National Trust (by Mrs Rosalind Westwood) it is unlikely more evidence will emerge; apart from inventories of 1688 and 1698 (in which no Gibbons item appears) there are few accounts prior to 1737.

49–50. Amsterdam, the Stadthuys. Two details of the marble carving by Artus Quellin I, c.1650 (Photographs: The Stadthuys)

Gibbons presumably knew these carvings in detail when he was associated in the early 1660s with the Quellin family. I have also assumed that Gibbons possessed Hubertus Quellin's two volumes on the carvings at the Stadthuys, published in 1665–6. The similarity of this carving to Gibbons's work in wood at Petworth is surely more than a coincidence.

51–52. Petworth House, W. Sussex. Carved Room, two details of a trophy, limewood, by Grinling Gibbons, c.1692 (Photographs: Jeremy Whitaker (51); Geoffrey Beard (52))

Amongst work by John Selden, the competent 'house-carver' and by Jonathan Ritson senior, is much of Gibbons's own superb carving, including this trophy. It alludes to what he might have seen in Amsterdam more than twenty years previously (Pl. 49). The assemblage of instruments, notated score, quiver of arrows, portrait medallion and point-lace cravat is as good as the carving in the Cosimo Panel (Pl. 6).

53. Petworth House, W. Sussex. Carved Room, detail of the trophy with the Star of the Order of the Garter and two antique vases, by Grinling Gibbons, limewood, c.1692 (Photograph: A. F. Kersting)

Flanked by carved filigree picture frames (which may be by John Selden) the trophy contains what Horace Walpole described as 'an antique vase with a basrelief, of the purest taste and worthy the Grecian age of Cameos'.

The reasoning behind the inclusion of the vases is not clear, in the way that the presence of the emblems of the Order of the Garter is: the sixth Duke had been installed as a Knight of the Order in April 1684. Vertue recorded (*Notebooks*, II, p. 81) that John Selden had lost his life 'saving the carving being burnt when the house was on fire' in 1715. We do not know what was lost, but one of the vases is charred at the foot.

54–55. Petworth House, W. Sussex, Carved Room, two details of the Gibbons carvings, limewood, *c*.1692 (Photographs: A. F. Kersting (54); Geoffrey Beard (55))

This section of the carvings on the east wall (directly above that shown in Pl. 49) uses a basket similar to those depicted in the flower paintings of Jean Baptiste Monnoyer (1634–99), who worked in England from 1678 until his death. Above are the wings of Fame from which on a simulated ribbon hangs the George of the Order of the Garter. Between is the cypher of the intertwined initials 'C' and 'E' for Charles Seymour and his wife Elizabeth Percy, the sixth Duke and Duchess of Somerset (Pl. 55).

56. Petworth House, W. Sussex. Carved Room, detail of the carving, on the south wall, limewood, *c*.1692 (Photograph: The National Trust)

Whilst the carvings on the east wall (Pls. 51–55) are undoubtedly among the most important at Petworth this arrangement merits attention. Whorls of acanthus are scrolled among two cherubs' heads in a masterly way, fully worthy of Gibbons; however there is no documentation in the form of a precise payment and John Selden's skills are all too evident in the carvings surrounding the portrait of Henry VIII, and in the Chapel. (See: G. Jackson-Stops, 'The Building of Petworth', *Apollo*, 105, May 1977, p. 329)

57–59. Dalkeith House, Lothian, Scotland. Neptune and Galatea overmantel and two details of the relief by Grinling Gibbons, marble, 60 × 30 ins, *c*.1701 (Photographs: Scottish National Monuments Record)

This documented overmantel was made for Moor Park, Hertfordshire, which had been settled on the Duchess of Buccleuch (then a countess) by James II in 1685. In 1701 the Duchess decided to return to Scotland and to refurnish Dalkeith House. Gibbons's bill, dated June 1701, is for: 'a Basterleafe in Marble being the Story of Neptune and Gallatea with a marble base Cornich Slips a new firehart, one paire of covings, boxing and fixing up, £80'.

60–61. Blenheim Palace, Oxfordshire. Exterior from the south-east and (61) a detail of the east wing lantern and finials, by Grinling Gibbons in stone, *c*.1709 (Photographs: A. F. Kersting)

In December 1708 the Strong family of masons charged for time in: 'Hoisting & Setting up a Trophy for a Modell in the south east corner of the south east tower, taeking the first Trophy down againe and Setting up a Globiler Vause on the first Corner for My Lady Dutchesses Approbation . . .'.

The silhouette of these tower-finials, sixteen at an overall height of 30 ft, was important to Vanbrugh and the testy Duchess of Marlborough. Gibbons charged for them at £20 each as 'the Scrolls a flower De Luce revers'd and Corronett upon the same'.

62. Blenheim Palace, Oxfordshire. Trophy on west side of steps below the north portico, by Grinling Gibbons, stone, *c*.1710 (Photograph: A. F. Kersting)

Whilst the helm on this trophy has slumped from its high position in the last few years (it will be restored as part of the ongoing programme of stone restoration at the house) the emphasis is still evident: the accoutrements of military activity interpreted in a Roman manner. The whole story of the first Duke of Marlborough's successful routing of the armies of Louis XIV is put in the Latin inscription on the entablature of the south front (Pl. 60); in translation it reads: 'The assertor of the liberty of Europe dedicates these lofty honours to the genius of Britain'.

63. Blenheim Palace, Oxfordshire. Hensington Gate, piers by Gibbons, stone, *c*.1709 (Photograph: Geoffrey Beard)

Gibbons carved and 'frosted' the gate piers for the formal garden on the east front of the Palace. The Duchess of Marlborough lost no time in ordering the destruction of the flanking archways as it blocked her view. The wall survives in part but the piers, probably to a design by Nicholas Hawksmoor, and topped with basins of flowers for which Gibbons charged £8 each, were re-erected as the Hensington Gate on the Oxford side of Woodstock.

64. Blenheim Palace, Oxfordshire. Design for the saloon, *c*.1707. *Bodleian Library, Oxford*, MS., Top. Oxon., a. 37* folio 32 (Photograph: Library)

The first idea for the saloon proposed by Vanbrugh and Hawksmoor consisted of round-headed recesses between Corinthian pilasters, an echo of the arrangement in the Great Hall. However a French artist, Louis Silvestre, prepared a long critique of it in September 1707, and sent his own scheme. He was seemingly no threat to the established team and the scheme with niches and giant statues remained the accepted one until work was resumed (after a four-year delay) in 1716.

Re-examination of the scheme after the Duchess of Marlborough had dismissed John Vanbrugh caused a radical change. The niches, which Grinling Gibbons had already carved (for the 10 ft statues Vanbrugh was trying to acquire from Italy) were to disappear beneath the paintings of Louis Laguerre.

65. Blenheim Palace, Oxfordshire. Saloon, painted by Louis Laguerre (1719); marble doorcases by Grinling Gibbons, *c*.1712 (Photograph: A. F. Kersting)

Gibbons charged £179 6s in 1712 for the 'Great Doorcase in the west wall of the Salon and marble work for the Neeches there'. Work then ceased at the house but Gibbons and his team must have made the three other doorcases (although they were not installed) between June and September 1712: in the latter month the house was abandoned to the nightwatchmen, until the spring of 1716. The niches which Gibbons had carved disappeared finally under Laguerre's paintings, but Vanbrugh, in an estimate of 1714 to finish the saloon, had included £1,200 for the three marble doorcases, a handsome payment bearing in mind the earlier charges.

MONUMENTS AND STATUES

(all in marble unless otherwise stated)

66. Detail of the Chancery document recording a dispute between the 'Coepartnership' of Grinling Gibbons and Arnold Quellin, 1683. *Public Record Office*, MS., C9/415/250 (Photograph: Record Office)

Published here for the first time, the Chancery suit was taken out by Gibbons against his partner, in that Quellin had failed to render monies due for work done or keep any proper accounts. The articles of co-partnership were

therefore cancelled. Bearing in mind that in 1686, the year of Quellin's death, he and Gibbons were working jointly on the Catholic Chapel at Whitehall being prepared for James II it would seem the quarrel was resolved 'out of court'.

67. All Saints, Sutton, Bedfordshire. *Sir Roger Burgoyne*, d. 1677 (Photograph: Geoffrey Beard)

The first dated Gibbons monument so far known is that to Sir Roger Burgoyne. It is competent but ordinary, although some of the characteristics of later work are present: in particular, the gadrooned sarcophagus. The monument was erected at the order of Sir Roger's friend, Sir Ralph Verney. At its completion Sir Peter Lely or Hugh May were to decide whether £100 or £120 should be paid for it, but the cost was not to exceed the larger sum.

68–70. St Editha, Tamworth, Staffordshire. *The Ferrers Monument* and two details of the figures of John Ferrers (d. 1680) and his son Sir Humphrey (d. 1678) (Photographs: National Monuments Record (68); Geoffrey Beard (69–70))

This fine monument at the west entrance ante-chapel to Tamworth's parish church must be mainly the work of Gibbons's partner, Arnold Quellin. The articles of partnership (Pl. 66) allow this firm suggestion. Sir Humphrey was drowned crossing the River Trent in 1678. The splendidly Baroque kneeling figure of him (Pl. 69) facing his father (pl. 70) shows the skills which the Gibbons team could now offer, even if Quellin did act carelessly and dishonestly. Both faces may be compared for treatment of curls and stance with the documented monument by Quellin to the memory of Thomas Thynne (Pl. 72).

71. Grocers' Hall, London. *Sir John Cutler*, 1681–2, by Arnold Quellin, detail (Photograph: David Ryskamp)

This standing figure, costed at £83, was paid for in 1681–2. Another figure of Cutler by Quellin was made for the College of Physicians in 1683; it is now in the Museum of London. Cutler is shown here, in his furred livery gown, with his left hand outstretched. I am assuming that Quellin, 'servant' to Gibbons from 1679, and

his partner from 1681, was acting on their joint behalf.

72. Westminster Abbey, South Choir Aisle. Detail of the monument to Thomas Thynne, d. 1682, by Arnold Quellin (Photograph: Michael Felmingham)

Arnold Quellin was in England and in Gibbons's service by 1679. He became a partner in the monument business in 1681. The best known of his surviving works is that to Thomas Thynne, who was murdered in 1682. Quellin died young in 1686, at the age of thirty-three.

73–74. St Andrew, Burnham-on-Sea, Somerset. Two of the carved angels (? by Arnold Quellin), marble, 1686, from the upper cornice of the altarpiece. From the Chapel, Whitehall Palace, dispersed 1695 (Photographs: A. F. Kersting)

In May 1685, within three months of James II's accession, Wren, by royal command, had designed and begun to build the richly furnished Catholic Chapel. The high altar, in marble, was contracted to Gibbons and to Arnold Quellin: 'that they will set up, finish and complete the same at or before the 25th day of September next ensuing under the penalty of £100, to be forfeited and deducted out of their payment . . .'. For their efforts they charged £1,800, for a great deal of carving in wood and marble. The Chapel was finished, and the first service held on Christmas Day, 1686.

Within two years James II had fled abroad and the Protestant William III and his Queen (James's daughter Mary) were ready to assume the English throne. The Chapel was neglected, but by 1695 Gibbons was paid £130 for taking down the great altarpiece, and loading it for use at Hampton Court. However, it slumbered in store and finally Wren and Gibbons installed it again, in 1706, at Westminster Abbey. It served its liturgical purposes there until the coronation of George IV when it was 'temporarily

removed.' The move became permanent and the many pieces were offered to Walter King, Bishop of Rochester, and a Canon of Westminster, for the Church of St Andrew's, Burnham-on-Sea, Somerset, of which he held the benefice. Towards the end of the nineteenth century the remnants were once more dismantled and scattered about the church. Quellin's angels, ten cherubim (formerly at the top of the altarpiece) and smaller pieces are at Burnham, two panel reliefs are in Dean's Yard at Westminster, and the Victoria and Albert Museum acquired two panels carved in bas-relief in 1973.

The Quellin angels are shown here out of chronological sequence, to show the development of his figure-carving (Pls. 68–74).

75. St Multose, Kinsale, Co. Cork, Ireland. *Robert Southwell*, d. 1677, and his wife Helena (*neé* Perceval), 1681–2 (Photograph: *Courtesy of Dr Rolf Loeber*)

This monument is one of a small number done by Gibbons and Quellin for Anglo-Irish patrons. Knowledge of them is due to the researches of Dr Rolf Loeber (*Studies*, 72, 1983, pp. 84–101). Robert Southwell died in 1677 and was survived by his wife Helena and their son Sir Robert Southwell. Sir John Perceval, the third baronet, dealt with the contract and in a letter of March 1681 (British Library, Add. MS. 46958 A, f. 36) noted that he would proceed to perfect the articles with 'Mr Quellan' as one of the undertakers. The other undertaker, though unnamed, was undoubtedly Gibbons for on 2 August 1681 'Mr Gibbons, the stone cutter' was paid £50 by Sir Robert Southwell's steward for his work 'in part of the monumt'.

76–78. St Andrew, Radbourne, Derbyshire. *German and Anne Pole*, 1683–4 (Photographs: National Monuments Record (76); Geoffrey Beard (77–78))

The little church in the park at Radbourne is

dominated by Gibbons's monument, dated to 1683 by the contract in the Chandos-Pole archives. A model was made, and approved of by Anne Pole who outlived her husband (dying in 1700). The contract specified the monument was to be in the best white Italian marble, to stand 15 ft high by 10 ft broad and to cost £300. It was set up in the early summer of 1684 and Gibbons's receipt is dated 22 September 1684. The cherubims bearing the coat of arms (Pl. 77) are also mentioned in the contract, together with the 'two cherabims heads graspinge a scutcheon' (Pl. 78).

79–80. York Minister, North Choir Aisle. *Archbishop Richard Sterne*, d. 1683 (Photographs: A. F. Kersting)

The Archbishop died in June 1683 and presumably a relative saw to the ordering of his monument. In 1976 Dr J. Douglas Stewart published in the *Burlington Magazine* (CLXVIII, July 1976, p. 508) the text of a letter (the present whereabouts of which is unknown) from Gibbons to John Etty in York. It is dated 10 July 1684 and apart from being evidence that Gibbons kept up an association with the Ettys – he had stayed with them when he came to England – mentions a letter from 'Mr Stavnes' which may be the best Gibbons could do with the surname of one of the Archbishop's relatives.

Gibbons mentions that he hopes his man will be in York by mid-July, 'for I hoep he has don in Darby'. This is presumably a reference to the Pole monument (Pls. 76–78). This is, however, not as competent as that to the Archbishop. A detail of the head is shown in Pl. 80.

81–84. Three Royal Statues, The Royal Hospital, Chelsea, east front with the statue of *Charles II*, bronze, (?) 1676.

Tobias Rustat, Yeomen of the Robes to Charles II, paid £500 for this gift to the King. It has been dated to 1676, was originally gilded, and

is said to have been removed to Chelsea, probably at the instance of James II, about 1688 (*Wren Society*, XIX, p. 80).

The king is shown laurel-crowned, in Roman armour, with a baton in his right hand. The pose was used again in 1691 by Gibbons for his statue of Charles Seymour, sixth Duke of Somerset (Pl. 27).

82. *Charles II*, terracotta model by Arnold Quellin, 1685. *Sir John Soane's Museum, London* (Photograph: Museum)

This model by Quellin for a *Charles II* to be set up by the Grocers' Company at the Royal Exchange, was distinct from that erected there by the Merchant Adventurers of England. In contemporary dress it is an accomplished work betokening great promise. (See: K. A. Esdaile, *Architectural Review*, CII, 1947, p. 174)

83–84. Whitehall, London, (now in front of the National Gallery). *James II*, ordered from Gibbons, bronze, 1686–7. (Photographs: Courtauld Institute of Art, University of London)

George Vertue records the agreement by Tobias Rustat (*Notebooks*, V, pp. 58–9), 'for a Statue of King James the second to be made by Mr Grinling Gibbons for the sum of three hundred pounds'. Gibbons signed an acquittance for part of this sum on 11 August 1687. He turned for the execution of this bronze statue to the two Flemings, Laurens Vandermuelen of Brussels and Dievot of Malines. They were employed to 'model and make it' which may have involved the design, although this could have been provided by Quellin before his untimely death. However, a further complication is that a drawing of 1722 by William Stukeley, sold in 1963, bore the inscription that the statue was made by Thomas Bennier (See: Margaret Whinney, *Sculpture in Britain, 1530–1830*, revised edn, 1988, p. 443, fn. 121)

85–86. St Mary the Virgin, Bottesford, Lincolnshire. *Seventh Earl of Rutland*, d. 1641, erected 1684–5. (Photographs: Bruce Bailey (85); Geoffrey Beard (86))

The ninth Earl had first commissioned Caius Gabriel Cibber (1630–1700) in 1682 to make his father's tomb but instead used Gibbons. Gibbons's bond and receipts survive in the Belvoir Castle archives but are now not accessible. They have been noted (Green, *Gibbons*, p. 154; reconfirmed to me by Dr H. M. Colvin) as a bond in £500 dated 17 August 1684 to observe covenants of the same date. The two tombs to be set up were probably erected before the end of 1685: Gibbons's receipts of 18 November 1684 and 12 July 1686 are in the sums of £250 and £100 respectively.

For the bibliographical record the receipt for £100 is the only one mentioned in the Historical Manuscripts Commission volumes on the Rutland archives (Vol. IV), and there is no mention of Gibbons in the three articles on the Bottesford monuments by Lady Victoria Manners in *Art Journal*, 1903.

87–88. St Mary the Virgin, Bottesford, Leicestershire. *Eighth Earl of Rutland*, d. 1679 (Photographs: Bruce Bailey (87); Geoffrey Beard (88))

John Manners, who had suffered ill health as a young man and had procured release from appointments as a result in the early 1640s nevertheless lived to the age of seventy-five. Marrying in 1628 Frances, the daughter of Thomas Cotton (of the family for whom Gibbons made a signed monument in 1697), he had a married life of over forty years before his wife's death in May 1671. She is commemorated in a standing figure on the right of Gibbons's tomb, which was erected at the orders of the ninth Earl of Rutland in 1684–5 (See note to Pls. 85–86 above). The macabre skull is set at the foot of the plinth to the urn (Pl. 88).

89–93. St Peter and St Paul, Exton, Rutland. *Baptist Noel, third Viscount Campden,* d. 1682. (Photographs: Courtauld Institute of Art, University of London (89, 91, 92); A. F. Kersting (90, 93))

The inscription on the Campden tomb states that the third Viscount died on 29 October 1683, but the *Complete Peerage* gives this as a year earlier, 1682, with the will proved on 5 November 1682. If this is assumed, then the Exton monument falls in the centre of the short Gibbons-Quellin partnership. However, Campden's fourth wife, Elizabeth, daughter of the second Earl of Lindsey, had died about 20 July 1683 and by her will, proved on 6 August, the third son was instructed to erect the tomb. It was completed by 1686.

The two oval reliefs commemorate: (Pl. 90) the first wife, Anne, daughter of the first Earl of Denbigh, whose three children died in infancy; (Pl. 91) the second wife, Anne, daughter of Sir Robert Lovet of Lipscombe (Gibbons may have done a later Lovet tomb there, see Appendix I, Monuments) whose one child was still-born. Below the central figures are two long reliefs. The lower of the two (Pl. 92) shows the six children of Campden's third wife, Hester Wotton, one of whom, a daughter, died in infancy. The upper relief (Pl. 93) shows the progeny of the fourth wife, Elizabeth, whose third son, as noted, erected the tomb.

94. Jesus College Chapel, Cambridge. Detail of *Tobias Rustat,* d. 1693 (Photograph: Courtauld Institute of Art, University of London)

Tobias Rustat died on '15 March 1693', (1693/4). The monument was erected under the terms of his will (October 1693) in the 'Church or Chappell of Jesus College in Cambridge, where my Tomb is in readinesse to bee sett up . . .'. It was probably sculpted by Arnold Quellin in about 1685. The oval medallion portrait is surmounted by a coat of arms in a car-

touche, the form of which is similar to that on the Campden tomb (Pl. 89). Two *putti* at either side derive from those on the Van den Eynde monument by François Duquesnoy in S. Maria dell'Anima in Rome, and are almost identical to those on the Ferrers monument at Tamworth, thought to be by Quellin (Pl. 69).

95–96. The Stadthuys, Amsterdam, North Gallery. Details of the marble carvings by Artus Quellin I, *c.*1650 (Photographs: The Stadthuys)

Such carvings were obviously useful examples to follow or adapt in the various parts of a monument. The loving birds (Pl. 95) are a feature in at least two Gibbons wood-carvings and appear (Pl. 89) in a variant on the Coventry tomb (Pl. 97).

97. St Mary Magdalene, Croome D'Abitot, Worcestershire. *Fourth Lord Coventry,* d. 1687 (Photograph: National Monuments Record)

Lord Coventry died at the early age of thirty-three and Gibbons agreed with his mother Margaret, daughter of the second Earl of Thanet and wife of George, third Lord Coventry to erect his monument. The agreement (Croome Estate archives) specifies that it was to cost £322 10s. and gives its exact form. A model was to act as guide and all was carefully carried out except for the Gibbons signature. The coronet was to have been 'tumbled at his feet'; for many years it had been incongruously set too small, on Lord Coventry's head, but it is now in an obvious but neutral position. The two standing figures represent (*left*) Hope and (*right*) Faith.

98. Tower of London. Horse, carved by Gibbons, wood, 1688. *H. M. Royal Armouries* (Photograph: Courtauld Institute of Art, University of London)

The complex story of the various horses and effigies carved for the Line of Kings in the Horse Armoury of the Tower of London has been

examined (see A. Borg in *Archaeologia*, CV, 1976, p. 317). Gibbons, Thomas Quellin and John Nost were all involved, Gibbons's bill (June 1688) reads: 'To Grinling Gibbons for a statue of wood by him made & delivered into his Majesty's Store of Armory, whereon was carv'd the face and body of King Charles the first. As also a horse statue of wood whereon the said statue was mounted according to an order him directed, 40 L.' The heads of Charles I and II are shown by Green (*Gibbons*, 1964, Pls. 192, 194.)

99. Rochester Cathedral, Kent. *Sir Richard Head*, d. 1689 (Photograph: National Monuments Record)

On the evidence of a brief statement in Collins's *English Baronetage*, this monument is attributed to Gibbons. Compared with the sophistication of that to Tobias Rustat (Pl. 94), two hands are soon evident. By 1689 Quellin was dead and the Gibbons work had dropped back to a competent but uninspired level. The flaming urn is missing from the top, which does not help the composition, and there seems to have been little advance in the twelve years since the Burgoyne monument (Pl. 67).

100–102. St Kenelm, Clifton-on-Teme, Worcestershire. *Elizabeth Jeffreyes*, d. 1688; (101) drawing, *Society of Antiquaries of London, Prattinton Collection*; (102) *Jane Jeffreyes*, d. 1718

Henry Jeffreyes contracted with Gibbons on 10 May 1689 (the contract is at the Society of Antiquaries) to erect his wife Elizabeth's monument at a cost of £40 (£10 due and £30 at setting-up). Henry died in July 1709 at the age of seventy-three, a fact noted in an added inscription to Elizabeth's tablet.

The same studio presumably carved the almost identical tablet to Henry's cousin and 'Heir Adopted', Jane Winnington, who, pursuant to his will, took the surname of Jeffreyes (Pl. 102).

103. York Minster, South Choir Aisle. *Archbishop Thomas Lamplugh*, d. 1691 (Photograph: J. B. Morrell)

This sedate monument was contracted by Gibbons on 9 October 1691 (Bodleian Library, Oxford, MS., Autog., D. 11, f. 335) for the sum of £100, with Lamplugh's son, also Thomas. There is some attempt to copy the draped curtaining of Archbishop Sterne's monument (Pl. 79) but the monument shows the low state into which the Gibbons team had fallen.

104. Westminster Abbey, St Michael's Chapel, North Transept. *Sarah, eighth Duchess of Somerset*, d. 1692 (Photograph: Courtauld Institute of Art, University of London)

This monument, sadly, has now been mutilated. The engraving in John Dart's *Westmonasterium* ... (*c.*1723; Green, *Gibbons*, Pl. 242) shows panelled pilasters, draped curtains and an elaborate display of arms at the top. It was mentioned as a work by Gibbons in a letter to the sculptor from Theophilus Hastings, seventh Earl of Huntingdon. (See: *Burlington Magazine*, CV, March 1963, p. 125)

The Duchess, who retained the precedency of a Duchess, despite her marriage in 1682 to Henry, Lord Coleraine, died on 25 October 1692. Her will (May 1686, proved 1704) gave directions for her tomb. She authorised expenditure on it of £500 with a further £300 for her funeral. Any unused balance of the £300 was to be added to the £500 for the monument.

105. St Mary, Nannerch, Flintshire, N. Wales. *Charlotte Mostyn*, d. 1694

This awkward monument, in which the elements of many others seem to have been crudely assembled, commemorates Charlotte Mostyn, daughter of John Digby and wife of Richard

Mostyn. An engraving in the Bodleian Library, Oxford (Gough Maps, 44, f. 117) credits Gibbons with authorship, in the inscription: '*G. Gibbons fec. S Gribelin Sculp.*'.

106. Design for Monument to Queen Mary II, 1695. *All Souls College, Oxford,* Wren Drawings, I. No. 5 (Photograph: College)

This spirited drawing shows how good Gibbons was with his pen and brush. Together with Sir Christopher Wren the design of a monument to the Queen, intended to rise over her tomb in Henry VII's Chapel in Westminster Abbey, was prepared. The recumbent Queen is propped up on a lion and unicorn and *putti* above her profer the heavenly crown. On the left plinth is the emblem of St George which appears in marble as part of the Order of the Garter accoutrements on the tomb of the first Duke of Beaufort (Pls. 111, 116). The Queen's tomb was not proceeded with, and although a much modified drawing was done for a proposed monument to William and Mary (Green, *Gibbons,* Pl. 93) this, too, was abandoned.

107–108. St Mary, Conington, Cambridgeshire. *Robert Cotton,* d. 1697 (Photographs: Courtauld Institute of Art, University of London)

For some reason Gibbons signed this monument ('G. Gibbons, Fecit') on the palm fronds at the lower left side of the oval portrait medallion. Robert Cotton died at the age of 'fourteen years 3 months & 7 days' as the inscription poignantly records. Possessed of all the virtues, this son of Sir Robert Cotton is shown in Roman dress surrounded by sprays of poppies, peonies and lilies.

109. Christ's Hospital, London (now Horsham, W. Sussex). *Sir John Moore* (d. 1702), 1697–8 (Photograph: Courtauld Institute of Art, University of London)

Within his lifetime the Court of Christ's Hospital wished to honour its principal benefactor, Sir John Moore. It commissioned a marble statue from Gibbons in December 1694.

110. St Paul's Cathedral, Crypt. *Dr William Holder,* d. 1698, and *Susanna Holder,* d. 1688 (Photograph: Courtauld Institute of Art, University of London)

This unusual wall-tablet commemorates William Holder and his wife Susanna, the only sister of Sir Christopher Wren. With his close association with Wren over many years Gibbons would be the obvious sculptor for the family to choose. Gibbons's drawing (Fitzwilliam Museum, Cambridge; Green, *Gibbons,* Pl. 231) shows that the monument was a faithful rendering.

111–116. St Michael, Badminton, Gloucestershire. *Henry Somerset, first Duke of Beaufort,* d. 1700 (Photographs: Courtauld Institute of Art, University of London)

Henry Somerset, third Marquess of Worcester, had been elevated to the dukedom by Charles II in 1682. At his death from fever on 21 January 1700 in his seventieth year he was buried in the Beaufort Chapel of St George's Chapel, Windsor. The monument remained at Windsor until 1874 when it was moved to the parish church at Badminton and erected on the north side of the chancel.

117. St Michael, Coxwold, Yorkshire. *Earl Fauconberg,* d. 1700, and his father, the *Hon. Henry Belasyse,* d. 1647 (Photograph: National Monuments Record)

This monument has entered the Gibbons canon because of the similarity of one of its main features, the winged *putti* proffering the rewards of virtue, the starry crown and the palm. The almost identical motif appears on the Beaufort tomb (Pl. 112) and, in a different form, in the drawing for the Queen Mary monument (Pl.

106). The flanking urns are particularly attractive as they are carved on the sides with winged cherubim. However, it should be noted that the monument has also been attributed to John Nost (Margaret Whinney, *Sculpture in Britain 1530–1830,* revised edn, 1988, p. 445, fn. 75)

118. St Thomas's Hospital, London. Detail of statue, *Sir Robert Clayton,* 1701–2 (Photograph: Courtauld Institute of Art, University of London)

Sir Robert Clayton was President and benefactor of St Thomas's Hospital. On 15 June 1702 the Governors viewed the Gibbons statue of him, expressed themselves satisfied and ordered the balance of £150 (with £50 already paid) to be given to the sculptor (Green, *Gibbons,* p. 135).

119. Westminster Abbey, North Aisle. *Mrs Mary Beaufoy,* d. 1705 (Photograph: A. F. Kersting)

This monument, like almost all Gibbons's work, is unsigned, but the inscription proclaims that it is 'by Mr Grinling Gibbons'. The form of the cherubim proferring the starry crown, the gadrooned sarcophagus and two weepers are further indications of authorship. The monument was erected at the instructions of Lady Charlotte Beaufoy, Mary's mother: 'made and Erected at her own charge in Memory of her dear Daughter . . .'. The monument has probably been amended at the top; the customary arms and urn are absent.

120–121. Westminster Abbey, North Aisle. *Admiral Sir Cloudesly Shovell,* d. 1707 (Photographs: National Monuments Record)

This monument was much criticised in the early eighteenth century by Joseph Addison, as portraying a lolling comfortable beau rather than a gallant sailor who had died after shipwreck. The setting is grand with double Corinthian columns at each side, the elegant canopy and the hand-

some plinth, carved with the Admiral's stricken flagship, the *Association* (Pl. 121). The Shovell monument was paid for by the Treasury in the sum of £322 10s., perhaps an indication of parsimony, for Gibbons had charged £1,000 for both the Campden and Beaufort tombs.

122. St Clement, Knowlton, Kent. Detail of monument to *Sir John Narborough* and *James Narborough,* both d. 1707 (Photograph: Geoffrey Beard)

Killed in the same battle and shipwreck as Sir Cloudesly Shovell (the brothers' step-father-in-law), John and James Narborough were also commemorated by their mother, Sir Cloudesly's widow, and their tomb bears a replica of the *Association,* in which they also served. I assume the tomb is by Gibbons.

123–124. Westminster Abbey, North Aisle. *Admiral George Churchill,* d. 1710. (123) Drawing, *Westminster Reference Library* (Photographs: Library (123); (Photographs: Library (123); National Monuments Record (124))

Gibbons's drawing for this monument was found in 1932 in a copy of Pennant's *London* and is now in the Westminster Reference Library. There is also a letter from Gibbons, dated 1 June 1710, in which he says that he has received £50 and promises to be as 'Expedises' as he can at completion. The overall design occurs in at least three monuments attributed to Gibbons (see Appendix I: Monuments), namely to Sir John and Lady Nicholas, Francis, Earl of Bradford, and in a modified form to Robert Lovet.

125. St Lawrence, Whitchurch, Little Stanmore, Middlesex. *James Brydges, first Duke of Chandos,* d. 1744 (and his first and second Duchesses, d. 1719 and d. 1735), *c.*1717 (Photograph: A. F. Kersting)

It befitted the character of 'Princely Chandos' that he should arrange his tomb by Gibbons within his lifetime. The first Duchess, Mary Lake, kneels at the left and the second, Cassandra Willoughby, at the right. The monument was probably made around 1717, for that date appears on the inscription under the figure of Mary Lake. There is however a letter in the Brydges MSS (Huntingdon Library, San Marino, California) of 10 January 1718, in which the Duke queried the demand Gibbons was making for his work on the monument (£350 was still due of an unspecified amount), in that he did not like the figures or know of anyone who did. However, he relented and allowed payment of the balance. (C. H. C. & M. I. Baker, *The Life and Circumstances of James Brydges, First Duke of Chandos*, 1949, pp. 413–14).

Bibliography

Many references to specialised literature are contained in the Notes to each Chapter. This list describes books and articles under the headings (A) Early Sources, (B) Manuscripts, (C) Life, (D) Woodwork, and (E) Monuments and Statues. Publication at London unless otherwise stated.

(A) EARLY SOURCES

CUNNINGHAM, Allan, *Lives of Eminent British Painters, Sculptors and Architects*, 6 vols., 1829–33.

DART, John, *The History and Antiquities of the Abbey Church of St Peter's, Westminster*, 1723.

DEFOE, Daniel, *A Tour through the Whole Island of Great Britain*, 1724–6, eds. G. D. H. Cole and D. C. Browning, 2 vols., 1962.

EVELYN, John, *Diary* (edn by E. S. de Beer, Oxford, 6 vols., 1955).

—, *Sylva*, 1706.

FIENNES, Celia, *Journeys through England c.1682–1712*, ed. C. Morris, 1947, illustrated edn, 1984.

MAGALOTTI, L., *The Travels of Cosimo III, Grand Duke of Tuscany, through England during the reign of Charles the second*, 1821.

OGILBY, John, *THE KING'S CORONATION: Being an Exact Account of the Cavalcade, with a Description of the Triumphal Arches, and Speeches prepared by the City of London* etc., 1685.

PHILLIPS, Samuel, *To Mr Grinsted [i.e. Grinling] Gibbons, his carving the matchless statue of the King erected in ... the Royal Exchange*, 1684.

PYNE, R., *The History of the Royal Residences*, 3 vols., 1817, 1819.

TATE, Nahum, *Poems Written on Several Occasions*, 2nd edn, 1684.

—, *Poems by Several Hands and on Several Occasions* (collected by N. Tate), 1685.

THORESBY, Ralph, *Diary 1658–1725*, 2 vols., 1830.

—, Thoresby's *Museaum* in T. R. Whitaker, *Ducatus Leodiensis*, Leeds, 1816, p. 49.

VERTUE, George, 'The Notebooks of George Vertue relating to Artists and Collections in England', *Walpole Society*, Vols. XXVIII, XX, XXII, XXIV, XXVI, indexed XXIX, 1929–42.

WALPOLE, Horace, *Anecdotes of Painters*, Collected Works, III, 1798.

WREN, Sir Christopher and Stephen, *Parentalia*, 1750.

(B) MANUSCRIPTS

Cambridge

Fitzwilliam Museum
Drawing for Holder monument (Chapter III, No. 34).

London

British Library
Department of Manuscripts: Huntingdon correspondence (Harleian 4712, ff.366–84);

Marlborough Manuscripts (Add. MSS., 19,
595–8), Blenheim (Add. MSS., 61353–6
etc., calendar available); King's MS., 40, f. 43
(E. Dummer, 'A Voyage into the Medi-
terranean Seas . . .', 1685, gives information
on the Cosimo Panel.)

British Library, Print Room
Portrait of Gibbons, Sir John Medina.
Drawings by Gibbons for statue to James II;
monument to William and Mary.

Child's Bank (1 Fleet Street)
Seventeenth-century Ledgers searched for
payments to Gibbons; these are noted in the
text.

Drapers', the Worshipful Company of, Court
records (for Gibbons's involvement and the
names of his apprentices).

Genealogy Library of the Mormon Church (64
Exhibition Road).
International Genealogical Index, 'The
Mormon Microfiche Index'.

Guildhall Library
MS. 3295. St Mary Abchurch, reredos.
Drawings formerly at St Paul's Cathedral
Library (calendared by Professor Kerry
Downes and published 1988).

Public Record Office (Chancery Lane)
C9, 415/250 Chancery suit, 1683, Gibbons
and Arnold Quellin.
LC Lord Chamberlain's Department, Prob
11, Wills and Administrations.

Public Record Office (Kew)
AO1 Exchequer and Audit Department,
Declared Accounts (often duplicated in
E351, Pipe Office, Declared Accounts). e.g.,
AO1/2479/272. Panel sent to Cosimo III
by Charles II.
T Treasury Board Papers.
Works 5. Accounts (some British Library,
Harleian MSS).
6/1 Windsor Castle Warrants
5/145 Contract Book, 1668–1724.
These papers are well related to building and

decoration in *The History of the King's Works,*
ed. H. M. Colvin, V, 1976.

Sir John Soane's Museum
Drawing, mostly projects for Hampton
Court

Society of Antiquaries Library, Contract and
letter; Henry Jeffreyes monument.

Westminster Public Library
Drawing and letter, George Churchill monu-
ment (Chapter III, No. 43).

Oxford

Bodleian Library
Ashmole MS., 243, f. 331 verso (Horoscope
cast for Gibbons by Elias Ashmole).
Gough Maps 44, f. 117. Engraving of
Mostyn monument (Chapter III, No. 30).
Smith MS. 40, f. 181 (Huntingdon monu-
ment, Chapter III, No. 35).
MS., Autog., L11, f. 335. Receipt for Lam-
plugh monument (Chapter III, No. 26).
MS. Top. Oxon, a 37, Drawing for Saloon
at Blenheim Palace.

Country Houses and County Record Offices (CRO)

Belvoir Castle, Leicestershire
MSS relating to monuments of seventh and
eighth Dukes of Rutland at Bottesford
(Chapter III, Nos. 18–19).

Chatsworth, Derbyshire
Sketches by Samuel Watson (one of his
sketchbooks at Derbyshire CRO, Matlock).

Warwickshire CRO, Warwick
Newdigate MSS (Chapter III, Nos. 28–29).

West Sussex CRO
Petworth MSS, John Bowen's Account Rolls;
sixth Duke of Somerset's Disbursement
Book.

Worcestershire CRO
Croome Court MSS (some still at Croome
Court Estate Office, Severn Stoke; Chapter
III, No. 22).

(C) LIFE

BLAKISTON, Noel, 'Notes on British Art, from Archives', *Burlington Magazine*, February 1957.

BOYD, P., 'Grinling Gibbons's Maternal Ancestry', *Genealogists' Magazine*, IX, p. 345.

ESDAILE, K. A., 'Grinling Gibbons, 1648–1721', *The Architect*, 30 September 1921.

GREEN, David, *Grinling Gibbons, His Work as Carver and Statuary, 1648–1721*, 1964. A standard, well-written work.

NOTES AND QUERIES. Various. 4th series III, pp. 504, 573, 606; IV, pp. 43, 63, 106, 259.

ROGERS, W. G., 'Remarks upon Grinling Gibbons', *Trans., Royal Inst. of British Architects*, 1866–7, p. 179.

SHERWOOD, G., 'Genealogy of Grinling Gibbons', *Genealogists' Magazine*, V, p. 322.

STEWART, J. Douglas, 'New Light on the Early Career of Grinling Gibbons', *Burlington Magazine* CLXVII, July 1976, p. 508.

TIPPING, H. Avray, *Grinling Gibbons and the Woodwork of his Age*, 1914. Useful still for its perceptive insights and the wide range of illustrations reproduced at folio scale.

WHINNEY, Margaret, 'Master Carver to the Crown', *The Listener*, 8 April, 1948.

(D) WOODWORK

BEARD, Geoffrey, 'Some English Woodcarvers', *Burlington Magazine*, CXXVII, October 1985, pp. 686–94.

BULLOCK, Albert E. *Grinling Gibbons and His Compeers*, 1914. Illustrations at folio size, short text.

GREEN, David, as in Section C above.

—, 'A Pea-pod Myth Exploded', *Country Life*, 8 August 1963.

OUGHTON, Frederick, *Grinling Gibbons and the English Woodcarving Tradition*, 1979.

PARKER, James, 'A Staircase by Grinling Gibbons' (i.e. Cassiobury), Metropolitan Museum of Art, New York, *Bulletin*, June 1957, pp. 229–36.

SYMONDS, R. W., 'Grinling Gibbons the Supreme Woodcarver', *Connoisseur*, CVII, April 1941, pp. 141–7; reply by F. Gordon Roe, *ibid.*, CVIII, August 1941, pp. 74, 88.

TIPPING, H. Avray, as in Section C above.

TOWNSEND, W. G. P., 'Grinling Gibbons, Carvings from Holme Lacy', *Connoisseur*, XXVII, 1927, p. 181.

WEBSTER, Mary and LIGHTBOWN, R. W., 'Princely Friendship and the Arts: a relief by Grinling Gibbons', *Apollo*, XCIV, September 1971, pp. 192–7.

(E) MONUMENTS AND STATUES

APTED, M. R., 'Arnold Quellin's Statues at Glamis Castle', *Antiquaries Journal*, LXIV, Pt.1, 1984, pp. 53–61.

BEDFORD, W. R. K., 'The Stuart Statues from the Workshop of Grinling Gibbons', *Home Counties Magazine*, V, p. 150.

ESDAILE, K. A., 'Arnold Quellin's Charles II', *Architectural Review*, CII, 1947, p. 174.

ESDAILE, K. A. and TOYNBEE, M., 'More Light on "English" Quellin', *Trans., London and Middlesex Archaeological Society*, XIX, pt.1, 1956, p. 34.

FREMANTLE, Katherine, *The Baroque Town Hall of Amsterdam*, Utrecht, 1959.

GREEN, David, 'The Monuments of Grinling Gibbons', *Country Life, Christmas Annual*, 1963.

GUNNIS, Rupert, 'Sculpture in Rochester

Cathedral', *Friends of Rochester Cathedral, Report*, 1948, p. 20.

—, 'The Ferrers Monument at Tamworth', *Country Life*, 9 February 1951 (erroneously regarded the monument as by Samuel Watson on the basis of his drawing; see Chapter III, No. 5).

—, *Dictionary of British Sculptors, 1660–1851*, 1953. I have used the typescript revision by John Physick (Victoria and Albert Museum Library).

LOEBER, Rolf, 'Arnold Quellin's and Grinling Gibbons's Monuments for Anglo-Irish Patrons', *Studies*, Dublin, 72, Spring 1983, pp. 84–101.

O'CONNELL, S., 'The Nosts: A Revision of the Family History', *Burlington Magazine*, CXXIX, December 1987, p. 802.

PHYSICK, John, *Designs for English Sculpture, 1680–1860*, 1969.

STEWART, J. Douglas, 'Some Unrecorded Gibbons Monuments', *Burlington Magazine*, CV, March 1963, p. 125.

VIVIAN-NEAL, A. W. 'Sculptures by Grinling Gibbons and Quellin, originally in Whitehall, later in Westminster Abbey, now in the Church of Burnham-on-Sea', *Proceedings, Somersetshire Archaeological and Natural History Society*, LXXXI, 1935, pp. 127–32.

WHINNEY, Margaret, *Sculpture in Britain, 1530–1830*, 1953, revised by John Physick, 1988.

Chronology

1648 4 April, Grinling Gibbons (GG) born at Rotterdam to James and Elizabeth Gibbons, who had married c.1637.

c.1665 GG possibly spends time in the Quellin workshops at Amsterdam and/or Antwerp.

c.1667 GG, 'about 19' in John Evelyn's words, settles in England, firstly in the Etty household (?) at York, then at Deptford as a ship's carver. Does some carving for Thomas Betterton's Dorset Gardens playhouse.

c.1670 GG marries Elizabeth – surname unknown; possibly at St Bride's, Fleet Street (registers missing for relevant years). Living at 'La Belle Sauvage', Ludgate Hill.

1671 John Evelyn 'discovers' GG carving the *Crucifixion* panel after Tintoretto at Deptford. Introduces him to Charles II and Sir Christopher Wren.

1672 23 May. A first son, James, born to GG and Elizabeth, baptised at St Botolph without Aldgate, London; GG admitted on 19 January to freedom of the Drapers' Company.

1675 28 May. A second son, Grinling, born to GG and Elizabeth, baptised at St Bride's, Fleet Street.

1678 15 August. A first daughter, Anne, born to GG and Elizabeth, baptised at St Paul's, Covent Garden; GG moves to 'King's Arms', Bow Street, from Ludgate Hill.

1680 22 April. A second daughter, Sarah, born to GG and Elizabeth, baptised at St Paul's, Covent Garden.

1681 28 April. Mary born to GG and Elizabeth, baptised at St Paul's, Covent Garden.

1681–3 Partnership with Arnold Quellin.

1682 18 July. Jane born to GG and Elizabeth, baptised at St Paul's, Covent Garden; appointed Surveyor and Repairer of carved Work at Windsor Castle; GG's horoscope prepared by Elias Ashmole; carved Cosimo Panel.

1683 June. Charles born to GG and Elizabeth, baptised at St Paul's, Covent Garden.

1684 19 May. Katherin born to GG and Elizabeth, baptised at St Martin-in-the-Fields.

1685 21 May. James born to GG and Elizabeth, baptised at St Paul's, Covent Garden.

1687 Anna born to GG and Elizabeth, baptised at St Anne's, Soho.

1689 George born to GG and Elizabeth, baptised at St Anne's, Soho.

1693 2 December. Appointed Master Sculptor and Carver in Wood.

1702 GG's house burned.

1704–5 GG appointed Renter-Warden, The Drapers' Company.

1712–13 GG appointed Second Warden.

1714–15 GG appointed First Warden.

1718–20 Gibbons stood in as Master of the Drapers' Company but was not elected.

1719 11 November. GG appointed Master Carpenter to the King's Works; 30 November, Elizabeth Gibbons dies, buried at St Paul's, Covent Garden.

1720 4 May. GG's last attendance at the Board of Works.

1721 3 August. GG dies; buried at St Paul's, Covent Garden on 10 August.

1722 15 November. Sale of GG's collections.

Appendix I

Works attributed to Grinling Gibbons

This list is arranged in five categories: (A) Carvings, (B) Church Fittings, (C) Country Houses and Livery Halls, (D) Miscellaneous, and (E) Monuments. References are given to further reading and to illustrations where possible.

(A) CARVINGS

'A Dove, Carved in Wood by Mr Gibbons'
Lit: Catalogue of the Collection of Edward, Earl of Oxford. Auctioned at the Cock Inn, 8–13 March 1742, lot 16 (8 March); Green, *Gibbons*, p.148, fn. 7.

'Charles I' and 'Charles II', carved heads
Coll: Tower of London, Armoury
Lit: Green, *Gibbons*, Pls. 192, 194.

'Charles II', head and shoulders, limewood, attached to a blank cartouche; may have been part of an overmantel.
Coll: Victoria and Albert Museum, London.
Lit: Green, *Gibbons*, Pl. 193.
Another *Charles II* was sold at Christie's, 13 April 1983, lot 23.

CARVING, BOXWOOD
'King David playing a harp and singing'
Lit: Sotheby's, November 1963; Green, *Gibbons*, Pl. 206.

'The History of Elijah under the Juniper Tree, supported by an Angel (1 Kings, 19): all perform'd in Wood by the celebrated Mr Grindlin Gibbon, when Resident at Yorke, Six Inches in Length and four in Breadth'.
Lit: Ralph Thoresby in T. R. Whitaker, *Ducatus Leodiensis*, 2nd edn, 1816. Horace Walpole notes this in Thoresby's Collection (*Collected Works*, III, 1798, p. 343).

PICTURE FRAMES
(a) Two, formerly at Hackwood, Hampshire, and now at Bolton Hall, Yorkshire. 'Birds and trussing look well enough, but in each case the head of the frame lacks richness and inspiration' (Green). One of the frames has two portrait medallions of (i) William III crowned by *amorini*, and (ii) Victory, with sword and palm.
Lit: Green, *Gibbons*, p. 116.

(b) Black and gold. Attributed to Gibbons by Horace Walpole and containing portrait of Sir Robert and Lady Walpole by J. Wootton and J. G. Eccardt. Strawberry Hill sale, 1842; Christie's, 7 March 1930.
Coll: Yale University, Wilmarth S. Lewis collection at Farmington.
Lit: Tipping, *Gibbons*, Pl. 74; Wilmarth S. Lewis, *Horace Walpole*, 1961, Pl. 3.

(c) *c*.1683: Surrounding portrait of Elias Ashmole. One of the more likely attributions.
Lit: Green, *Gibbons*, Pl. 120.

(d) Acquired by Randolph Hearst for St Donat's Castle.
Acquired by the Boymans Museum, Rotterdam.
Lit: Green, *Gibbons*, Pl. 205.

(e) Noticed by Horace Walpole in 1770 at Uppark, Sussex, surrounding a portrait of Sir Robert Cotton. No longer there.
Lit: *Walpole Society*, XVI, p. 68.

(B) CHURCH FITTINGS

All Hallows, Barking, Essex.
Font cover, limewood, 'a pyramid of peaches and *putti*' (Green).
The church was damaged in the Second World War.
Lit: Green, *Gibbons*, Pl. 73.

All Hallows the Great, Upper Thames Street, London.
Pulpit.
This is now at St Paul's, Hammersmith. It bears the legend: 'This Pulpit executed by Grinling Gibbons for Sir Christopher Wren's Church of All Hallows, Upper Thames Street was presented to this church in 1900 by Prebendary A. J. Ingram of St. Margaret's, Lothbury.'
Lit: *Wren Society*, X.

All Hallows, Lombard Street, London.
Pulpit and font.
Now at All Hallows, Twickenham.
Lit: R. H. Harrison, *Trans., Ancient Monuments Society*, VIII, 1960.

Duke of Chandos's Chapel, Cannons, Edgware, London.
Pulpit.
Now at Fawley, Bucks, St Mary.
Various fittings bought at demolition of Cannons, 1747, including font, stalls, panelling, communion rail and the pulpit, pews and reader's desk.

Ellingham Church, Ringwood, Hants.
Reredos.
Attributed to Gibbons.

German Church, Trinity Lane, London
Reredos, limewood, *c*.1684.
Now Hamburg Lutheran Church, Dalston.
Lit: Records, Guildhall Library, indicate screen was made in 1684; unlikely to be by Gibbons.

St Alphege, Greenwich.
Carving (unspecified), 1711–14.
Gibbons paid £156 9s.4d. This church was damaged in the Second World War. The pulpit, said to have been by Gibbons, was destroyed. Replica by White of Bedford, *c*.1953.
Lit: H. M. Colvin, 'The Fifty New Churches', *Architectural Review*, March 1950.

St Bartholomew, by the Exchange, London.
Pulpit.
Church demolished: said to have contained an oak pulpit (and reading-desk) by Gibbons.

St Dunstan in the West, Fleet Street, London.
Pulpit.
The pulpit, attributed to Gibbons, was moved to Wavendon, Bucks, St Mary's. Marquetry panels, garlands and cherubs' heads at the angles.

St James's Palace, Queen's Chapel.
Royal Arms, and gilded woodcarving.
Gibbons is known to have worked in the chapel. The palms, cornucopiae surrounding the royal arms over the chimneypiece, royal pew, and six panels of gilded woodcarving flanking the altar and below the cornice may be his.

St Nicholas, Deptford Green.
Reredos, oak, *c*.1697.
John Evelyn, writing to Gibbons in 1683, calls it 'our church'. Gibbons did the monument to Evelyn's father-in-law, Sir Richard Browne, therein (Chapter III, No. 6).
The reredos, originally a triptych, has recumbent evangelists, *putti*, festoons, flaming urns and the royal arms of William III.
Damaged, Second World War, 1940.

(C) COUNTRY HOUSES AND LIVERY HALLS

Abbey House, Abingdon.
Carved drop from Fitzharrys House, demolished.
Lit: Green, *Gibbons*, Pl. 204.

Adlington Hall, Cheshire.
Drawing room, overmantel and overdoors.
Lit: *Country Life*, 12 December 1952.

The Admiralty, London.
Overmantel, pearwood, *c.*1695.
In the Board Room of the Admiralty. Has date '1695' scratched on a sextant in the bottom right-hand corner. It surrounds a wind-compass, *c.*1710, by Norden.
Lit: Green, *Gibbons*, Pl. 196.

Cassiobury, Hertfordshire, dem. 1922.
'There are divers faire & good rooms, & excellent carving by Gibbons, especially the chimney-piece of ye library.' John Evelyn, *Diary*, 18 April, 1680; Tipping, *Gibbons*, p. 75.
A section of the staircase (now Metropolitan Museum, New York) is shown with other carvings of high quality in *Country Life*, 17 September 1910. I do not, however, think the staircase is by Gibbons; it is more in the foliated style of Edward Pearce. At the Cassiobury sale, June 1922, some of the carvings were bought for the Wernher and Hearst Collections. The former are at Luton Hoo, Bedfordshire, the latter in the Judge Untermeyer Collection, Metropolitan Museum, New York and the Art Institute, Chicago.
Lit: *Country Life*, 17 September 1910; Metropolitan Museum of Art, *Bulletin*, June 1957, pp. 229–36.

Chippenham Park, Newmarket, Suffolk.
Lord Orford's seat, rebuilt 1791 and again 1886. Visited in the late seventeenth century by Celia Fiennes, who commented on 'the finest carv'd wood in fruitages, herbages, gemms, beasts fowles etc. very thinn & fine all in white wood without paint or varnish . . .'.

Gallery, 'Mr Norton's, Southwick, Hampshire'.
'At Mr Norton's at Southwick in Hampshire was a whole gallery embroidered in pannels by his hand.' Horace Walpole, *Collected Works*, III, 1798, p. 343.

Farnham Castle, Surrey.
Chapel.
The chapel is fitted with late-seventeenth-century woodwork. Bold panelling, each bay separated from the next by the same design of a cherub with folded wings above a long vertical swag of fruit: for once the inevitable attribution to Grinling Gibbons might not be far from the truth.
Lit: Ian Nairn and N. B. Pevsner, *Buildings of England: Surrey*, 1962, p. 201.

Hackwood, Hampshire.
Overmantels, saloon and library, pearwood, *c.*1687.
Many woodcarvings introduced by the fifth Duke of Bolton in the mid-eighteenth century from Abbotstone, his other Hampshire seat.
Lit: Tipping, *Gibbons*, p. 202; Green, *Gibbons*, Pl. 164.

Holme Lacy, Herefordshire.
Oak carvings.
Many carvings sold by Knight, Frank and Rutley, 2 February 1910; some now at Kentchurch, Herefordshire. The fine work there merits documentation but none seems forthcoming.
Lit: Tipping, *Gibbons*, pp. 210–11, Pls. 199–201; Green, *Gibbons*, p. 40.

Houghton Hall, Norfolk.
Chimneypieces.
'At Houghton two chimneys are adorned with his foliage.' Horace Walpole, *Collected Works*, III, 1798, p. 343.

Kirtlington Park, Oxfordshire.
Panel, limewood.
Overmantel panel in entrance hall, 60 × 72 ins.
Lit: Tipping, *Gibbons*, p. 218; Green, *Gibbons*,
 Pl. 163.

Lyme Hall, Cheshire.
Carved drops and frame. Attributed to Gibbons
in 1867 by W. G. Rogers. Unlikely to be accurate.
Lit: W. G. Rogers in *Trans., Royal Inst. of
 British Architects*, 3 June 1867.

Melbury House, West Dorset.
Hall, staircase.
Lit: Tipping, *Gibbons*, pp. 217–18.

Mercers' Company Hall, London.
Marquetry panel, oak, 72 × 60 ins, n.d.
Carved with eagles, sunflowers, martagons and
the crest of the Mercers' Company (a crowned
maiden). Trusses carved later?
Lit: Green, *Gibbons*, p. 140.

Mercers' Company Hall, London.
Oak carvings, *c*.1680.
Twelve oak carvings in the form of drops or
pendent trusses. The Company decided to dec-
orate its Hall in 1674–5 but left the final decision
to its Master, Rowland Wynn.
Lit: Green, *Gibbons*, p. 140.

New River Head, Clerkenwell.
Overmantel, oak, *c*.1696–7.
In the Oak Room of the New River Head,
Clerkenwell, with arms of William III and his
motto (now head office, Metropolitan Water
Board).
Lit: Green, *Gibbons*, Pls. 198–9.

Ramsbury, Wiltshire.
Overmantel, *c*.1683.
Lit: C. Hussey, *Country Life*, 7, 14, 21
 December 1961; Green, *Gibbons*, Pl. 155.

Skinners' Company, London.
Court Room.
The Court Room is panelled in cedar. It was

attributed to Gibbons in 1869 but this is
unlikely.
Lit: *Notes and Queries*, IV, July 10, 1869, p. 43.

Stowe School, Bucks.
Chapel.
The woodwork (panelling, pulpit, Royal Arms
etc), said to have been by Gibbons, was moved
from Stowe House in Cornwall, a house of
c.1680. It is now known to have been carved
by Michael Chuke (1679–1742), a native of
Kilhampton, who is said to have studied in
London with Gibbons. He does not, however,
feature as one of Gibbons's known apprentices.

Swallowfield Park, Berks.
'The staircase was taken down and a new oak
one made, to effect which the richly carved
cornice, executed for Lord Clarendon by Grin-
ling Gibbons at Evelyn's instigation, was remo-
ved.'
Constance, Lady Russell, *Swallowfield and its
Owners*, 1901, p. 257.

Syon House, Middlesex.
Urns, twelve in Portland stone. Conservatory
terrace, *c*.1700.
G. J. Aungier, in his *History and Antiquities of
Syon Monastery*, 1840, claims them as: 'sculp-
tured by the masterly hand of Grinling
Gibbons'. However, they do not resemble Gib-
bons's urns at Blenheim Palace, Oxon.

Valentines, Barking, Essex.
Said by Daniel Lysons, *Environs of London*, IV,
p. 87, to have carvings by Gibbons. Demolished
1808.

Winchester College.
Carvings, stated in 1908 as 'executed by Grin-
ling Gibbons in the year 1660'. An unlikely date,
as Gibbons was only twelve and not even in
England. The carvings are known to be by
Edward Pearce.
Lit: *Journal*, Royal Inst. of British Architects, 8
 February 1908.

(D) MISCELLANEOUS

Gate, iron, unspecified location, c.1681.
The Earl of Longford wrote to the Marquess of Ormond on 24 December 1681: 'He [the statuary] has not signed any articles with the smith about the iron gate because his Grace had not signified his choice of the two drafts; if his Grace fixes upon Mr Gibbons' draft it will cost 80L., whereas the other will be done for 60L.'
Lit: Hist MSS. Comm. Ormond MSS., VI, p. 279.

Ivory.
'Herodias with St John's head, alto relievo in ivory'.
Coll: Possession of Horace Walpole. Noted in his *Collected Works*, 1798, III, p. 343.

Ivory.
'The Earl of Strafford, a whole length'; owned by the actress Mrs Oldfield in 1730.
Lit: *Notes and Queries*, 19 June 1869.

Shallop, c.1690.
Built for Queen Mary. A warrant of 18 January 1698 survives from William Lowndes to pay £725 1s. 3d. to John Luftus, Alexander Fort, Grinling Gibbons and William Ireland 'upon their Warrants for building of Barges for his Majesty'.
Coll: National Maritime Museum, Greenwich.
Lit: PRO, Disposition Book, XIV, p. 287; *Country Life*, 22 June 1935, p. 656; Green, *Gibbons*, Pl. 202.

(E) MONUMENTS

This list is based on suggestions made by several scholars (including the late Mrs K. A. Esdaile, the late Rupert Gunnis and the late Dr Margaret Whinney), on comments within the Esdaile papers at the Huntingdon Museum and Art Gallery, San Marino, on the photograph files of the Courtauld Institute of Art, University of London, and on other sources, cited.

Sir John Barrington, d.1682.
St Andrew, Hatfield Broad Oak, Essex
Thought to be the work of Gibbons by the late Rupert Gunnis (Green, *Gibbons*, p. 184). I concur with this opinion. The gadrooned sarcophagus, and flaming urn between mourning *putti* are there, below swags falling from a coat of arms. At the top is a tasselled cushion similar to that on the tomb of the first Duke of Beaufort, documented as by Gibbons (Chapter III, No. 36).

Robert Berkeley, d.1694.
All Saints, Spetchley, Hereford and Worcester
This monument also commemorates Robert

Berkeley's widow, Elizabeth, and was erected by her before her own death in 1708. A gadrooned sarcophagus rests above a plinth attended by *putti* as weepers. The coat of arms is set around by flowers and three cherubim. The design may have been by Gibbons, in the opinion of the late Rupert Gunnis (Green, *Gibbons*, p. 185): 'the execution not'.

Francis, Earl of Bradford, d.1708.
St Andrew, Wroxeter, Shropshire
A marble monument without figures except for two mourning *putti* kneeling at left and right of the reredos background. This has an arch supported by pilasters and a large urn beneath. The pattern was used again in the monument to Sir John and Lady Nicholas and the documented one to George Churchill (Chapter III, No. 43). The Bradford one does not, however, have the flanking obelisks present in the other two.

The Dormer family
St Mary and Holy Cross, Quainton, Buckinghamshire

This monument commemorates Fleetwood Dormer (d.1638), John (d.1679) and Fleetwood (d.1696). The urns, weeping *putti*, cartouches and swags are all there. It may well be a work by Gibbons. The late Rupert Gunnis thought the central part 'school of Edward Marshall' and the *putti*, urns, etc. 'could be Gibbons' (Green, *Gibbons*, p. 183).

Benjamin Godfrey, d.1704.
St Mary, Norton, Kent
The urn at the top is of 'Gibbonsian virtuosity' (John Newman in N. Pevsner, ed., *Buildings of England: North East and North Kent*, 1969, p. 393). Thought to be by Gibbons by the late Rupert Gunnis (Green, *Gibbons*, p. 184).

Sir Thomas Hare, d.1695.
Holy Trinity, Stow Bardolph, Norfolk
Semi-reclining figure in Roman armour and a wig. Thick gadrooned cornice at the top of the base. The figure leans on an acanthus embroidered cushion (as do several on documented Gibbons monuments such as that of Sarah, Duchess of Somerset, Chapter III, No. 27). Inscription records that Dame Elizabeth as widow (d. 25 January 1750) erected the monument. Thought to be by Gibbons by the late Rupert Gunnis (Green, *Gibbons*, p. 184). I concur with this opinion.

Lord Denzel Holles, d.1699.
St Peter, Dorchester, Dorset
A large standing monument but not in its original place. The two weeping *putti* should be left and right of the pilasters. Lord Holles reclines on a gadrooned sarcophagus. Many of the Gibbons forms are present here, including the coronet on a tasselled cushion at the top between two urns, with draped curtains below, similar to the documented first Duke of Beaufort (Chapter III, No. 36).

Mary Kendall, d.1710.
Westminster Abbey, St John the Baptist Chapel
Thought to be by Gibbons by the late Rupert

Gunnis (Green, *Gibbons*, p. 183) but the kneeling figure, said to be reminiscent of that of Mrs Mary Beaufoy (Chapter III, No. 40) is not typical.

Sir Thomas Longueville, d.1685.
Holy Trinity, Old Wolverton, Buckinghamshire
Thought to be by Gibbons by the late Rupert Gunnis (Green, *Gibbons*, p. 183). A semi-reclining figure in Roman armour with hand on heart. The sarcophagus is large with a reredos background.

Robert Lovet, d.1699.
All Saints, Soulbury, Buckinghamshire
Stated by the late Rupert Gunnis to be 'documentarily certain' as by Gibbons (N. Pevsner, *Buildings of England: Buckinghamshire*, 1960, p. 241).
A sarcophagus without gadrooning above a plinth with the inscription recording many other Lovet family details, weeping *putti*, a flaming urn with two winged cherubim, one holding a crown and a palm frond. A coat of arms at the top, two obelisks to right and left of the reredos topped by the pelicans of piety. All in white marble and similar to the monuments to George Churchill (Chapter III, No. 43), Francis, Earl of Bradford, and Sir John and Lady Nicholas noted in this list.

Sir John and Lady Nicholas (d.1704 and 1703)
St Mary, West Horsley, Surrey
The same architectural frame as used on the documented monument to George Churchill (Chapter III, No. 43), with mourning *putti*, obelisks and an urn within a niche. Ian Nairn and N. Pevsner (*Buildings of England: Surrey*, 1962, p. 29) are in error in suggesting Gibbons as the author of the adjacent monument to Sir Edward Nicholas (d.1669). See also 'Francis, Earl of Bradford' (note above).

Lady Francesca North, d.1678.
All Saints, Wroxton, Oxfordshire
This monument may well be by Gibbons as

there is a payment to him in 1680 recorded in
the North bank account (Child's Bank). At its
head two *putti* are seated on a gadrooned sar-
cophagus, flanking a skull and bones. Flower
drops flank the inscription: there is a cartouche
at the foot. Thought to be by Gibbons by the
late Rupert Gunnis (Green, *Gibbons*, p. 184).

Oxinden family, d. 1682.
St Mary the Virgin, Wingham, Kent
Likely by date to be the work of Arnold Quellin
who was in partnership with Gibbons in 1682
(see Chapter III).

Lit: John Newman in N. Pevsner, ed., *The
 Buildings of England: North East and East
 Kent*, first attributed the monument to
 Quellin or Gibbons in the first edn of
 Newman and Pevsner, 1969, p. 481 (3rd
 edn, 1983, p. 500).

Martha Price, d. 1678
Westminster Abbey, west end of north aisle.
Thought to be by Gibbons by the late Rupert
Gunnis (Green, *Gibbons*, p. 183) but in my
opinion unlikely.

George Savile, d. 1695.
Westminster Abbey, Queen Elizabeth Chapel.
Thought to be by Gibbons by the late Rupert
Gunnis (Green, *Gibbons*, p. 183) but in my
opinion unlikely. The sarcophagus is plain and
Gibbons invariably applied gadrooned ornament
to his.

James Scudamore, d. 1668.
St Cuthbert, Holme Lacy, Herefordshire
Clearly this monument is later than the date of
death. The figure is semi-reclining on a sar-
cophagus. To the left and right pilasters with
fluted capitals and outside them large volutes;
an urn and shield at the top. Thought to be by
Gibbons by the late Rupert Gunnis (Green,
Gibbons, p. 184). I have examined the Scu-
damore bank accounts (Child's Bank) but found
no relevant payment.

Sir John Spencer, d. 1699.
St Mary Magdalene, Offley, Hertfordshire
A standing wall monument with a reredos back-
ground. Semi-reclining figure in wig and con-
temporary clothes, on a plinth gadrooned at
each corner. At his feet a kneeling female with
one hand raised. Two *putti* with crown and
palm branch above. The usual acanthus-decked
cushion for Sir John to lean on. Attributed by
Mrs K. A. Esdaile to E. Stanton or John Nost.
In my opinion it could be by Gibbons.

Thomas Taylor, d. 1689.
St Thomas of Canterbury, Clapham, Bedford-
shire
Thought to be by Gibbons by the late Rupert
Gunnis. The mourning *putti* are on a gadrooned
cornice but the upper part of the monument is
not convincing.

Appendix II

The Quellin (Quellien) family

Erasmus Quellien I = Betje van Unden
sister of Lucas, painter of landscapes

11 children

including – Erasmus II (1607–?) *painter*
Artus I (1609–68) *Sculptor at the Town Hall, Amsterdam*
Hubertus (1619–after 1665) *author of 2-volume work on the Town Hall sculptures*

Another branch of the Quellin family

Arnoldus Quellin = Maria Morren
possibly a brother of Erasmus I

One of their children was:
Artus II (1625–1700), *a pupil of* Artus I;
contemporary sources call him a 'kozjin, cousin, vetter' of Artus I.

Artus II married Anna Maria Gabron.

They had eight children, including:

Arnold (1653–86) who worked in England with Gibbons.
He married Francesca Siberechts, daughter of the topographical painter.

Thomas, who worked in England and Denmark.

This information is based on Juliane Gabriels, *Artus Quellien de Oude, kunstryck belthouwer*, Antwerp 1930. The information about Artus Quellien I in Thieme-Becker, *Allgemeines Lexikon de bildenden Künstler* (1909–47 etc) contains errors.

INDEX

Numbers in **bold** refer to the Plates